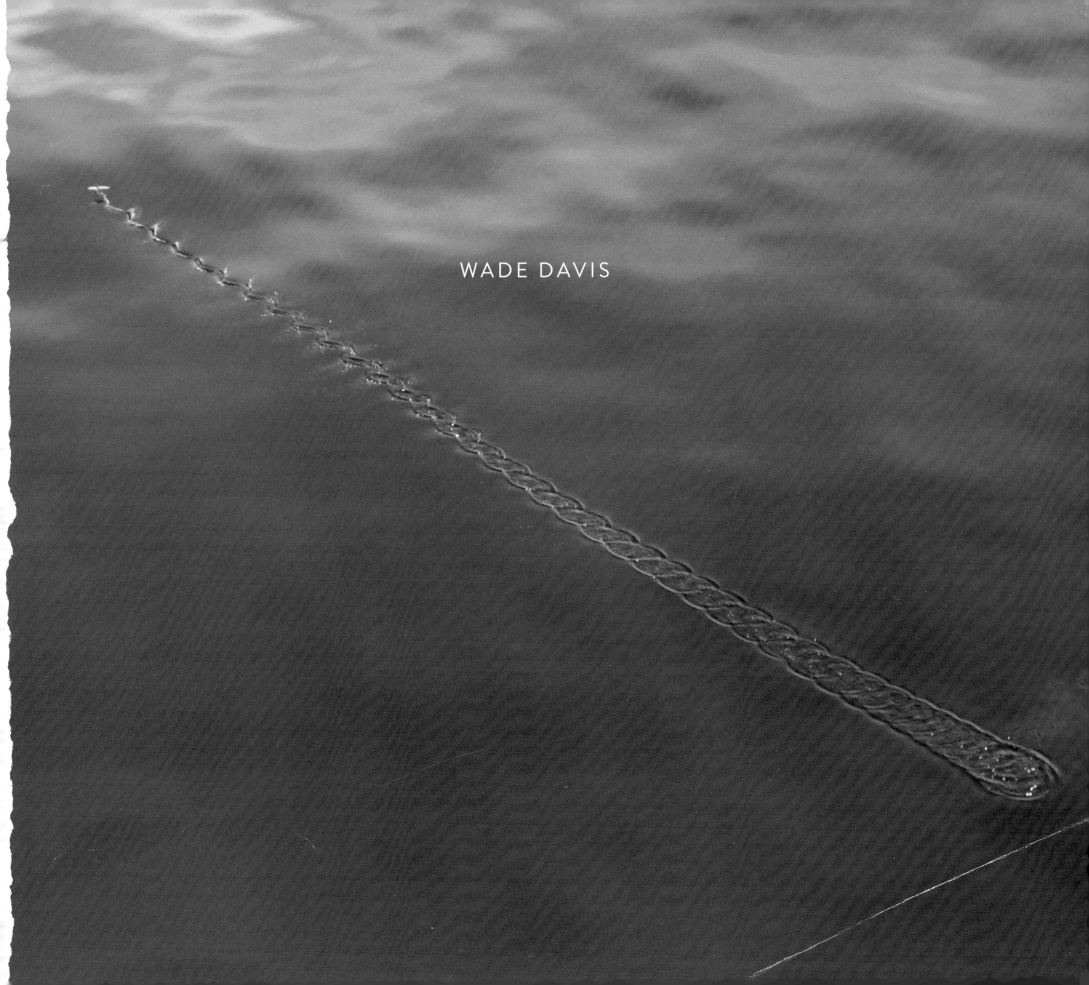

WADE DAVIS

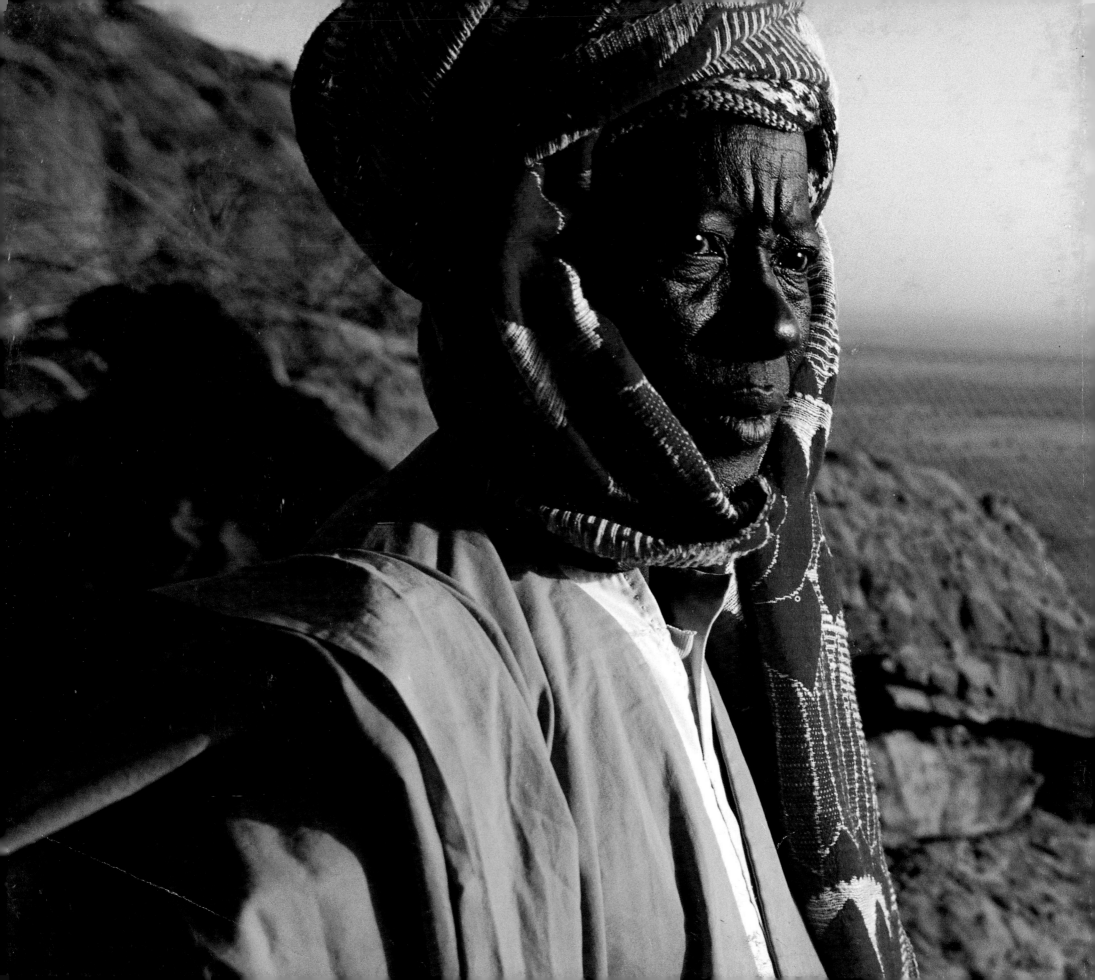

WADE DAVIS: PHOTOGRAPHS

WADE DAVIS

Douglas & McIntyre

CONTENTS

PAGE 1: A flying fish ripples the surface of the Sargasso Sea.

PRECEDING PAGES: A Dogon elder from the cliffs of the Bandiagara escarpment in Mali peers toward the lands of the Fulani, one of the many Muslim tribes that threaten the cultural survival of a people that have resisted Islam for a thousand years.

THIS PAGE: Sunset at sea, approaching the town of Illulisat on the west coast of Greenland.

INTRODUCTION

IN THE FALL OF 1979 HIS HOLINESS THE 14TH DALAI LAMA ended his first tour of the United States with a three-day visit to Harvard University. Cautioned by the American government to avoid overt political statements, the Tibetan spiritual leader made no mention of the millions killed by the Chinese, or the thousands of shrines, monasteries and temples reduced to rubble before the jeering mobs of the Red Guards. Instead he spoke of peace and loving compassion and the struggle of the Tibetan people to maintain their culture, a way of life that has contributed much to the well-being of humanity. His evening address on "The Nature of Self" at Sanders Theater drew a packed crowd of over fifteen hundred, with a waiting list for tickets that had students and faculty lining up around the block.

That same night, directly across the street from Sanders Theater, in the Lowell Lecture Hall, Pulitzer Prize–winning biologist E.O. Wilson stood at the podium to introduce Norman Myers, author of *The Sinking Ark*, one of the first popular accounts of the emerging biodiversity crisis. The cavernous room had but a smattering of students. In apologizing for the sparse audience, Wilson expressed his considerable frustration. The fact that even Harvard students, he suggested, failed to appreciate the importance of the loss of plant and animal species and would rather be across the way listening to (and I quote) "that religious kook" showed how much public education remained to be done in the society at large.

Professor Wilson, as kind and decent a man and as brilliant a biologist as has ever lived, would be the first today to regret his remark. But it was in fact indicative of the chasm that existed at the time between conservation biologists and anthropologists. The biologists for the most part viewed people, and indigenous peoples in particular, as part of the problem. Anthropologists could not abide what they viewed as the misanthropic and elitist position of the naturalists.

I may have been the only student on campus that night racing back and forth between both talks. If there was one theme propelling my work as a young botanist and anthropologist it was a concern for the erosion of both cultural and biological diversity, and a recognition that the loss of the former was directly related to the sacrifice of the latter. The forces responsible for the destruction of habitat and the extinction of plants and animals, whether in the Amazon or Borneo, West Africa or Nepal, were essentially the same as those compromising the human legacy—egregious industrial practices, ill-conceived development schemes and policies, brute power and the triumph of ideology implicit in the ubiquitous cult of modernity.

For this perspective I can thank two extraordinary mentors: David Maybury-Lewis, my undergraduate tutor in anthropology, and Richard Evans Schultes, who guided my doctoral research in biology. Both men were

At the annual Epe-Ekpe festival of the Guen people in Togo, a beautiful woman brings wooden dolls representing all the twins in her family's past. Each day these ancestors are bathed and ritualistically fed, as if still alive. In a sense they are, because in Africa twins never die.

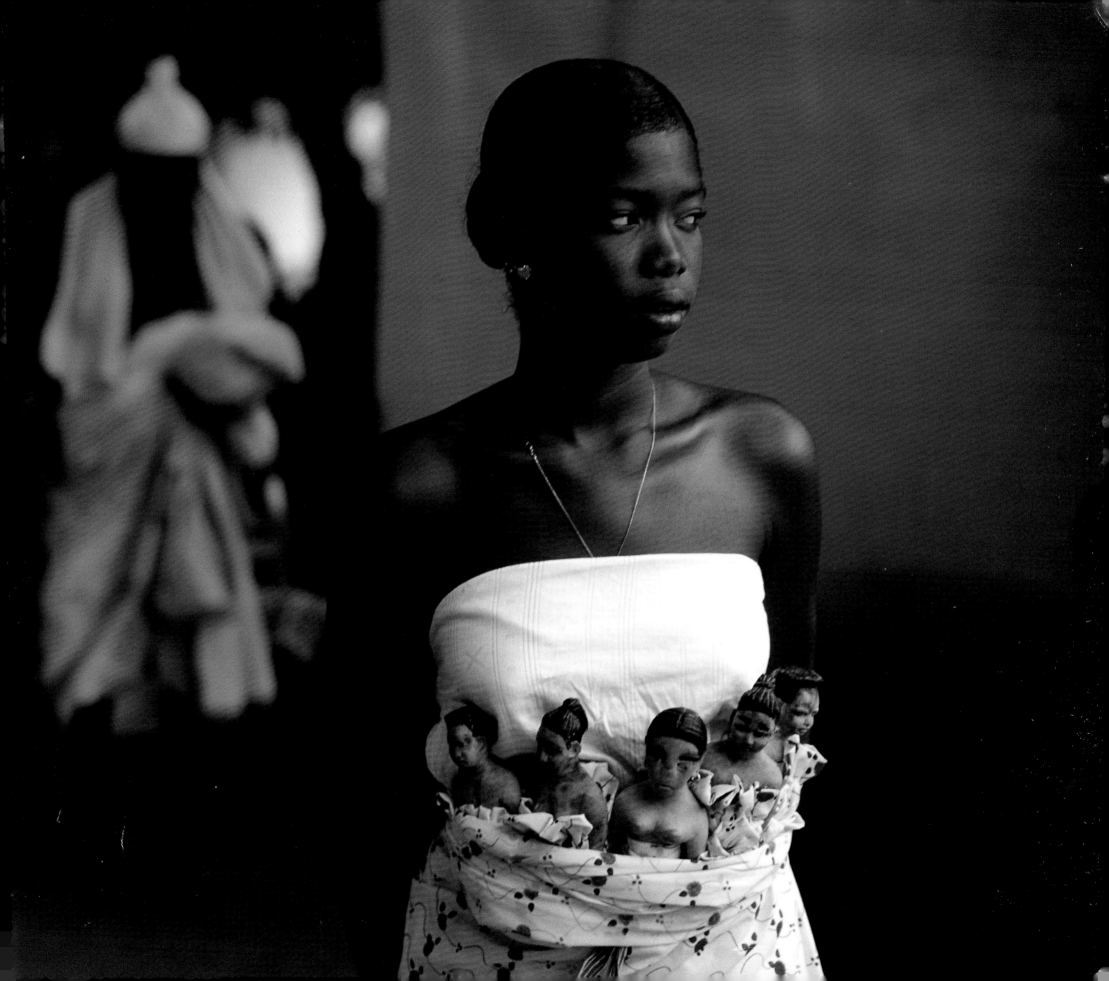

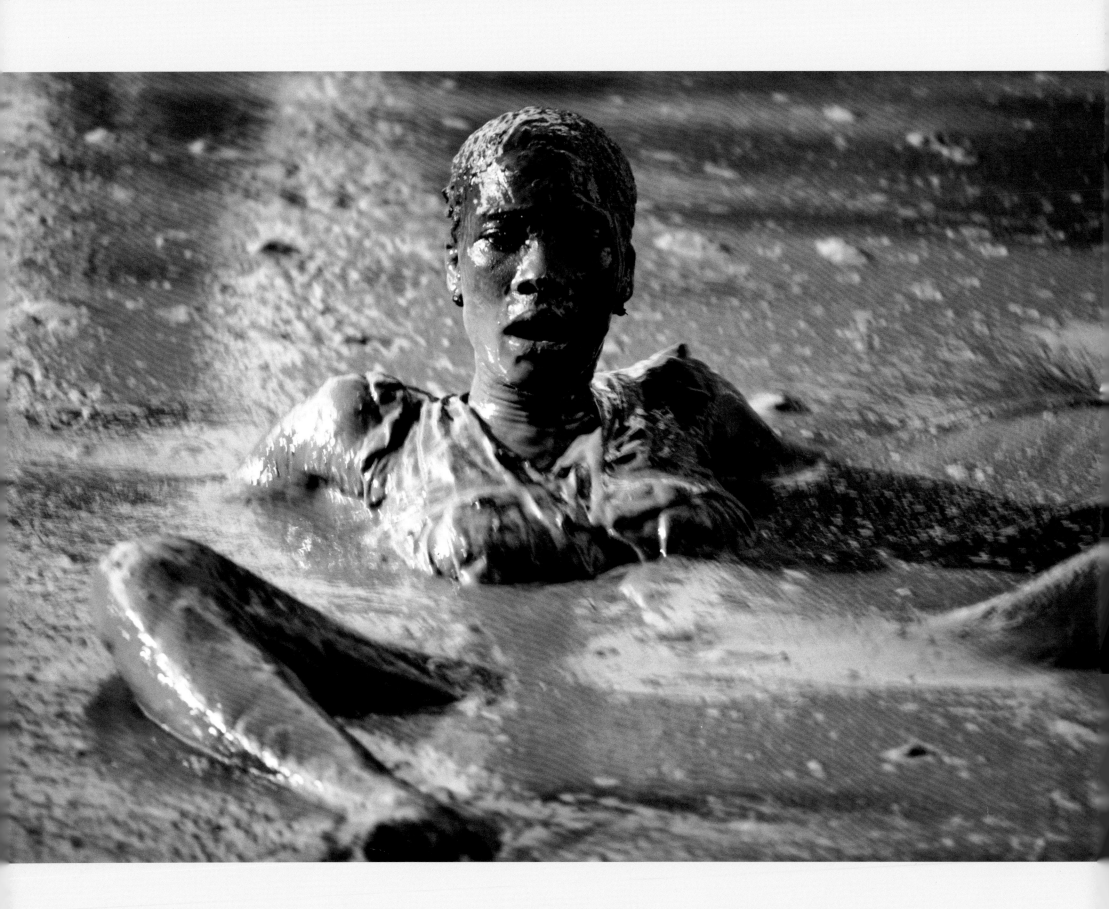

legends in their fields. By 1957 Maybury-Lewis had travelled up the Río das Mortes (River of the Dead), and flown into a remote mission to reach the lands of the Akwe-Shavante, at the time the most feared and warlike of all the indigenous tribes of Brazil.

A generation earlier Schultes had lived among the Kiowa and studied the peyote cult, ingesting the sacramental plant in ritual context as often as three times a week throughout a long hot summer of illumination. In 1938 he travelled to Mexico and discovered the botanical identities of *teonanacatl* and *ololiuqui*, hallucinogenic plants long sacred to the Aztec, thus solving one of the great mysteries of ethnobotany. In 1941 he disappeared into the Northwest Amazon, where he remained for twelve uninterrupted years, travelling down unknown rivers, living among unknown peoples, all the time enchanted by the wonder of the tropical rain forest. In time, mountains would bear his name, as would national preserves. The greatest Amazonian plant explorer of his century, he was the first Western scholar to fully understand and herald the botanical genius of the Indians, even as he recognized with growing dismay the speed with which this profound knowledge was being lost.

If Schultes inspired by the example of his deeds, David Maybury-Lewis awakened the imagination through the sheer power of his intellect, the wonder of his words and ideas and the integrity of his political convictions. For a year we met once a week in his book-lined office overlooking the courtyard of the Tozzer Library. His mind ranged over the entire history of the discipline. "Deciphering the stranger," David explained at the outset, "making sense of the exotic other is the very essence of anthropology."

One of his favourite stories concerned the Greek historian Herodotus, who in the fifth century BCE travelled the length of the known world. While living as a guest of the Persian court, Herodotus watched as the emperor Darius brought together representatives of two of his subject peoples, one from a culture that cremated their dead and the other from a culture that reputedly ate their dead. Darius asked each whether his people might consider emulating the death rituals of the other. Both expressed horror at the thought.

Herodotus concluded from this the obvious: every culture favours its own traditions and generally looks down upon those of any other. Five centuries before Christ this astute observer, in so many ways the ultimate father of anthropology, discerned the trait that more than any other has haunted humanity since the dawn of awareness: cultural myopia—the notion that our way is the right way and everyone else is a failure to be us.

Herodotus observed but did not judge. This is what made him so remarkable, and so vilified by his contemporaries. Plato accused him of sympathizing with barbarians and urged that he be banished from Athens for betraying his own people. If this sounds familiar, David quipped, it should, for to this day anthropologists are sometimes accused of loving every culture save their own.

Perhaps there is a sliver of truth in this. I certainly was drawn to anthropology at least in part because I wanted to leave a world—my world—that I had come to see as problematic in terms of the environment, social and racial justice, treatment of women, not to mention the endless and pointless war in Vietnam.

At the Haitian festival of Plaine du Nord, Vodoun pilgrims honour Ogoun, the god of fire and war. The clay is believed to be profoundly curative, and merely to enter the mud basin is to be transformed and taken by the spirits.

I suffered in my youth from what Baudelaire called the great malady: horror of home. Or perhaps, more simply, I sought escape from a middle-class world of monotony in the hope that I might find in distant places the means to rediscover and celebrate the enchantment of being human. Many anthropologists of my generation entered the field with a similar hunger for raw and authentic experience.

David naturally took a higher view. In the early years of the discipline, in the late nineteenth century and the first decades of the twentieth, anthropologists went to study remote tribal peoples because they were seeking the most exotic societies they could find, alien worlds where everything was different except for the basic humanity of their hosts. They went in search of answers to big questions.

What makes us human? Why are other societies so different from ours? What kind of sense lies behind their customs and what does this tell us about our own, and about human nature in general? And if these societies really did represent primitive stages of human evolution, as was commonly believed at the time, what could the study of them tell us about the history of humankind?

What anthropologists eventually discovered was quite the opposite. Though tribal societies lacked the technology of the industrial world, they were no less intelligent or rational than citizens of supposedly advanced nations. There were in fact no reasonable grounds whatsoever for considering any society to be primitive. In the end this would prove to be arguably the single most important contribution of anthropology. But this would all come later.

At its inception anthropology grew out of an evolutionary model in which nineteenth-century men such as Herbert Spencer, who coined the term "survival of the fittest," and Lewis Henry Morgan envisioned societies as stages in a linear progression of advancement leading, as they conceived it, from savagery to barbarism to civilization. Charles Darwin, of course, was the inspiration. If species evolved, surely cultures did as well. And if the theory of natural selection offered a mechanism that allowed for the evolution of biological life, would it not be possible to come up with some sweeping theory to explain the grand march of human history?

According to Morgan each of these phases of human development—savage, barbarian, civilized—was correlated with specific technological innovations. Fire, ceramics and the bow and arrow marked the savage. With the domestication of animals, the rise of agriculture and the invention of metalworking we rose to the level of the barbarian. Literacy implied civilization. Every society, it was assumed, progressed through the same stages, in the same sequence. Thus the technological sophistication of a people placed them on a particular step on the evolutionary ladder, which led inevitably from the jungles of Africa to London and the splendour of the Strand.

David referred to these early pioneers as armchair anthropologists. They sat back and concocted grand theories based on the literature or reports coming back from the ever-expanding frontiers of colonial empires. They were highly critical of their own culture and yet remained prisoners of it. They never doubted that Victorian society represented the apex of humanity's evolution. They lived in an era in which the supremacy of the white man was so broadly accepted that there was not even a word in the English language for what we now label as racism.

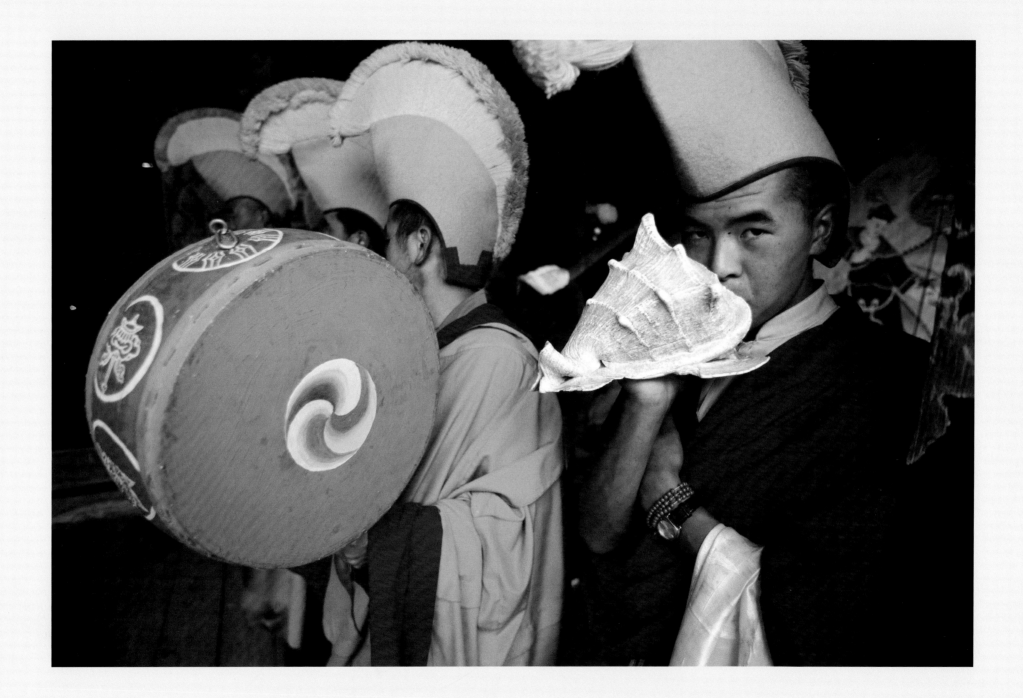

A monk at the Thubten Chöling Monastery in Solu Khumbu, Nepal, blows a conch trumpet during the Mani Rimdu, an eighteen-day festival that commemorates the transmission of Buddhism to Tibet by Padmasambhava in the eighth century.

There was, however, one scholar in the early history of anthropology who recognized the inadequacies of broad theories of culture concocted by men who never went to the field and whose ideas about human advancement were so obviously skewed by preconception. Franz Boas was a physicist, trained in Germany a generation before Einstein. His doctoral studies concerned the optical properties of water. Throughout his investigations his research was plagued by problems of perception, which came to fascinate him. In the eclectic way of the best of nineteenth-century scholarship, inquiry in one academic field led to another.

What was the nature of knowing? Who decided what was to be known? Boas became interested in how seemingly random beliefs and convictions converged into this thing called "culture," a term he was the first to promote as an organizing principle, a useful point of intellectual departure. Far ahead of his time he sensed that every distinct social community, every cluster of people distinguished by language or adaptive inclination, was a unique facet of the human legacy and its promise. Each was a product of its own history.

Boas saw evolutionary anthropology as intellectually flawed and morally defective. Anthropologists should not be collectors of missionary tales and spinners of grand theories but field scientists, collectors of data. His goal was to present objective descriptions of cultures within their unique historical and environmental context.

Boas became the father of modern cultural anthropology, the first scholar to attempt to explore in a truly open and neutral manner how human social perceptions are formed, and how members of distinct societies become conditioned to see and interpret the world. Working first among the Inuit of Baffin Island and later along the northwest coast of Canada, he insisted that his students learn and conduct their research in the language of the place, and as much as possible participate fully in the daily lives of the people they studied. Every effort should be made, he argued, to understand the perspective of the other, to learn the way they perceive the world and, if at all possible, to know the very nature of their thoughts. This demanded, by definition, a willingness to step back from the constraints of one's own prejudices and preconceptions.

This notion of cultural relativism was a radical departure, as unique in its way as was Einstein's theory of relativity in the discipline of physics. Everything Boas proposed ran against orthodoxy. It was a shattering of the European mind, the sociological equivalent of the splitting of the atom. At its core was the realization that the social world in which we live does not exist in some absolute sense but rather is simply one model of reality, the consequence of one set of intellectual and spiritual choices that our particular cultural lineage made, however successfully, many generations ago. The other peoples of the world are not inferior; they represent other options, other possibilities, other ways of thinking and interacting with the earth. Each is an inspired expression of our collective human genius. All have an equal claim on reality, just as none has a monopoly on the route to the divine. As David Maybury-Lewis often remarked, every culture has something to say, each deserves to be heard and each warrants a place at the council of wisdom and knowledge.

For David these were not idle sentiments, but deeply held convictions that made him, like Franz Boas, a tireless campaigner for human rights. In 1972 he and his Swedish wife, Pia, who with their infant son had accompanied him into the wilds of central Brazil, founded Cultural Survival, an organization that to this day remains a powerful voice for indigenous peoples throughout the world. They both believed that anthropologists had an obligation to be not just advocates for the cultures with which they had worked and lived, but activists committed to a global vision of pluralism that would celebrate the wonder

and contributions of all peoples of the world. Critically this did not imply blind acceptance of all human behaviour. Nor did it suggest that every trait of culture had to be defended simply because it exists. Anthropology, as David would always say, never calls for the elimination of judgment; it calls only for its suspension, so that those judgments we are ethically and morally obliged to make as human beings can be conscious and informed.

This subtlety of interpretation and analysis led David to believe strongly that the insights of anthropology deserved and needed to be part of the public discourse. In this respect he was very much in the lineage of Franz Boas. Cultural anthropology as a science, Boas maintained, made sense only if it was practised in the service of a higher tolerance. Margaret Mead, perhaps the best-known popular anthropologist of her era, was a student of Boas, as was Ruth Benedict, who distilled the essence of the discipline in a single line: "The main purpose of anthropology is to make the world safe for human differences."

Inspired by such scholars I came out of graduate school with a strong conviction that the lessons of anthropology were far too important to be sequestered in the silos of the academy, which is one reason I pursued an independent career as a writer, photographer and, in time, filmmaker. Ernest Hemingway wrote that the most important credential for a storyteller is to have something to say that the world needs to hear. In the years after I left Harvard several developments occurred that left me more convinced than ever that anthropology had plenty to say.

In an astonishing manner, using techniques that were unimaginable when I was a student, geneticists bridged the chasm that had long existed between biology and anthropology, and in doing so effectively proved to be true the central intuition of cultural anthropology. Studies of the human genome revealed beyond doubt that the genetic endowment of humanity is a single continuum. We are all brothers and sisters. Race is an utter fiction. Virtually every human alive is a descendant of a relatively small number of individuals who walked out of Africa some 60,000 years ago and then, on a journey that lasted 40,000 years—some 2,500 generations—carried the human spirit to every corner of the habitable world.

But here was the key revelation. If we are all cut from the same genetic cloth, then by definition all cultures share essentially the same mental acuity, the same raw genius. Whether this intellectual capacity and potential is exercised in stunning works of technological innovation, as has been the great achievement of the West, or through the untangling of the complex threads of memory inherent in a myth—a primary concern, for example, of the Aborigines of Australia—is simply a matter of choice and orientation, adaptive insights and cultural priorities.

There is no hierarchy of progress in the history of culture, no social Darwinian ladder to success. That Victorian notion of the savage and the civilized—with European industrial society sitting proudly at the apex of a pyramid of advancement that widens at the base to the so-called primitives of the world—has been thoroughly discredited, indeed scientifically ridiculed for the racial and colonial conceit that it was. It is no more relevant to our lives today than the notion, fiercely held by clergymen in the nineteenth century, that Earth was but six thousand years old.

We share a sacred endowment, a common history written in our bones. It follows, as anthropologists have long maintained, that the myriad of cultures in the world are not failed attempts at modernity, let alone failed attempts to be us. They are unique expressions of the human imagination and heart, unique

answers to a fundamental question: what does it mean to be human and alive? When asked this question, the cultures of the world respond in seven thousand different voices, and these collectively comprise our human repertoire for dealing with the complex challenges that will confront us as a species in the coming centuries.

Tragically, even as geneticists in all their brilliance affirmed the essential connectedness of humanity, another branch of science confirmed that many, if not most, of these cultural voices are being silenced. In 1992 Michael Krauss, then head of the Alaska Native Language Center in Fairbanks, published one of the most important and disturbing academic papers ever written. Based in part on his address the year before to the Linguistic Society of America, his paper "The World's Languages in Crisis" began with a litany of loss. Among the Eyak of the Copper River delta of Alaska, where Krauss had worked, there remained but two speakers of the language, both elderly. The Mandan of the Dakotas had but six fluent speakers, the Osage five, the Abenaki-Penobscot twenty, the Iowa five, the Tuscarora fewer than thirty, the Yokuts fewer than ten. Altogether some six hundred extant languages survive with fewer than a hundred speakers. Over 3,500 of the world's languages, Krauss reported, are kept alive by a fifth of 1 per cent of the global population.

In the southern Andes of Peru people meeting on a trail pause and exchange *k'intus* of coca, three perfect leaves aligned to form a cross. Turning to face the nearest *apu*, or sacred mountain, they bring the leaves to their mouths and blow softly, a ritual invocation that sends the essence of the plant back to the earth, the community and the souls of the ancestors.

My background in anthropology notwithstanding I was astonished to learn that fully half the languages of the world are not being taught to children, that every fortnight on average an elder passes away and carries into the grave the last syllables of an ancient tongue, that every two weeks another language dies. Within the linguistic community I could find no source to challenge Krauss's bleak assessment. This academic consensus was itself haunting. When I spoke to Ken Hale, an eminent linguist at MIT, he agreed without hesitation that 50 per cent of the world's languages were endangered. A language, he stressed, is not just a body of vocabulary and a set of grammatical rules; it's a flash of the human spirit, the means by which the soul of a culture comes into the material world. Every language is an old-growth forest of the mind, a watershed of thought, an ecosystem of social and spiritual possibilities. To lose a language, Hale said very simply, is like dropping a bomb on the Louvre.

When I finally reached Krauss in Alaska he compared the loss of languages with the erosion of biodiversity. No biologist, he noted, would dare suggest that 50 per cent of all plant and animal species are on the brink of extinction, certainly across the entire world. Yet this, the most apocalyptic assessment of the future of biological diversity, scarcely approaches what is known to be the best conceivable scenario for the fate of the world's languages and cultures. Newspapers, Krauss added, devote columns of print to the fate of the spotted owl, yet barely a word to the plight of the world's endangered languages. The American government spends one million dollars a year to save a single wildlife species, the Florida panther. The total budget for the study, documentation and revitalization of the 175 extant native languages in the United States was at the time a mere two million, as Krauss noted. Why does a species of bird or a flower, he asked, matter more than the poetry, songs and stories encoded in the memories of the surviving custodians of an ancient language?

My question for Krauss was rather different. If he was correct it surely implied that half of humanity's intellectual, spiritual and social legacy would disappear within a generation. Yet no one outside a small circle of academics was even talking about it. If virtually all linguists agreed with this dire prognosis, why on earth were they not screaming about it? Krauss responded with one word: Chomsky.

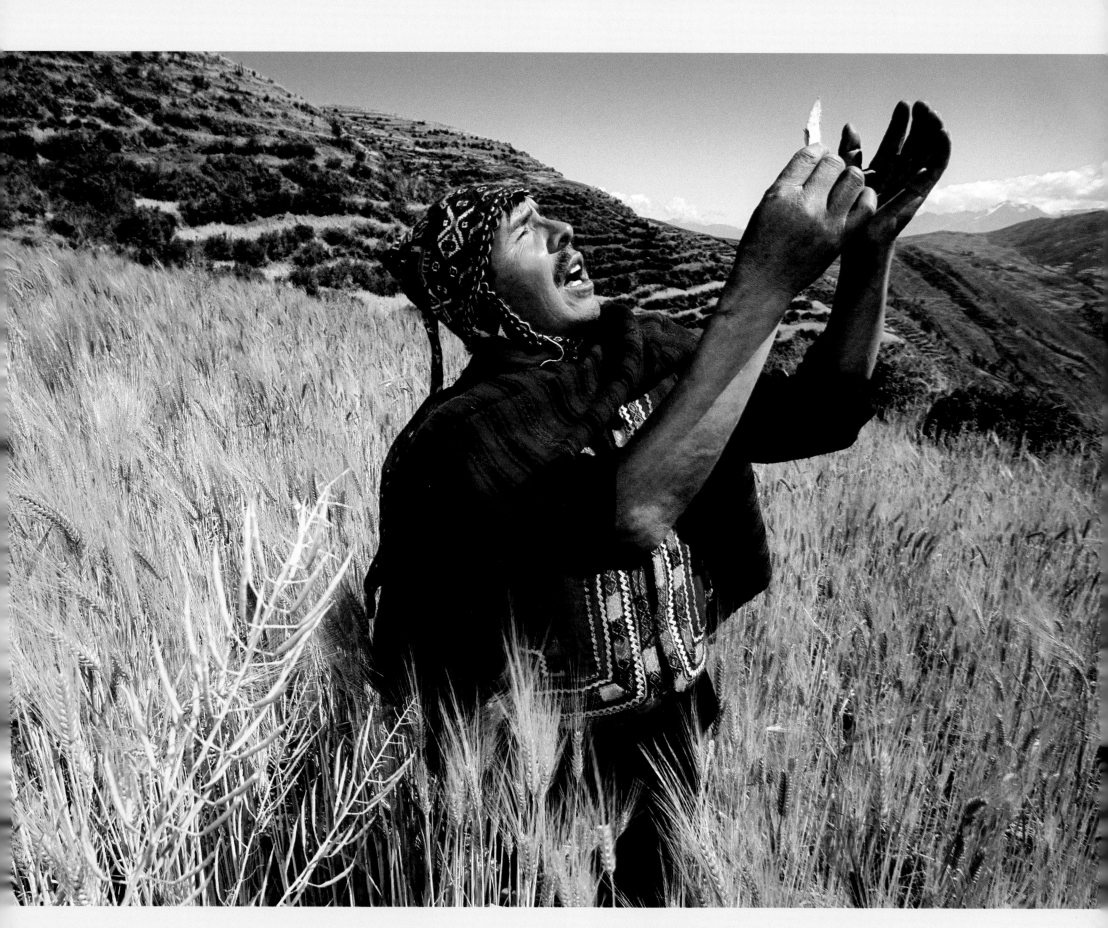

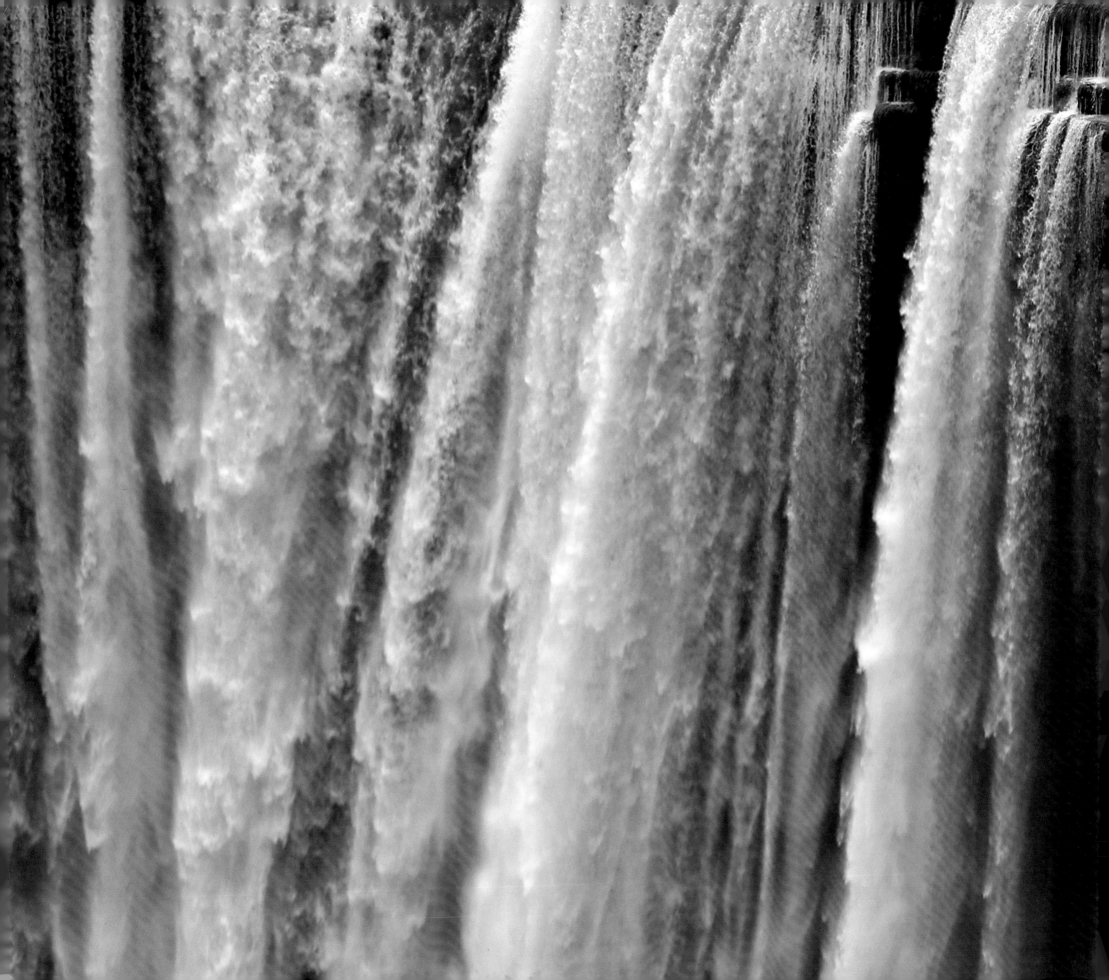

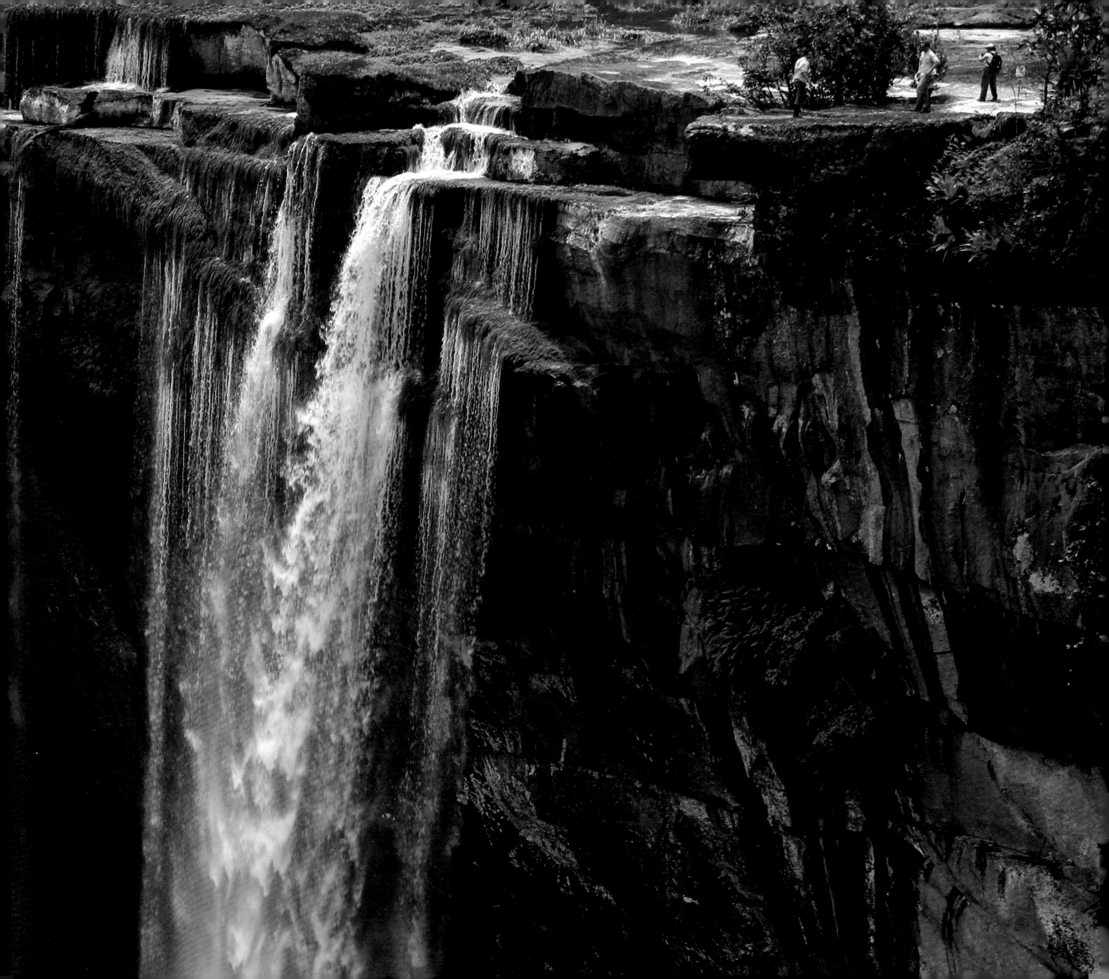

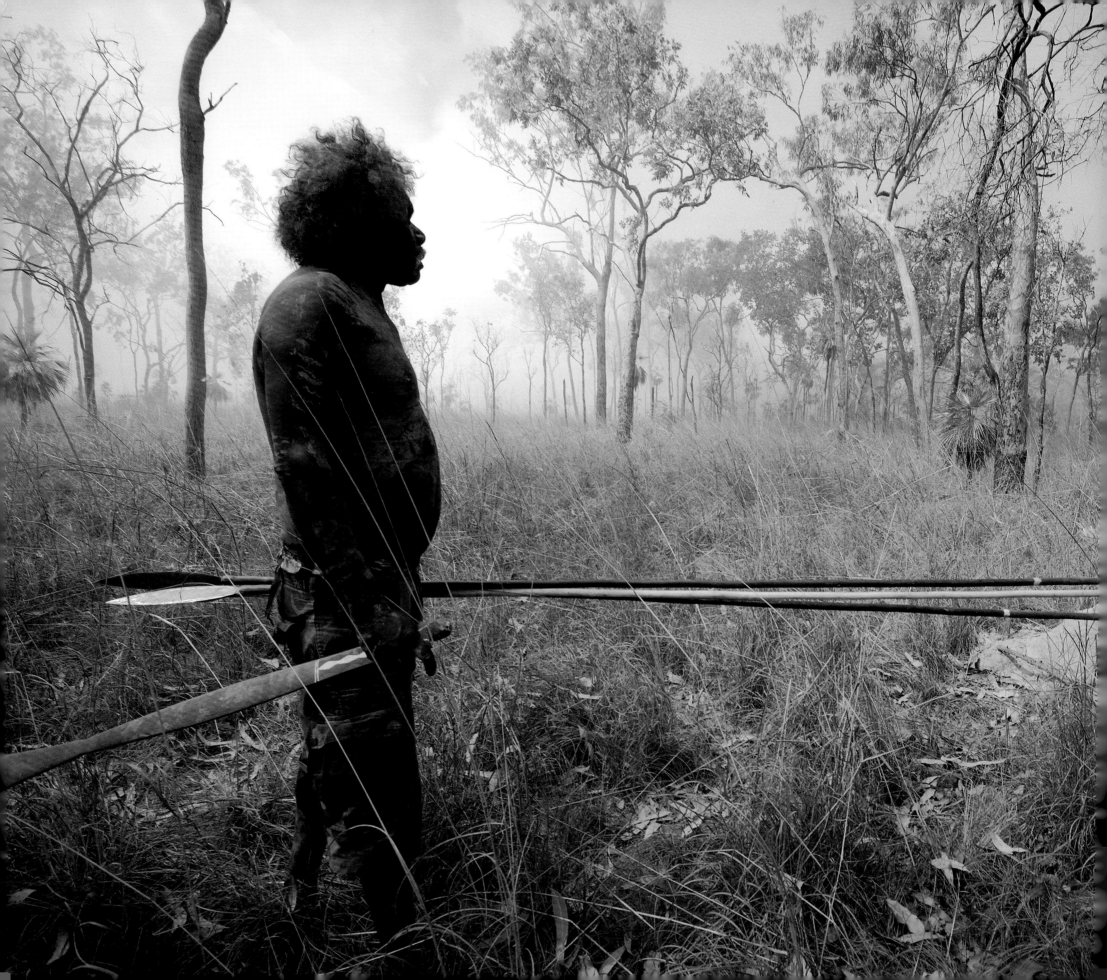

Noam Chomsky, a colleague of Ken Hale's at MIT, had been a hero during the heady days of student protests at Harvard, a prominent academic who consistently joined the ranks in the streets and spoke with great insight and passion at many of the most heated anti-war rallies. He was a darling of the New Left and this burnished his already formidable reputation as the most influential linguist of his generation. To critics he was virtually unassailable. His ideas and theories transformed and in time utterly dominated the entire field of linguistics.

Until Chomsky, linguists assumed that infants acquired language as they responded behaviourally to rewards and affirmation. Chomsky didn't buy it. He noted that language acquisition is an extraordinarily complex process that children throughout the world all manage to do at roughly the same age, as if designed to accomplish the task. He believed that the ability to learn language was in fact encoded in the human brain at birth as an immutable set of rules he called a universal grammar. This language organ did not exist in a physical sense, but it might be studied through the detailed analysis of the abstract structures underlying language. By doing so, he suggested, it might even be possible to learn something fundamental about intelligence and human nature.

Chomsky's theory was insightful and novel, and it became hugely influential in part because it suggested that linguists might be able to act as real scientists. Of enormous consequence was its premise that culture had no role to play in the study of language. To go off to the field to compile dictionaries and grammars of dying languages spoken by a handful of survivors was to Chomsky and his acolytes a completely pointless exercise. What mattered was linguistic theory and whatever might help reveal the nature of the universal grammar.

As Michael Krauss explained, Chomsky was interested not in what distinguished languages but rather in what they had in common. Krauss used an analogy from biology. A microbiologist interested in the fundamentals of life studies DNA and doesn't really care where the DNA comes from because it is so similar across the animal kingdom. Why go to the effort to get panda DNA, for example, when you can conduct the same experiments with the DNA of laboratory rats, which is so much easier to obtain? What matters to the microbiologist is the universal structure of DNA, not the fact that its phenotypic expression produces creatures as varied as pandas, rats and fruit flies. Biodiversity is important but it can be left to the conservation biologists and ecologists.

Such was Chomsky's influence that the entire field of linguistics for some thirty years focused exclusively, if you will, on the micro. Linguists pursued the Holy Grail of a universal grammar, blithely unconcerned that the actual expressions of that imagined deep structure—the languages of humanity—were disappearing by the day. Those who challenged this orthodoxy, who argued that language documentation, the creation of dictionaries and actual grammars, was indeed the real work of linguistics, found themselves for the most part ostracized by the academic world. Michael Krauss was an exception, as was Ken Hale, and both in time would inspire a new generation of linguists for whom language loss would be seen as one of the most pressing challenges of our times. But this change came slowly, and for the longest time Krauss and Hale remained as lone voices in the wild.

From my perspective as an anthropologist, language loss was the canary in the coal mine, a sure indicator of what was happening to cultural diversity throughout the world. It was something that everyone could understand. Audiences invariably gasped when they heard the dire statistics. How would it feel, I would ask during public lectures, to be the last speaker of your native language, enveloped in silence, with no means or ability to pass on the wisdom of your ancestors, or to anticipate the promise of your descendants? To those who suggested that the world would be a better place if we all spoke one language, that communication would be facilitated, that it would be easier for us to get along, I responded: fine—but let's make that universal language Haida or Yoruba, Lakota, Inuktitut or San. Suddenly people got a sense of what it would mean to be unable to speak their mother tongue.

I first wrote of language loss in *The Clouded Leopard*, a collection of essays that came out in 1998. That same year an assignment from the National Geographic Society (NGS) resulted in a story "Vanishing Cultures," which appeared in the Society's flagship magazine in August 1999. The follow-up surveys, which the NGS does for every article, indicated that the subject resonated powerfully with the readership. A year later I was invited to join the Society and its conservation mission as an Explorer-in-Residence (EIR), with the mandate of helping it address this crisis, even as we worked to change the way the world viewed and valued culture. In 2001 I published *Light at the Edge of the World*, a book of photographs and text that in a sense became the manifesto for my mission at the Society.

In that book I coined the term "ethnosphere" with the idea of inspiring a new way of thinking about this extraordinary matrix of cultures that envelops the planet. But how could we actually make a difference? When biologists such as Jane Goodall and the great oceanographer Sylvia Earle, who both served with me as EIRs at the Society, identify a region of critical importance in terms of biodiversity, they call for the creation of a protected area. One cannot designate a rainforest park of the mind, or sequester indigenous peoples in a preserve like some kind of zoological curiosity. As an anthropologist fully aware of the dynamic, ever-changing nature of culture, I had no interest in preserving anything. I just believed, as David once said, that all peoples ought to have the right to choose the components of their lives.

Recognizing that polemics are rarely persuasive, but with the hope that storytellers can change the world, I set out largely through the medium of film and photography to take the global audience of the NGS— literally hundreds of millions of people in 172 countries—to points in the ethnosphere where the beliefs, practices and intuitions are so dazzling that one cannot help but come away with a new appreciation for the wonder of the human imagination made manifest in culture.

My goal was not to document the exotic other, but rather to identify stories that had deep metaphorical resonance, something universal to tell us about the nature of being alive. We did not enter communities only as filmmakers and ethnographers; we were welcomed as collaborators, building on networks of relationships and friendships that often reached back for three decades or more. Our mandate fundamentally was to provide a platform for indigenous voices, even as our lens revealed inner horizons of thought, spirit and adaptation that might inspire, in the words of Father Thomas Berry, entirely new dreams of the earth.

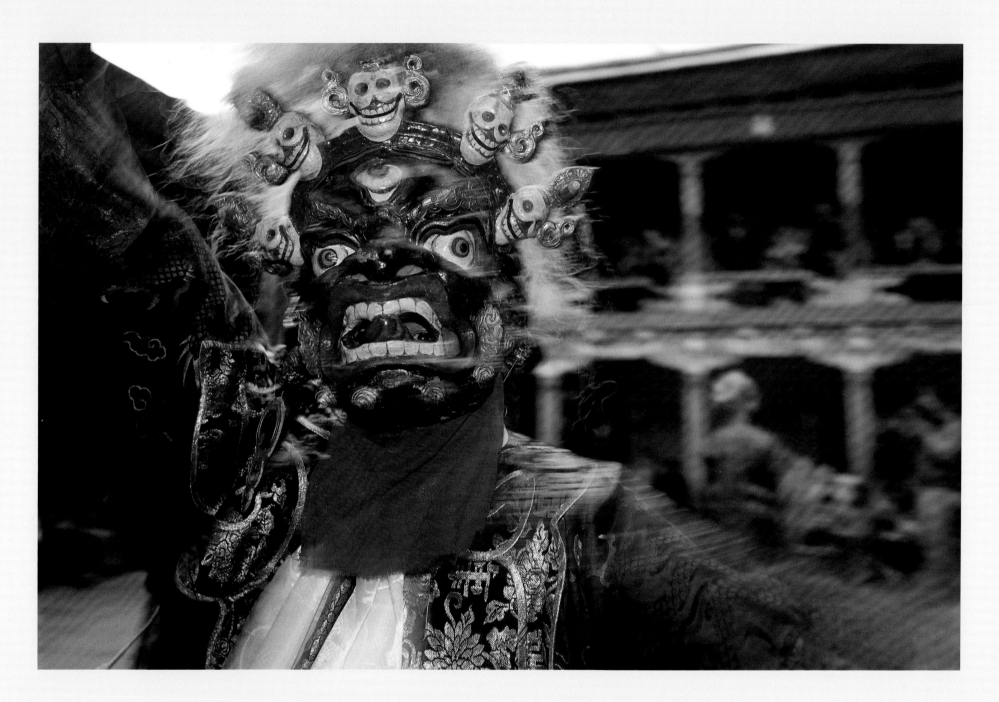

At Chiwong, a monastery that clings like a swallow's nest to the southern flank of the Himalaya in Solu Khumbu, Nepal, a masked dancer invokes a deity at the Mani Rimdu, a three-week festival that recalls the transmission of the Buddhist dharma to Tibet in the eighth century.

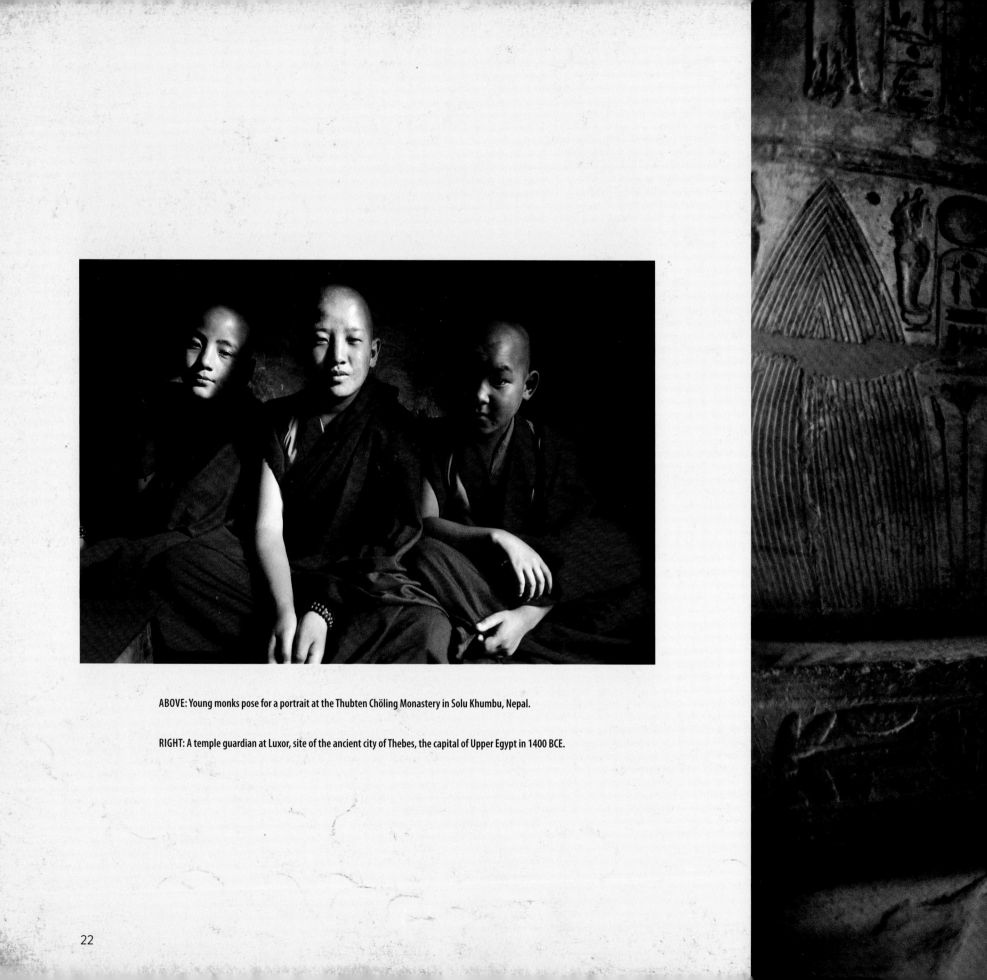

ABOVE: Young monks pose for a portrait at the Thubten Chöling Monastery in Solu Khumbu, Nepal.

RIGHT: A temple guardian at Luxor, site of the ancient city of Thebes, the capital of Upper Egypt in 1400 BCE.

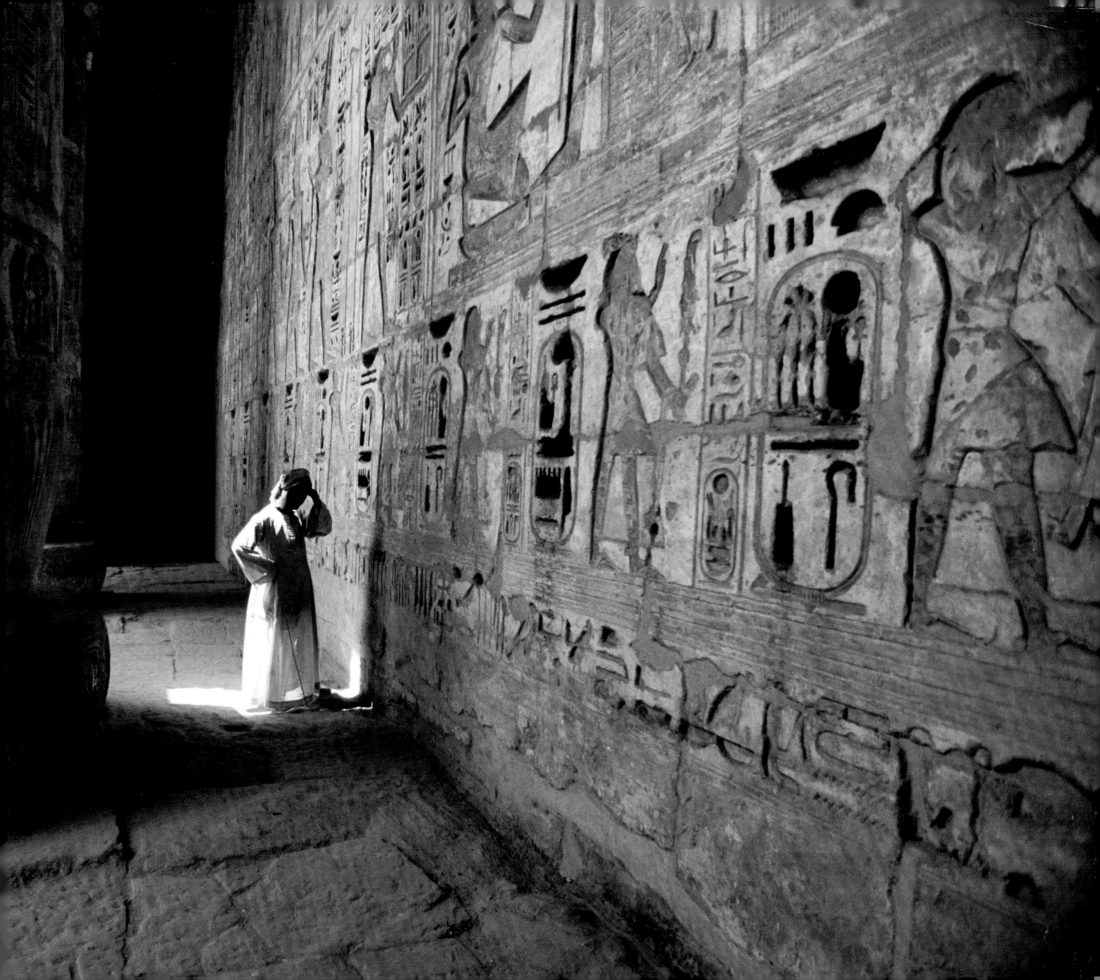

Altogether, with various colleagues, all extraordinarily talented, I made seventeen films in my years at the NGS. In the immediate wake of 9/11 I went to Timbuktu and journeyed overland four hundred miles north into the Sahara to the ancient salt mine of Taoudenni to tell a story of Islam. Later we explored the roots of Vodoun in Togo and Benin, before travelling to Hawaii, the Marquesas, Rapa Nui and Tahiti to make *The Wayfinders*, a celebration of the genius of Polynesian navigation. In *Hunters of the Northern Ice*, we explored a cultural world of ice among the Inuit in Nunavut and the Polar Eskimo of Greenland. I went to the Himalaya to reflect on the science of the mind that is Tibetan Buddhism, and to Andean Peru to examine the meaning and significance of pre-Columbian notions of sacred geography. A second four-part series gave voice to the Arhuacos and the Elder Brothers of the Sierra Nevada de Santa Marta in Colombia, celebrated the pastoral nomads of Mongolia, explored the philosophy of the Aboriginal peoples of Australia and visited the homeland of the people of the anaconda, the Barasana and Makuna in the Northwest Amazon of Colombia. Other film projects led to the lowland forests of Ecuador, the mountains of Oaxaca, the depths of the Grand Canyon and the homelands of the Havasupai and Hualapai, Zuni, Hopi, Paiute and Navaho.

Many of the photographs in this book were taken as we made these films; others came out of other expeditions or the journeys I went on as a lecturer for the travel office at the NGS, a rare privilege that allowed me to visit some eighty nations, many repeatedly, over my years as an EIR. One of the great joys of my affiliation with the Society was the opportunity to spend time both at the headquarters in Washington, D.C., and in the field with some of the finest photographers working today: Ed Burtynsky, Frans Lanting, Chris Johns, Angela Fisher, Carol Beckwith, Matthieu Ricard, Thomas Kelly, Aaron Huey, Sarah Leen, Art Wolfe, Chris Rainier and many others. It was an ongoing apprenticeship with the stars.

Just as I learned to write by reading and in effect deconstructing the very best of literary non-fiction, I became a photographer by paying attention to light and composition, and by studying intently the work of the masters. When I was a college senior a brilliant and irreverent photographer, Tod Papageorge, later director of the graduate photography department at Yale for three decades, came to Harvard as a visiting artist to teach an advanced seminar. It was designed only for those few highly accomplished photographers who had majored in visual studies and intended to work as professionals in the field.

In no way did I qualify, but by good fortune several of the young photographers were close friends and they essentially obliged Papageorge to accept me in the class, if only to provide entertainment value. And that was about all I could come up with for the first weeks of term. But Papageorge was an inspired teacher, in good measure because he had no interest in soliciting student opinion about anything. Each week he projected on the screen the work of the masters and for two hours, without pause, he explained why a photograph was good. He did not tolerate discussion and thus the atmosphere of the class was mercifully uncluttered by idle opinion. His laser insights went right to the source and like the photographs themselves became indelibly imprinted on the emulsion sheet of one's mind. I can still see Atget's Paris in the morning mist, the raw urban notes of Robert Frank, the timeless landscapes of Ansel Adams that led Henri Cartier-Bresson in frustration to lament during the 1940s that the entire world was falling apart and Ansel was still taking pictures of stones. "You are writing with light," Papageorge would proclaim; "go and find something to say."

After weeks of frustration I went to Virginia over spring break and found, in the shadows of a landscape, something magical and moving. I returned and showed Papageorge my images. Something had happened.

A young Masai warrior reaches for a beam of sunlight coming through the roof of his family home in a village high above the Ngorongoro Crater in Tanzania.

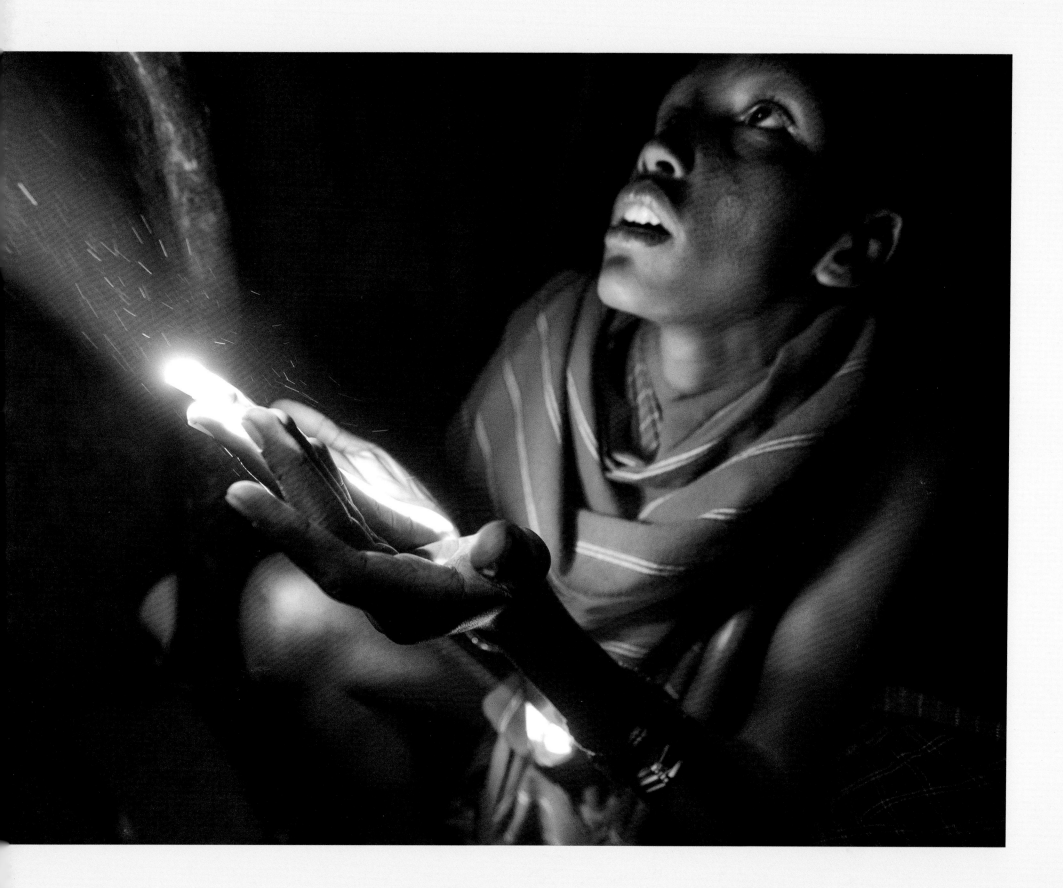

Somehow I had got it right. It was not about talent or skill or raw creativity. It was about listening and seeing and paying attention.

My close companion at the NGS for many years was Chris Rainier, a protégé and former assistant of Ansel Adams. Chris had done his time as a war correspondent in Sarajevo and Mogadishu and had been among the first journalists to witness the carnage of the genocide in Rwanda. But his passion was culture. For a decade he had chronicled traditional life in the most remote reaches of New Guinea, and he later spent another seven years following, as he put it, the flow of ink—documenting the art of ritual tattooing throughout the world. Chris lives for the open road. I have never known a more peripatetic traveller. A fine photographer, he is an equally skilled teacher, patient and generous to a fault.

Chris taught me the dance of photography—how to get in and out of a scene with effortless grace and causing no offence. He spoke no foreign languages yet when he was working he had a way of communicating with all by means of a simple facial expression, perhaps the touch of a hand, a self-deprecating laugh. "If you don't like your photos," he would say, quoting the great Robert Capa, "get closer." He would then plunge within inches of a subject, shoot off several frames and get out before anyone could object. Few ever did, because it was all coming from a place of sincere respect and affection. Chris once told me that photography makes it possible to express inner visions, realms linked to, yet beyond, ordinary reality. He made no pretense of being an anthropologist. Every one of his photographs was a purely subjective effort to evoke meaning and passion, a sense of mystery and wonder.

Ansel Adams unabashedly described the photograph as "an instrument of love and revelation" and said that "a great photograph is one that fully expresses what one feels…about what is being photographed and is, thereby, a true expression of what one feels about life in its entirety." Adams advised his students to be patient, to extract from the moment only what moves the heart and to anticipate the emotional response of a photograph long before triggering the shutter. Alfred Stieglitz wanted his every photograph to evoke for the viewer the same emotions he had sensed in the instant of exposing the emulsion to the light. Cartier-Bresson wrote that great photographs come about in the decisive moment when the head, heart and eye find perfect alignment in an axis of the spirit.

Photography, as Susan Sontag wrote, is a twilight art, an art of elegy. The very act of taking a photograph ensures that the images will in time resonate with nostalgia. Edward Curtis considered photography to be a salvage operation, and he posed his subjects with the explicit intention of recording the last vestiges of what he viewed as a doomed world. Even his exterior shots are reminiscent of the painted backdrops used by frontier photographers of the American West, who captured and froze Geronimo and Sitting Bull in defeat. For many it has become impossible to look at any photograph of tribal peoples engaged in ritual activities and not think of Curtis.

The subjects photographed in this book have not been manipulated and their lives are not vestigial. They are not archaic relics stranded in time, having at best a vague advisory role to play in contemporary life. In truth, all the cultures documented in this book—the Arhuacos and Tibetans, the San, Barasana, Makuna and Penan, the Rendille, Dogon, Inuit, Tamashek and Tuareg, not to mention all the traditional cultures of West Africa, Mongolia, Australia and Polynesia, and indeed the Colombian people as a nation—are very much alive and fighting not only for their cultural survival but also to take part in a global dialogue that will determine the future of life on earth.

That said, photography is no different from any other medium of artistic endeavour. The decisive moment does indeed come about as Cartier-Bresson famously proclaimed but surely such luminous moments can never be fully divorced from intent. Just as every book of literary non-fiction is crafted from the selective memory of the author, calling into question all notions of objective truth, so too every photograph is to some extent a constructed and invented reality. No photograph ever reflects a pure instant, perfectly caught in time, save perhaps one exposed accidentally as a camera tumbles to the ground, triggering the shutter.

Something on the order of 3.5 trillion images have been taken since the invention of photography. Every two minutes today as many images are snapped as were exposed in photography's first seventy-five years. The digital camera for millions of people has become a teacher and partner in the creation of images. Their sheer number, the ease of colour correction and manipulation, and the very speed with which photographs may be dispatched around the world has generated a popular tsunami that may well drown photography as a professional vocation.

When I first hosted travel trips for the National Geographic Society the most avid amateur photographers brought along perhaps thirty rolls of film; on my last such journey just one of the guests took over sixteen thousand frames in a fortnight. Wherever one travels these days everyone is taking pictures. Gone are the days when photography was the monopoly of the tourist, when gawky and intrusive visitors "took pictures" and "shot film" in what Susan Sontag described as an aggressive act of non-intervention. The digital revolution has provoked the democratization of an art form in a manner that is both rare and welcome, however disruptive it may be for those trying to make a living with their cameras. More people in more places are taking better and better images, taking the craft to ever-higher levels of artistic and journalistic achievement.

Technology has always been a part of photography; few artistic disciplines have benefited more from the speed of technological innovation. Ansel Adams, who spent hours in the darkroom, burning and dodging, transforming an image, would have been dazzled by the creative potential of the digital world. But he would have been the first to acknowledge that the fundamentals of the discipline will always remain the same. To be a photographer, as Tod Papageorge told us in class so many years ago, one must write with light and find something to say.

The photographs in this book most assuredly reflect a point of view. My goal is always to try to find in the chaos of visual perception and experience that perfect moment when subject, luminosity and perspective come together to affirm the eternal dignity of the human spirit.

Many years ago when I first joined the NGS and set out on this mission, I was asked to distill in a few lines the essence of what I hoped to achieve. "There is a fire burning over the earth," I wrote at the time, "taking with it plants and animals, ancient skills and visionary wisdom. At risk is a vast archive of knowledge and expertise, a catalogue of the imagination, an oral and written language composed of the memories of countless elders and healers, warriors, farmers, fishermen, midwives, poets and saints—in short, the artistic, intellectual, and spiritual expression of the full complexity and diversity of the human experience. Quelling this flame, this spreading inferno, and rediscovering a new appreciation for the diversity of the human spirit as expressed by culture, is among the central challenges of our times." This book is one small contribution to this effort, one modest way of remembering just how lucky we all are to be human and alive.

FOLLOWING PAGES: A camel caravan makes its way through the Sahara to Taoudenni, an ancient salt mine some four hundred miles north of Timbuktu.

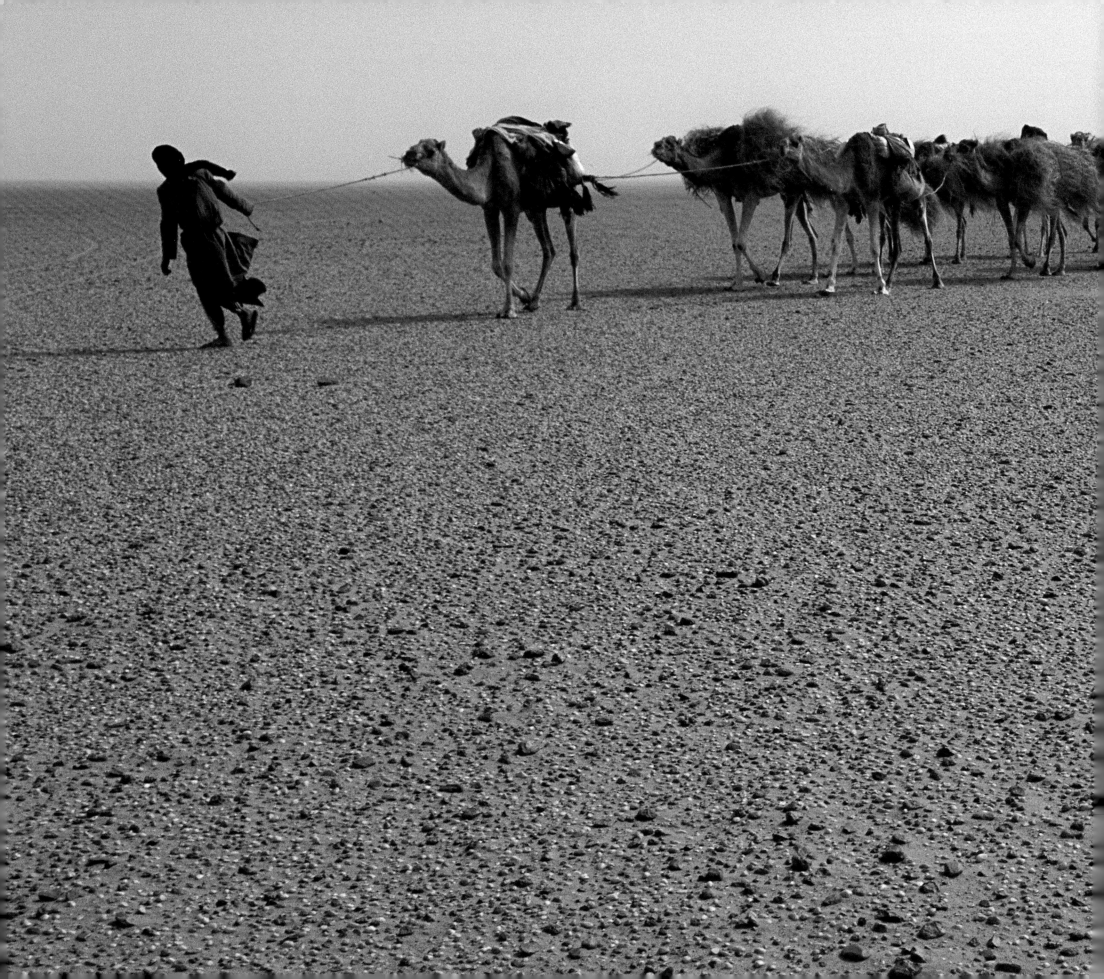

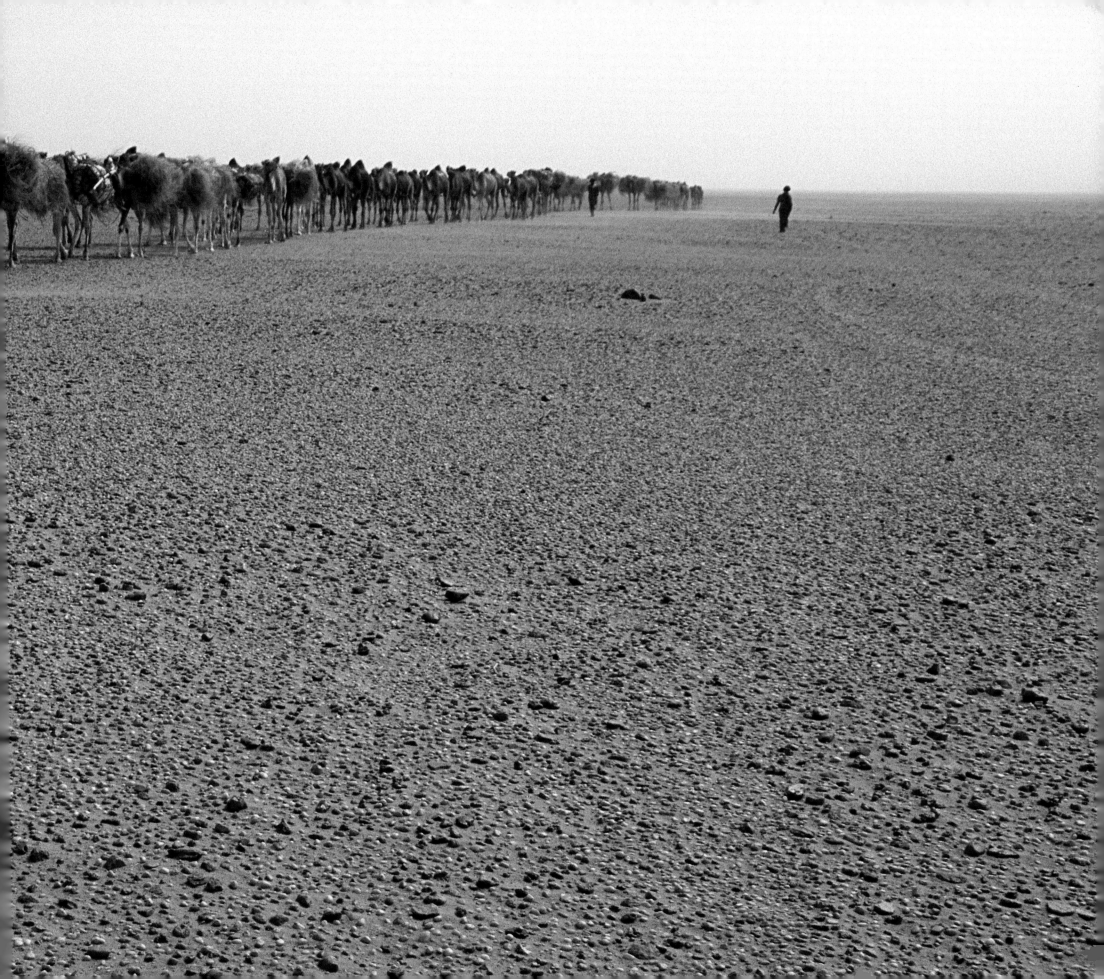

HUNTERS OF THE NORTHERN ICE

WHEN THE INUIT FIRST ENCOUNTERED EUROPEANS, they believed their wooden ships with billowing sails were gods. The British believed the Inuit were savages. Both were wrong. The British failed to understand that there was no better measure of genius than the ability to survive in the Arctic environment with a technology that was limited to what you could carve from ivory and bone, antler and animal skins, soapstone, slate and small bits of wood that drifted to shore as flotsam. The Inuit did not fear the cold; they took advantage of it. The runners of sleds were originally made from fish—three Arctic char laid in a row, wrapped in caribou hide and frozen. A knife could be made from human excrement. A moist skin left overnight became a shovel by dawn.

The Inuit are a people of the ice. As hunters they depend on it for their survival even as it inspires the essence of their character and culture. The writer Gretel Ehrlich, who lived eight years among the Polar Eskimo in Greenland, suggests that it is the nature of ice, the way it moves, recedes, dissolves and reforms with the seasons, that gives such flexibility to the Inuit heart and spirit. "They have no illusions of permanence," she explains. "There is no time for regret. Despair is a sin against the imagination. Their grocery store is out there on the land and this creates an emotional life that's so much bigger than that of those who live in cities. They deal with death every day. To live they must kill the things they most love. Blood on ice is not a sign of death but an affirmation of life. Eating meat becomes a sacramental experience."

Ipeelie Koonoo scans the sea for narwhal and belugas at Cape Crawford, Baffin Island. Every June, in one of nature's most epic animal migrations, seventeen million marine mammals return to the Arctic. Admiralty Inlet, which clefts the northern shore of Baffin Island, remains icebound and the Inuit hunters travel along the floe edge, where the ice meets the sea, and listen as the breath of whales mingles with the wind.

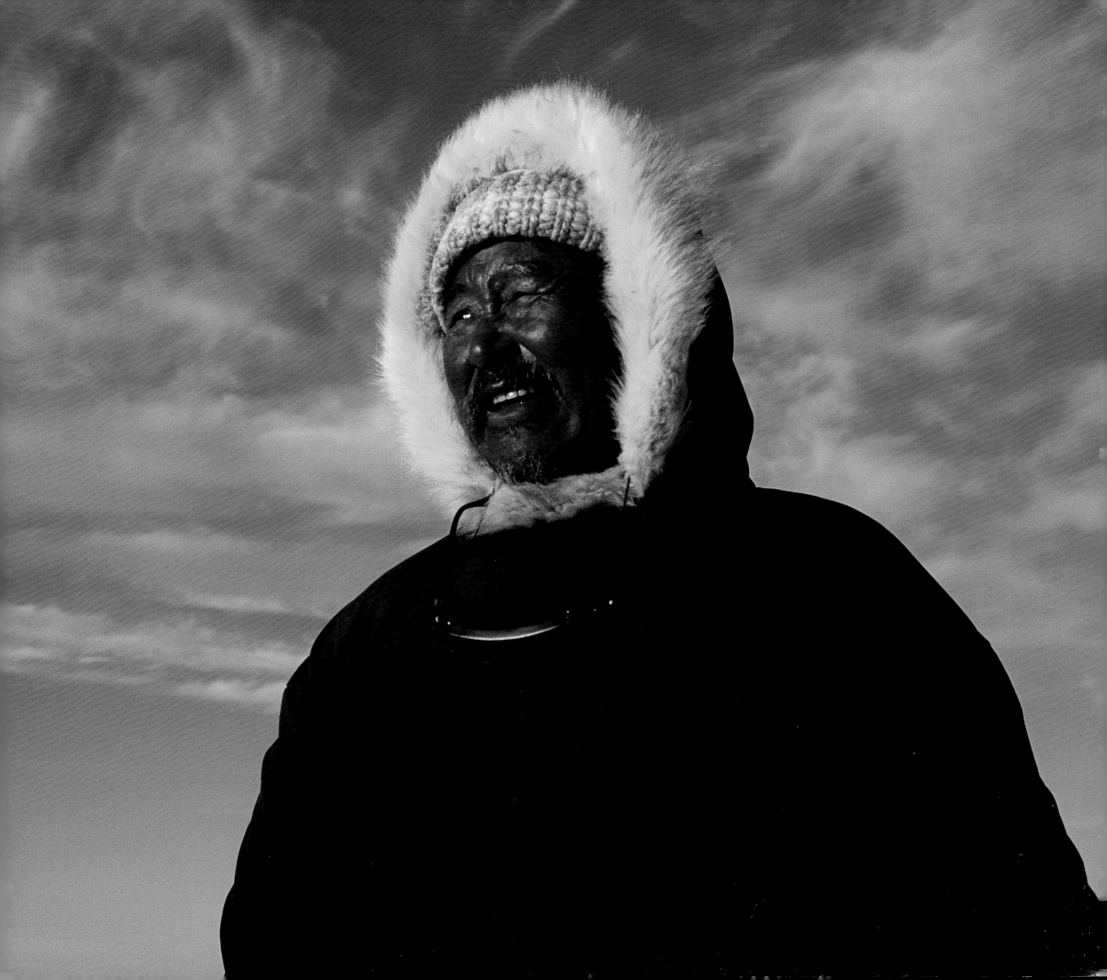

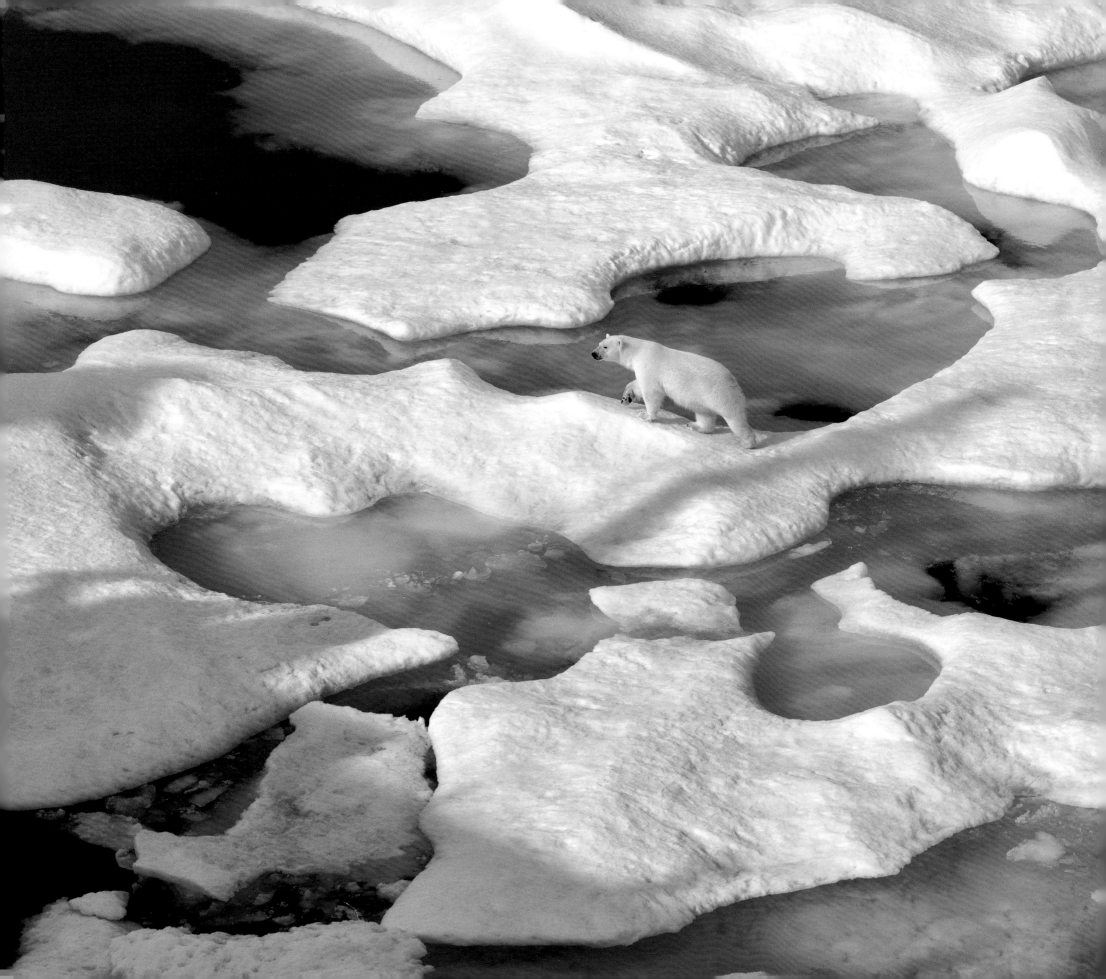

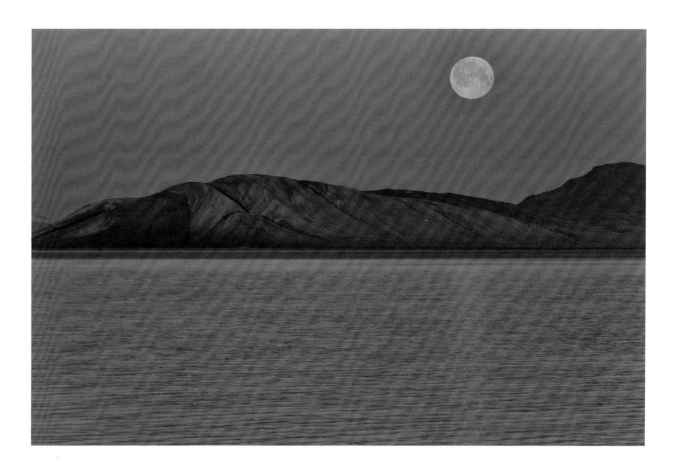

ABOVE: The moon rises over the western shore of Ellesmere Island, Vesle Fjord and Eureka Sound, 80 degrees north latitude.

LEFT: A polar bear hunts on the sea ice six miles off the eastern shore of Baffin Island. In winter darkness the Inuit follow leads in the new ice to find the breathing holes of ringed seals. The slightest shift in weight will betray their presence so they squat in perfect stillness, all the while knowing full well that as they hunt they are being hunted. Polar bear tracks run away from every breathing hole. If a seal does not appear the hunter may roll over, mimicking a seal to try to attract a bear so that predator may become prey.

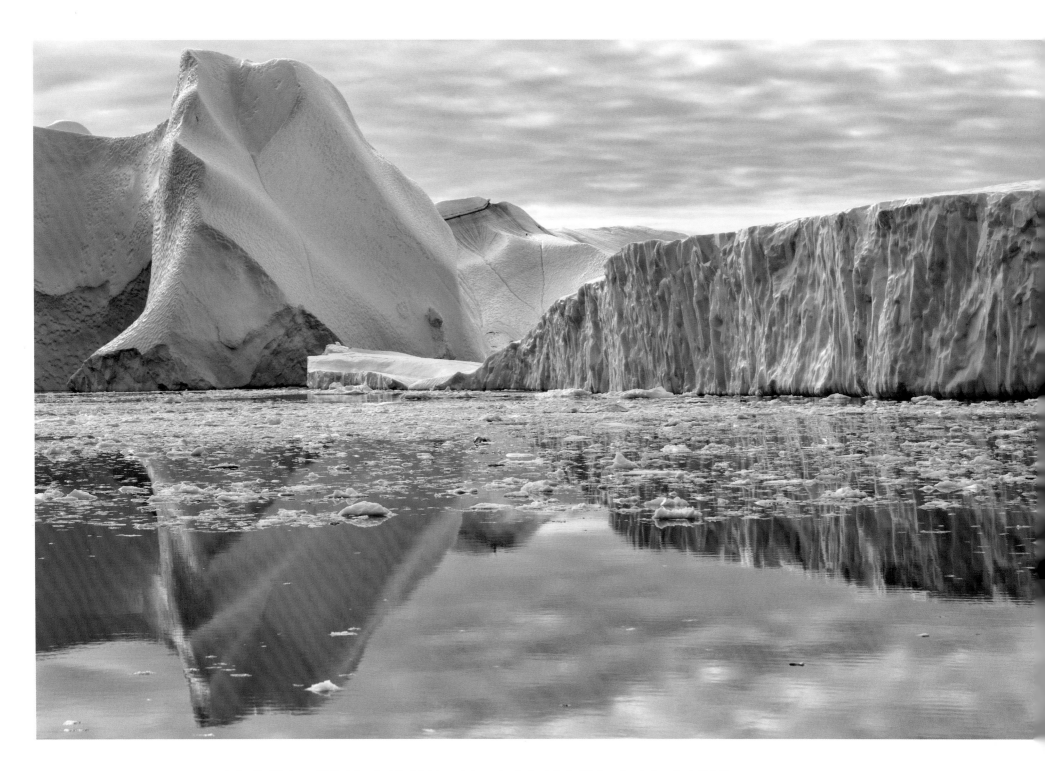

Just south of the town of Illulisat, Greenland, the Jakobshavn glacier reaches the head of a fjord that runs twenty-five miles to Disko Bay. The most productive glacier in the northern hemisphere, it moves as much as 120 feet a day, releasing into the sea 20 billion tonnes of ice every year. Eventually these icebergs reach the open ocean and the sea lanes of the northern Atlantic. Ice from the Jakobshavn was almost certainly responsible for the sinking of the *Titanic*.

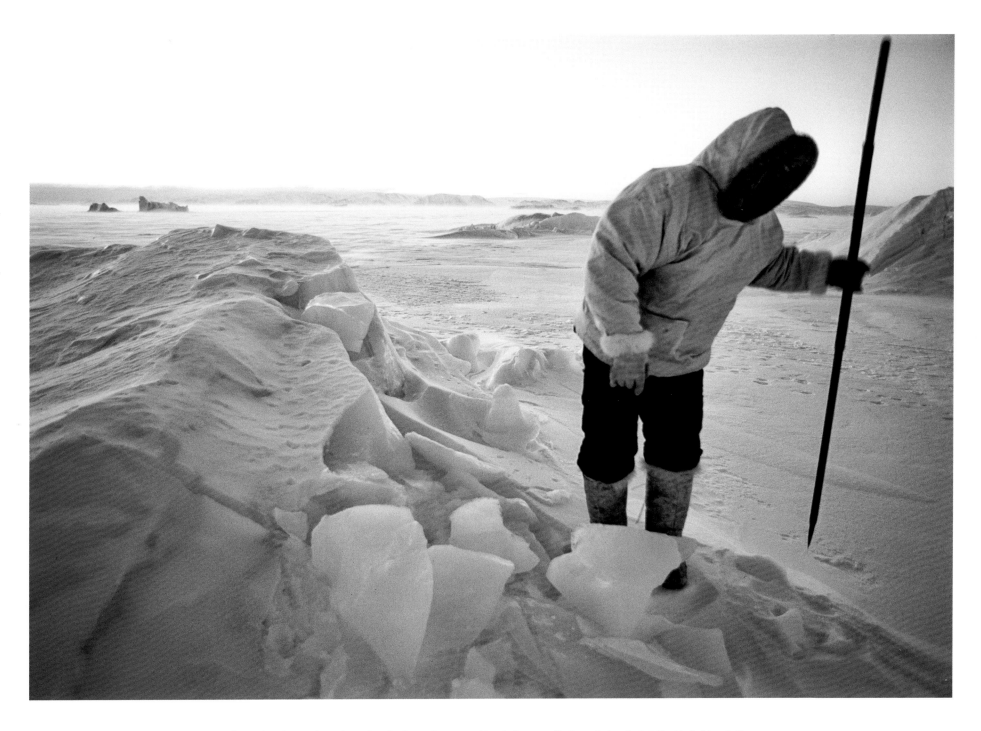

A hunter from Qaanaaq in northwest Greenland uses a harpoon to chip a shallow tunnel in the sea ice in order to tether his sled dogs. In the Canadian Arctic machines displaced dogs as long ago as 1962 when the snowmobile was introduced. But the people of Qaanaaq recognized that the use of dogs and the transmission of the necessary knowledge about their use between generations was the fulcrum of their culture. They chose instead to ban snowmobiles, save for dire emergencies. Dogs bring security to the night, loosen the shackles of the cash economy and make limitless the length of any journey, even as they hone the skills of hunters who must provide a constant supply of meat.

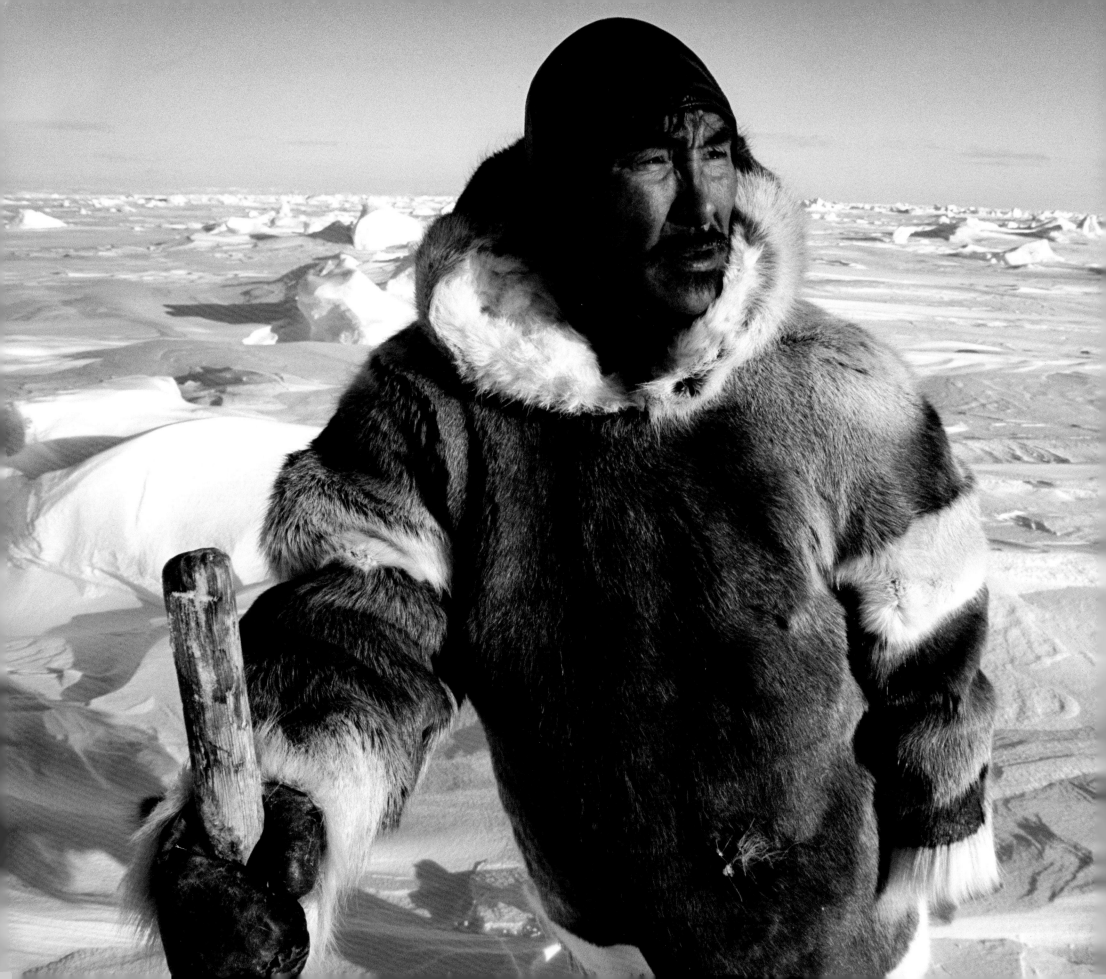

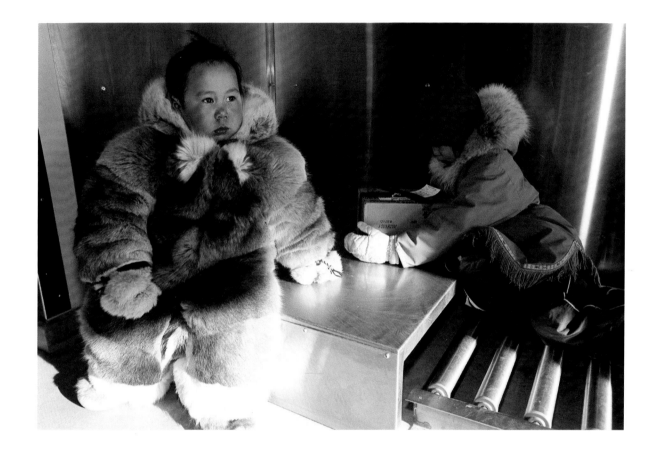

ABOVE: These young children represent the hopes and dreams of all Inuit men and women. They were born after the creation of Nunavut, a new territory the size of Western Europe under the administrative control of thirty thousand Inuit. The people have endured so much— epidemic disease, the humiliation and violence of the residential schools, the culture of poverty inherent in the welfare system and drug and alcohol exposure, leading to suicide rates six times that of southern Canada. Now, on the very eve of their emergence as a culture reborn politically, socially and psychologically, they find themselves confronted by a force beyond their control. The ice is melting, and with it quite possibly a way of life.

LEFT: An Inuk hunter from Igloolik camps a hundred miles out on the sea ice on a day that would see temperatures fall to minus 65 degrees Celsius. On the horizon, islands, ice and sky meld one into the other and the black sea is a distant mirage. But the Inuit seldom lose their way. In driving snowstorms they watch for patterns in the ice, small ridges of hard snow that are formed by the prevailing winds and reveal where they are. They study a map of the land reflected on the underside of low clouds. This hunter was out all night. He returned in the morning trailing the carcass of a polar bear on his sled.

THE RAIN FORESTS OF HOME

AS A YOUNG MAN I WAS RAISED ON THE COAST OF BRITISH COLUMBIA to believe that the rain forests existed to be cut. This was the essence of the ideology of scientific forestry that I studied in school and practised in the woods as a logger. A Kwakwaka'wakw youth of similar age was traditionally dispatched during his Hamatsa initiation into those same forests to confront Huxwhukw and the Crooked Beak of Heaven, cannibal spirits living at the north end of the world. Is the forest mere cellulose and board feet? Or is it truly the domain of spirits? Ultimately these are not the important questions. What matters is the potency of a belief and the manner in which it plays out in the day-to-day lives of a people. In a very real sense this determines the ecological footprint of a culture, the impact that any society has on its environment. The full measure of a culture embraces both the actions of a people and the quality of their aspirations, the nature of the metaphors that propel them onward.

Few cultures view the natural world through a lens of ecological purity. Life in the malarial swamps of New Guinea or in the searing sands of the Sahara leaves little room for sentiment. Still, throughout the world indigenous peoples have developed a mystical reverence for the earth, which is based not just on their deep attachment to the land, but also on the idea that the land itself is breathed into being by human consciousness. Mountains, rivers and lakes are not perceived as being inanimate, as mere props on a stage upon which the human drama unfolds. For these societies, the land is alive, a dynamic force to be embraced and transformed by the human imagination. The result is a profound sense of belonging and connection. A child raised to believe that a mountain is the abode of a protective spirit will be a profoundly different human being from a youth brought up to believe that a mountain is an inert mass of rock ready to be mined.

The intact rack of a moose, most likely killed by wolves, lies on the shore of Ealue Lake, British Columbia.

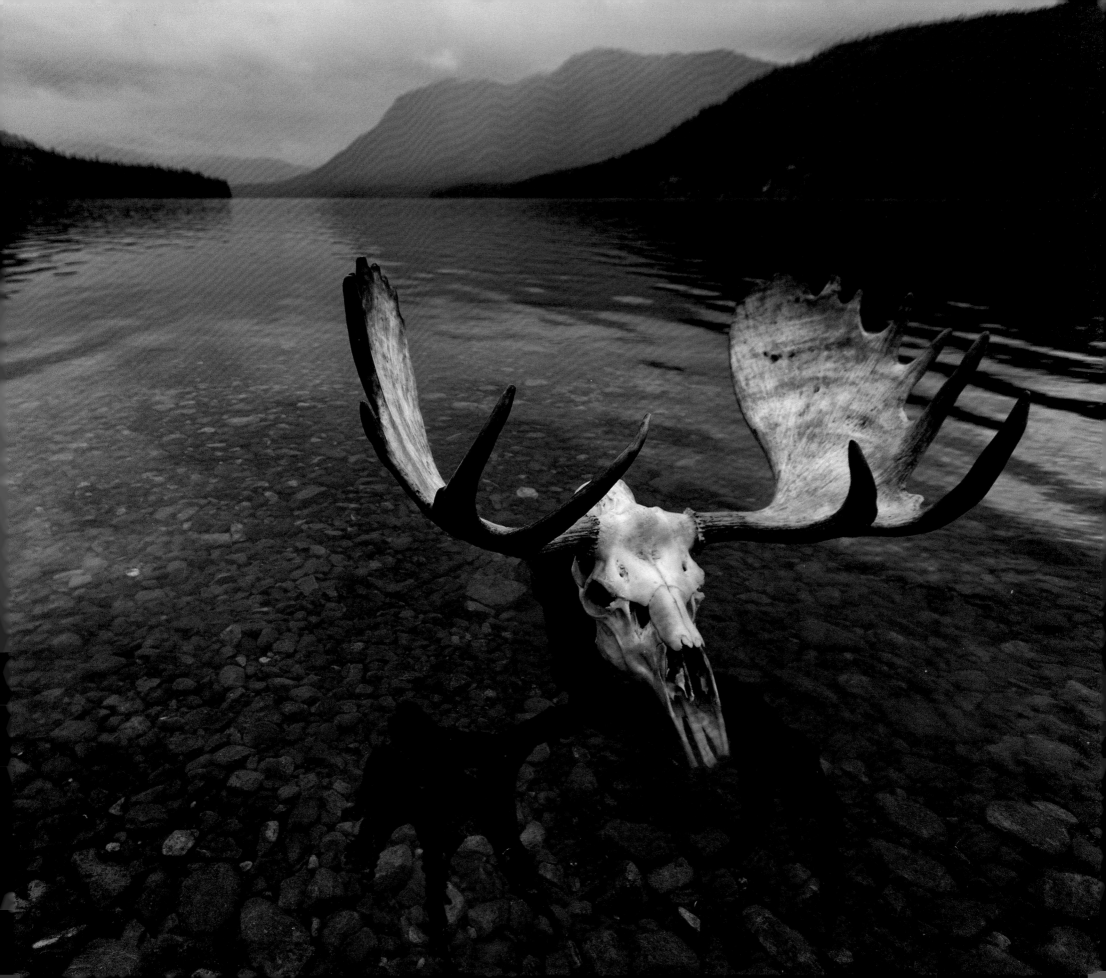

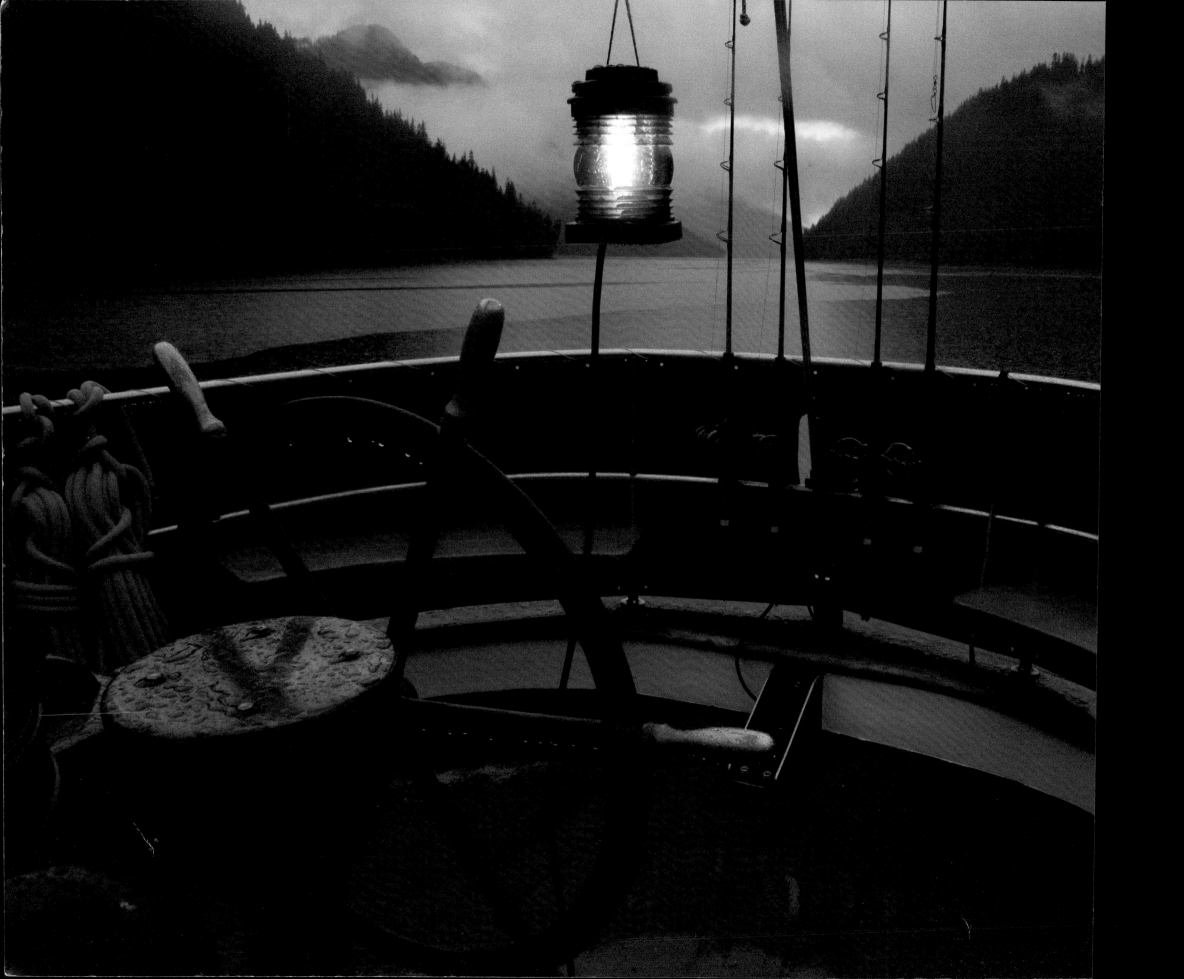

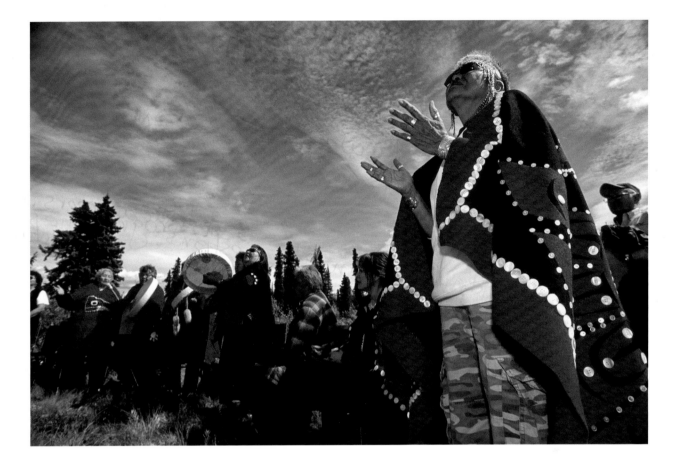

ABOVE: In the summer of 2006 representatives of nine First Nations came together to protest plans to extract methane gas from the meadows of the Sacred Headwaters, birthplace of the three great salmon rivers: the Stikine, the Skeena and the Nass. Each representative brought water from their lands to mix in a cedar box. Rhoda Quock, a Tahltan, declared: "This water is a symbol of our unity. Just as it will flow back into the three great rivers that sustain our people, we will return to our territories and protect our lands. At the Sacred Headwaters, we are drawing a line in the sand; this country bestowed to us by the Creator will be protected." Six years later the British Columbia government announced a moratorium on all industrial activity in the headwaters.

LEFT: The stern of the schooner *Maple Leaf* rests at dusk in the quiet waters of Haida Gwaii, an archipelago often described as the Galapagos of the north. In the 1980s plans to expand industrial logging sparked protests that culminated in the arrest of Haida elders, images of which inspired the world and ultimately led to the creation of Gwaii Haanas, a national park encompassing 138 islands.

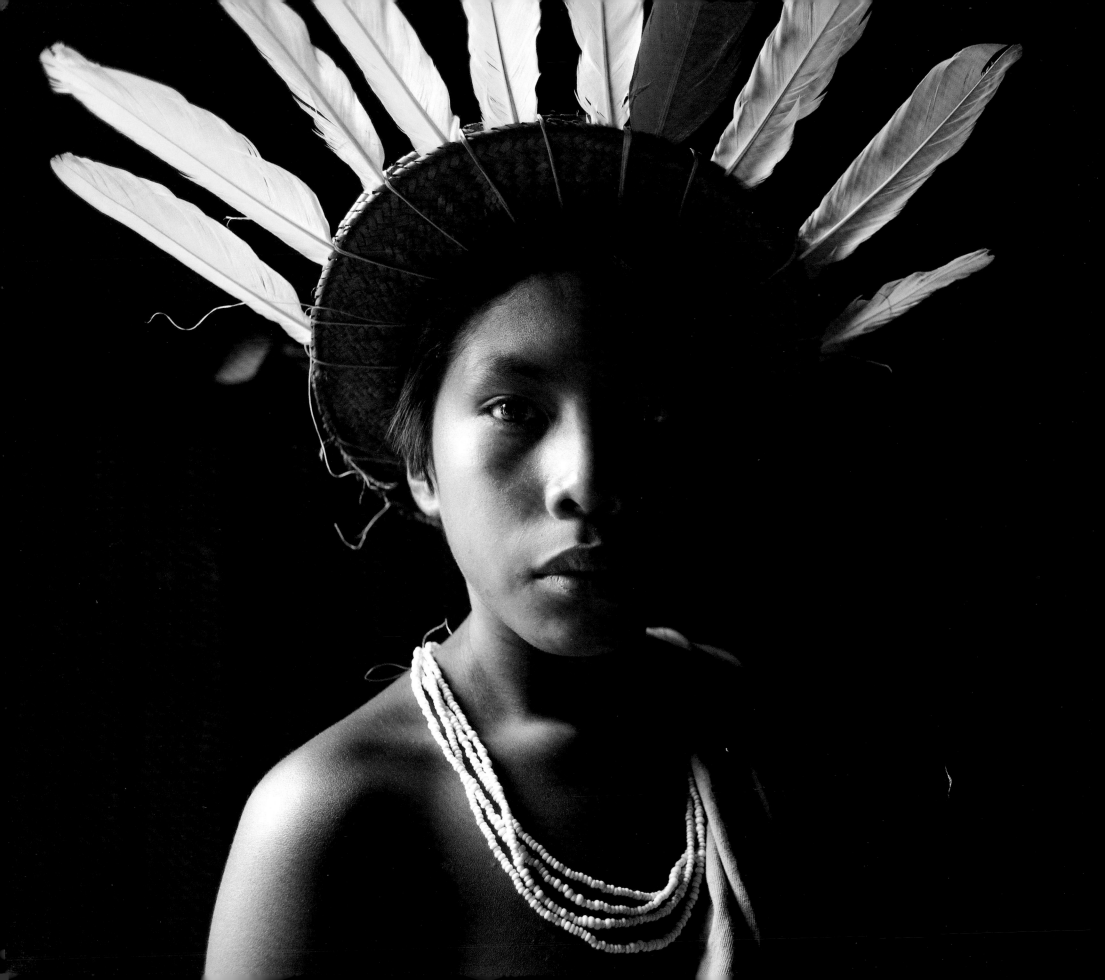

PEOPLES OF THE ANACONDA

FOR THE BARASANA AND MAKUNA IN THE NORTHWEST AMAZON OF COLOMBIA, rivers are not just routes of communication. They are the veins of the earth, the link between the living and the dead and the paths along which the ancestors travelled at the beginning of time. Their origin myths vary but always speak of a great journey from the east, of sacred canoes drawn up the Milk River by anaconda. Within the canoes were the first people, together with the three most important plants—coca, manioc and *yagé*—all gifts of Father Sun. When the serpents reached the centre of the world, they lay over the land, outstretched as rivers, their powerful heads forming river mouths, their tails winding away to remote headwaters, the ripples in their skin giving rise to rapids and waterfalls.

The Barasana and Makuna to this day live in enormous community longhouses, or *malocas*, every architectural element of which resonates with mythic significance. There is no word for time in their languages, yet they have a complex understanding of astronomy and solar calendars, and intense notions of hierarchy and specialization. Their systems of exchange, infinitely complex, facilitate peace, not war. To marry one must seek a spouse who speaks a different language. Status accrues not to the warrior but to the man of wisdom, and knowledge is acquired through time and intense priestly study and initiation. Their wealth is vested in ritual regalia as elegant as that of a medieval court. Their struggle to bring order to the universe—to maintain the energetic flows of life—and the specificity of their beliefs and adaptations amount essentially to a complex land-management plan dictating precisely how human beings in great numbers can thrive in the upland forests of the Amazon. Indeed it is now recognized that these remarkable peoples are the direct descendants of the lost civilizations of the Amazon. They both echo the ancient pre-Columbian past and point a way forward, embodying a model of how human societies can live and flourish in the Amazon basin without laying waste to the forests.

There is no beginning and end in Barasana thought, no sense of a linear progression of time, destiny or fate. Every object must be understood at various levels of analysis. A rapid is an impediment to travel but also a house of the ancestors. A stool is not a symbol of a mountain; it is in every sense an actual mountain, upon the summit of which sits the shaman. This lad's corona of oropendola feathers really is the sun, each yellow plume a ray.

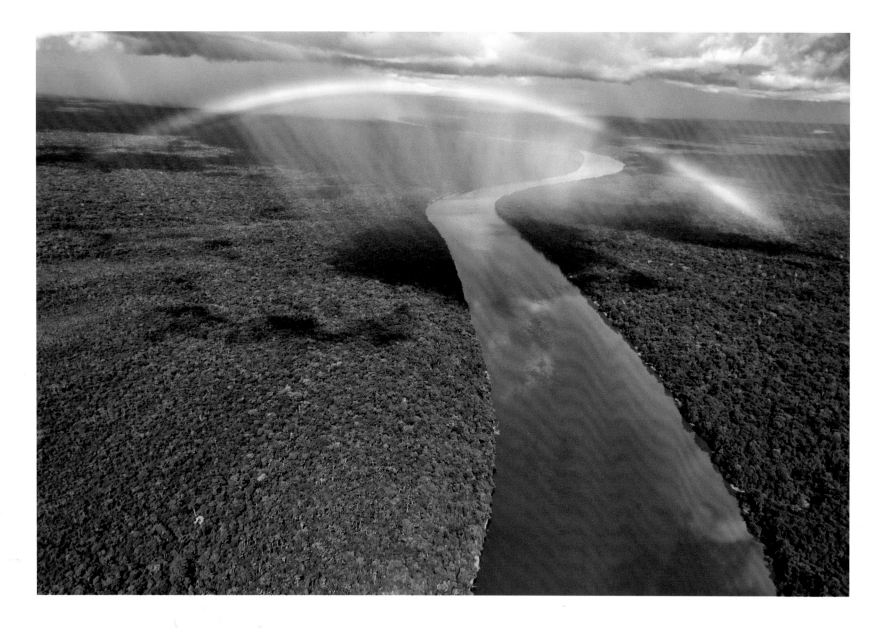

ABOVE: The Río Apaporis appears just above its confluence with the Río Caquetá. The Amazon at the time of European contact was no empty forest but an artery of civilization and home to hundreds of thousands, indeed millions, of human beings. Diseases such as measles and smallpox, previously unknown in the New World, swept away within generations 90 per cent of the Amerindian population from Tierra del Fuego to the Arctic.

RIGHT: A Barasana youth plays with his pet macaw in San Miguel on the Río Piraparaná. In 1986 Colombian president Virgilio Barco Vargas told Martin von Hildebrand, then Head of Indigenous Affairs, to do something for the Indians. In five extraordinary years Von Hildebrand secured for the native people of the Colombian Amazon legal title to an area roughly the size of the United Kingdom, land rights that were encoded in the 1991 Political Constitution. In the years that followed, as Colombia endured the ravages of war, a veil of isolation fell upon the Northwest Amazon. And behind this veil a cultural revival took place unlike anything previously seen in South America.

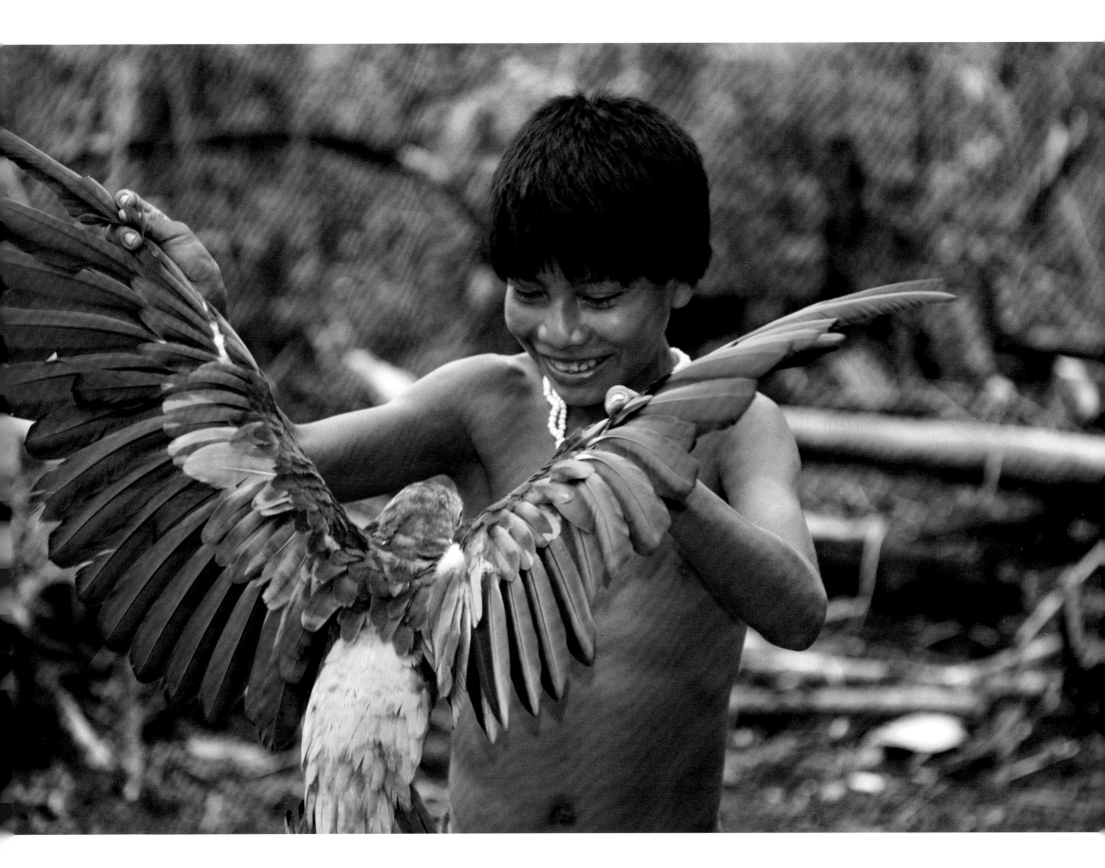

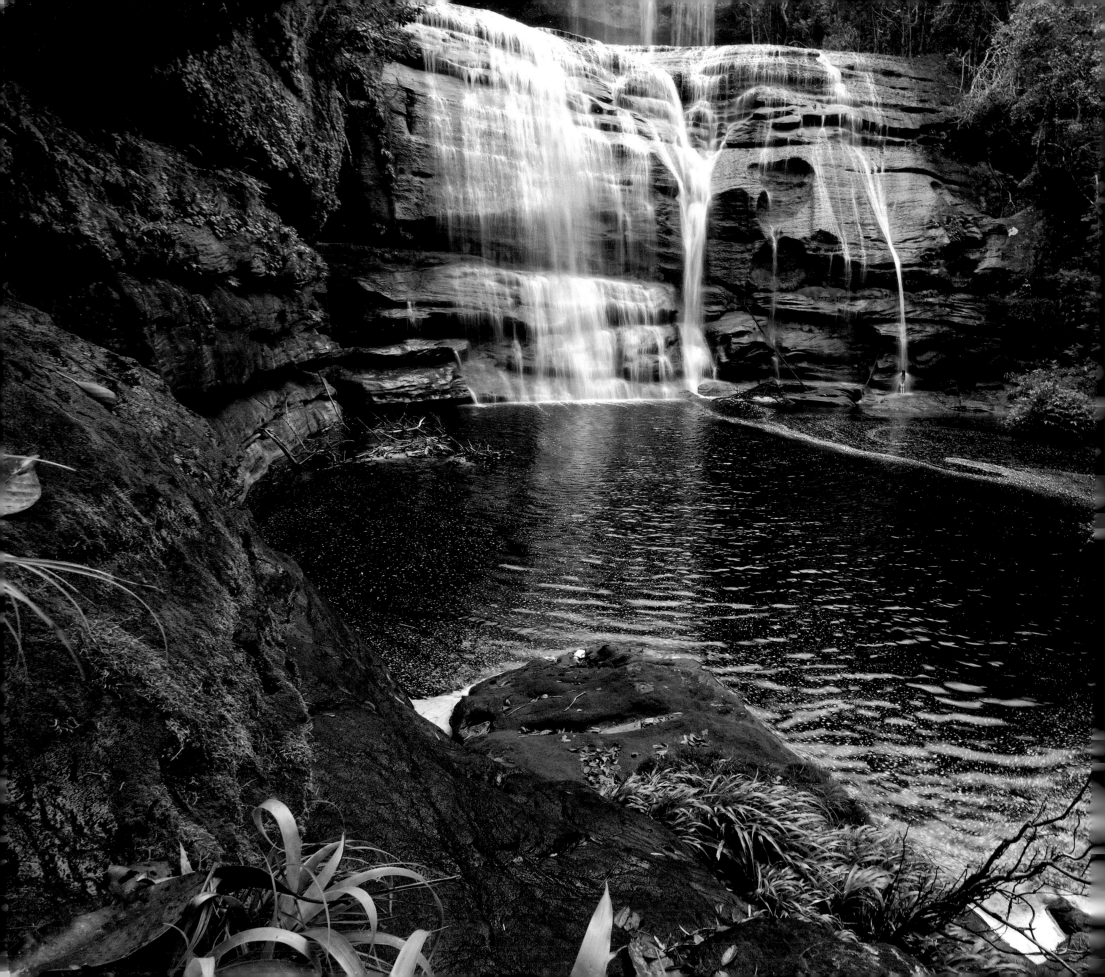

ABOVE: Barasana women, seen here boiling the fruits of a wild *solanum*, cultivate thirty or more food crops and regularly exploit some twenty varieties of wild fruits and nuts. Every morning they transform a poisonous root—bitter manioc—into their daily bread. The act of harvesting and preparing cassava is both a gesture of procreation and a form of initiation. The starchy fluid left over once the grated mash has been fully rinsed is seen as female blood that can be rendered safe by heat and drunk warm like mother's milk. The crude manioc fibre resembles the bones of men. Fired on the griddle and shaped by female hands the cassava is the medium through which the plant spirits of the wild are domesticated for the benefit of all. Food in this sense is power, for it represents the transfer of energy from one life form to another.

LEFT: This waterfall hidden deep within the forest is considered by the Barasana to be the primordial home of the Ancestral Mother, Romi Kumu. It is perhaps the most sacred site in their homeland. They say that in the beginning, before the creation of seasons, before she opened her womb, before her blood and breast milk gave rise to rivers and her ribs to the mountain ridges of the world, there was only chaos in the universe. Spirits and demons preyed on their own children, bred without thought, committed incest without consequence. Romi Kumu destroyed the world with fire and floods. She then turned the inundated and charred world upside down, creating an empty template from which life could emerge again. As Woman Shaman she bequeathed to all people the eternal obligation to manage the flow of creation.

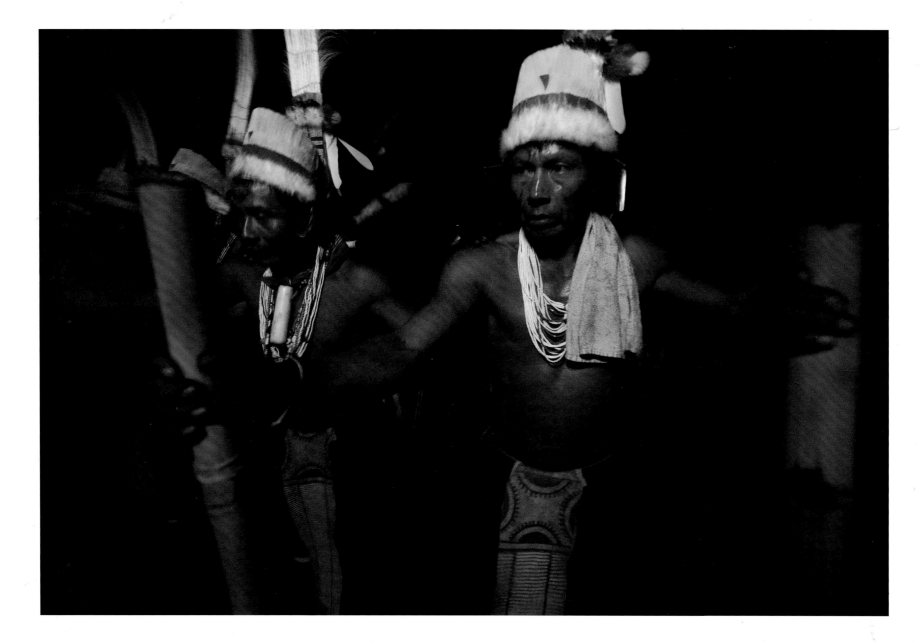

ABOVE: The fertility festival in honour of Cassava Woman lasts for two days and nights, attracting scores of men and women from along the Río Piraparaná to the *maloca* at Puerto Ortega. As the ritual begins, time collapses. Two series of dances are separated by the liminal moments of the day: dawn, dusk and midnight. In donning the feathers—the yellow corona of pure thought, the white egret plumes of the rain—the men become the ancestors, and under the influence of *yagé*, a powerful hallucinogenic potion known also as *ayahuasca*, they journey to the origins of the world.

RIGHT: Those responsible for weaving the feathered coronas are isolated in the *maloca* for several weeks and forbidden to eat meat or be with their wives. To create the brilliant yellow plumes they pluck the normally deep red feathers of living parrots and apply a paste of frog venom and toxic berries to the birds' breasts, causing a new plumage to emerge in the colour of the sun. The regalia are not decorative; they are a literal connection to liminal space—wings to the divine.

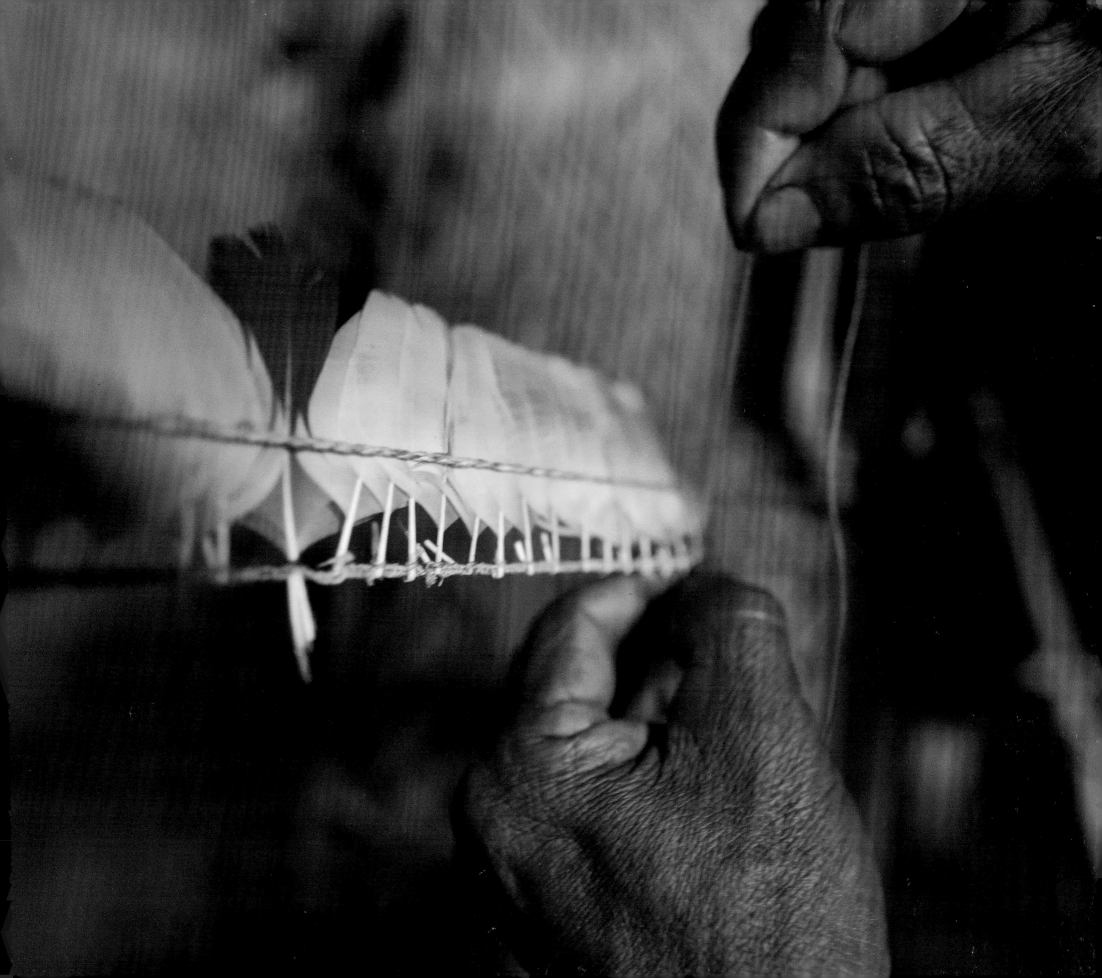

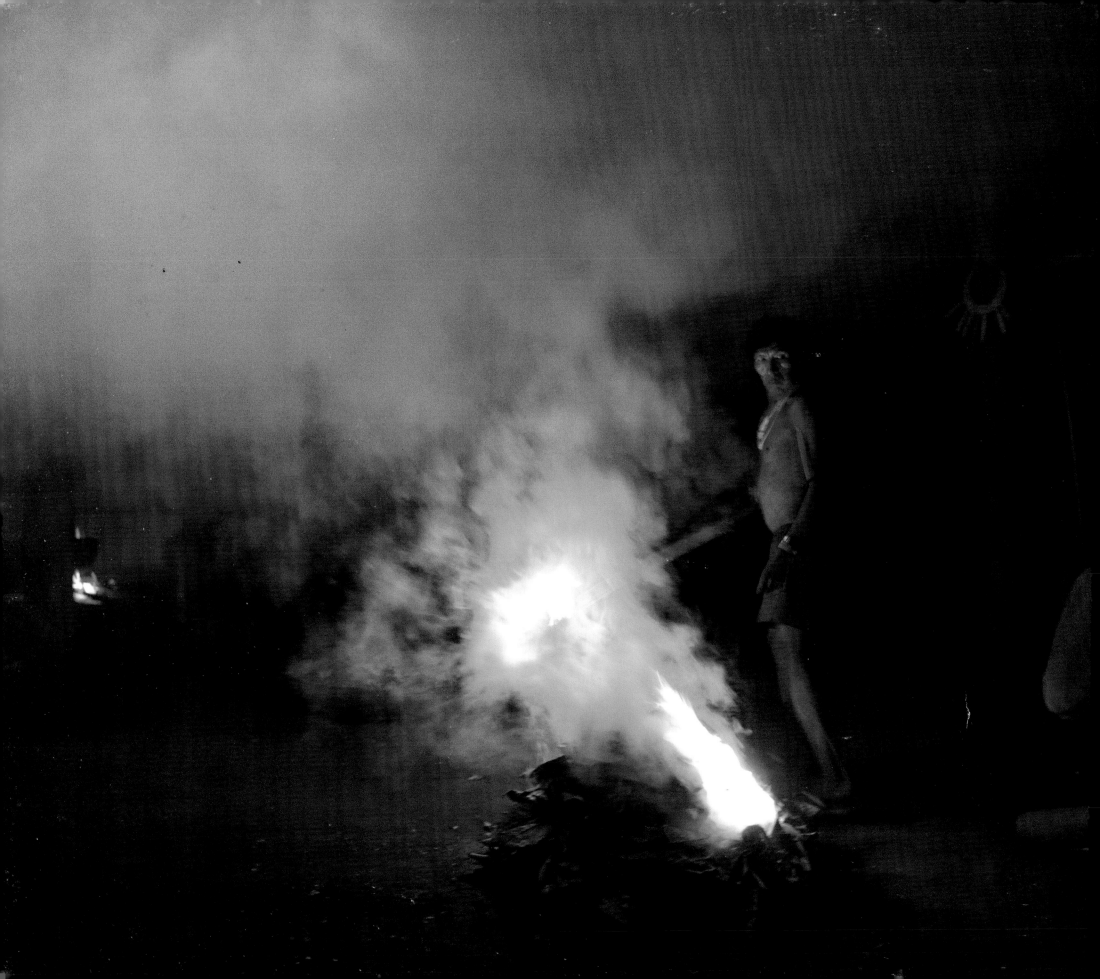

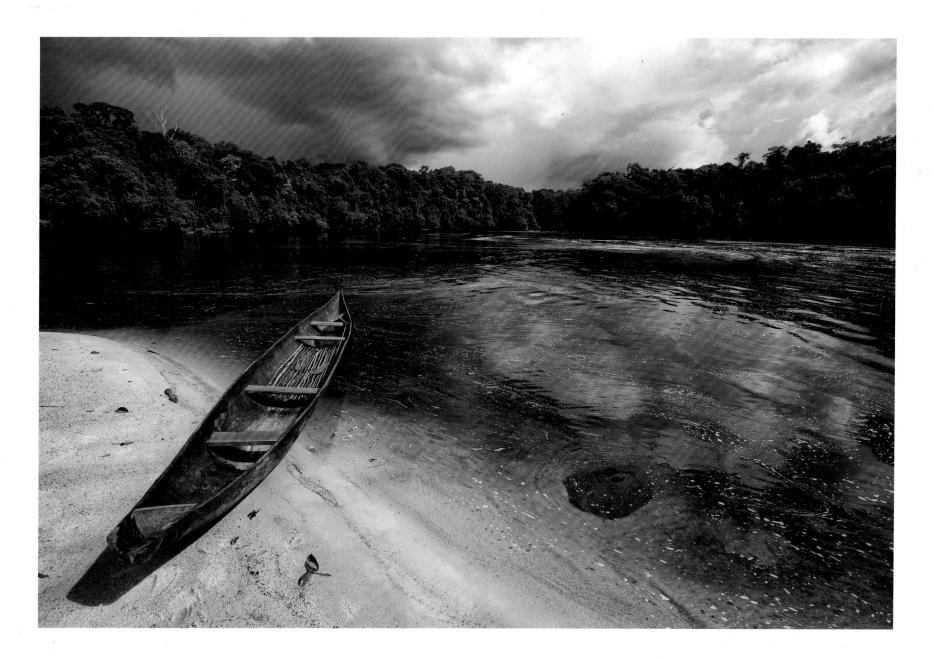

ABOVE: A dugout canoe lies on a white-sand beach of the black-water Río Piraparaná.

LEFT: White people see with their eyes, but the Barasana and Makuna see with their minds. When they ingest *yagé* they journey both to the dawn of time and into the future, visiting every sacred site, paying homage to every creature as they celebrate their most profound cultural insight—that animals and plants are only people in another dimension of reality. This is the essence of their philosophy.

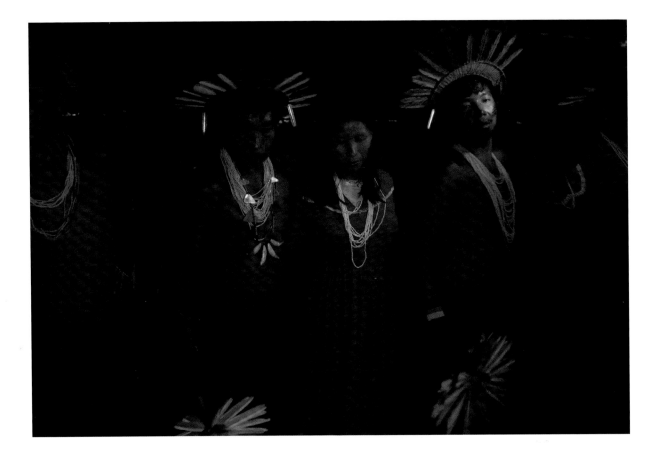

ABOVE: The shaman's most prized possession is a six-inch crystal of quartz, worn around the neck with a single strand of palm fibre. It is the crystallized semen of Father Sun, and within it are thirty colours, all distinct energies that must be balanced in sacred ritual. Once inside the crystal the shaman looks out at the world, over the territory of his people and the sacred sites, watching the ways of the animals, harnessing and restoring the energy of all creation. The shaman is a technician of the sacred. He is like a modern engineer who enters the depths of a nuclear reactor to renew the entire cosmic order.

RIGHT: With great care men prepare for the celebration of Cassava Woman, here applying face paint derived from vegetable dyes. The decoration anticipates transformation. The Barasana and Makuna liken *yagé* to a river, a journey that takes one above the land and below the water to the most remote reaches of the earth, where the animal masters live and lightning is waiting to be born. To drink *yagé*, the anthropologist Gerardo Reichel-Dolmatoff wrote, is to return to the cosmic uterus and be reborn. It is to tear through the placenta of ordinary perception and enter realms where death can be known and life traced through sensation to the primordial source of all existence.

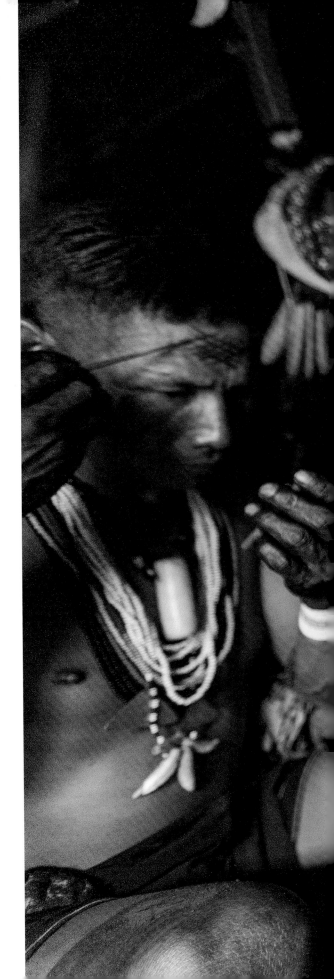

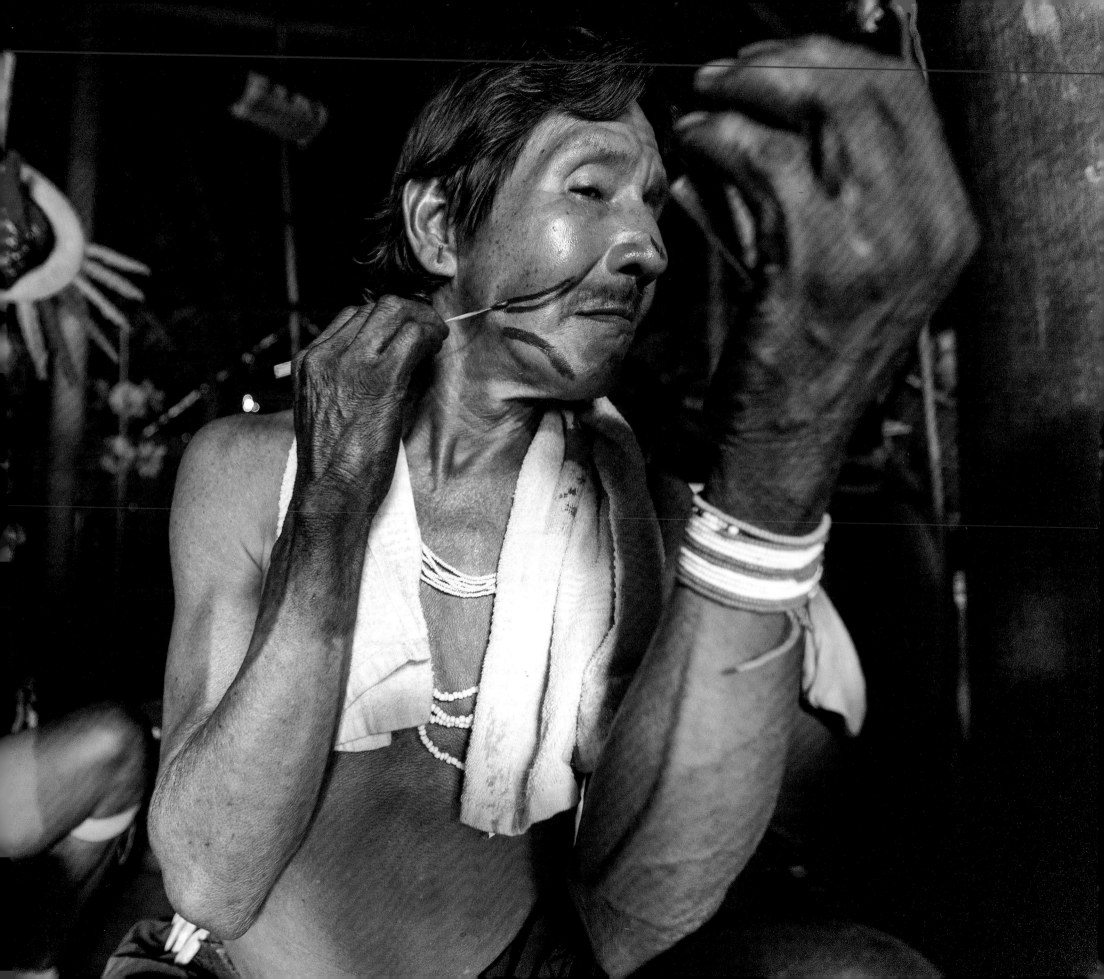

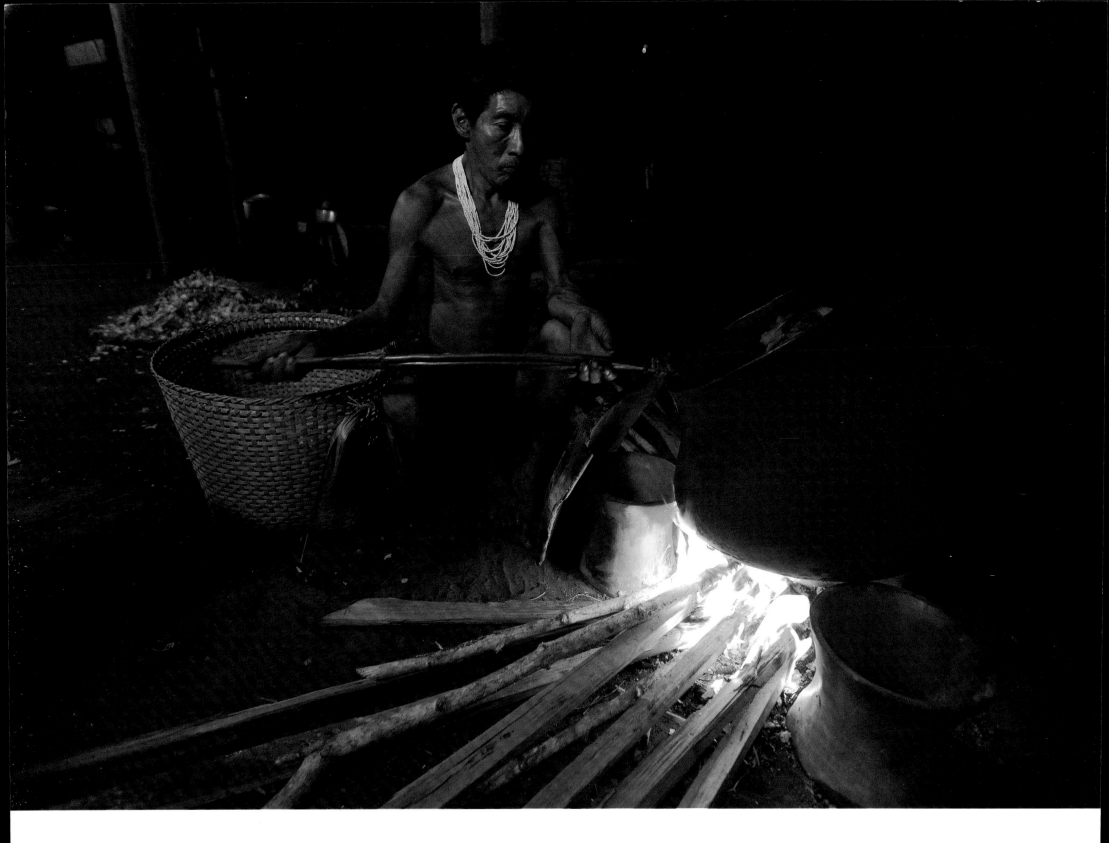

Barasana and Makuna men grow only two plants, tobacco and coca. To prepare coca they first dry the leaves in a ceramic vessel over a fire and then pound them in a wooden mortar, to which are added the ashes of *yarumo* leaves. This mixture is then passed through a fine bark filter to yield a final product the consistency of talcum powder. Taken orally coca is a mild but nutritious stimulant with especially high levels of calcium.

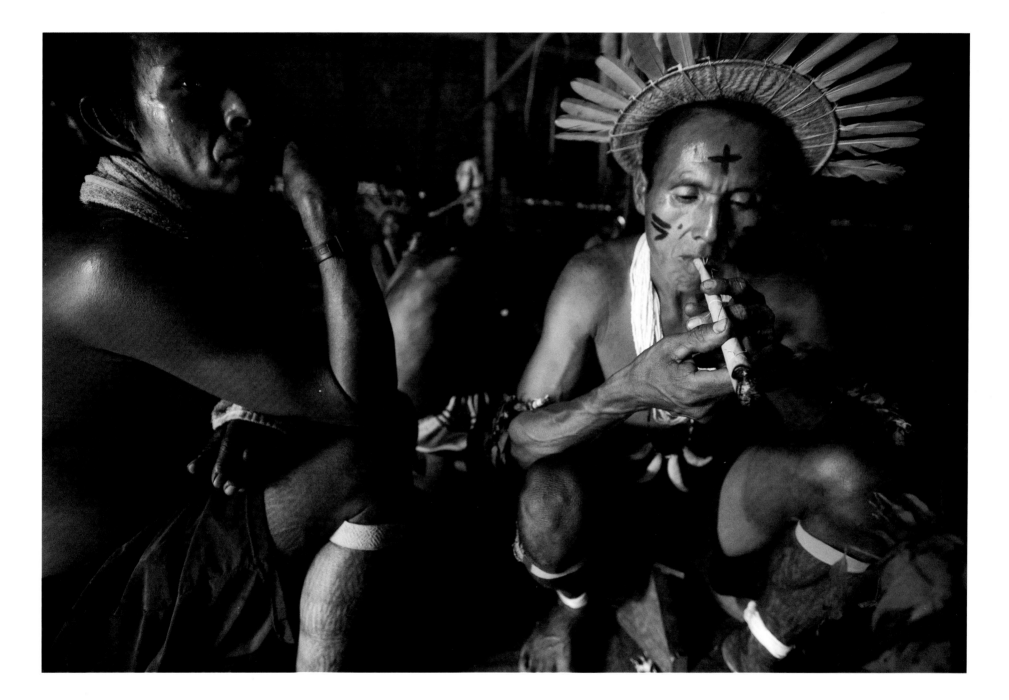

During the celebration of Cassava Woman men consume copious amounts of coca, tobacco and *yagé*. Amazonian tobacco is so strong that sweat beads on the fingertips as soon as the snuff is blown up the nose. The Barasana say that under the influence of *yagé* they travel through multiple dimensions, reliving the journey of the ancestors. In chants shamans do in fact recall with complete accuracy points on the landscape reaching east almost a thousand miles down the Amazon, through lands neither they nor any of their community have ever visited.

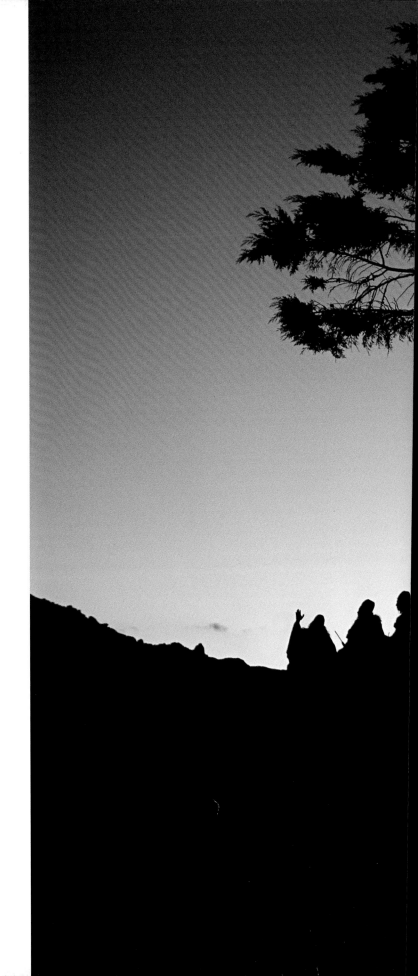

THE ELDER BROTHERS

IN A BLOODSTAINED CONTINENT THE INDIANS OF THE SIERRA NEVADA DE SANTA MARTA WERE
never fully vanquished by the Spaniards. Descendants of the ancient Tairona civilization, the Arhuacos, Kogi
and Wiwa escaped death and pestilence to settle in a mountain paradise that soars above the Caribbean
coastal plain of Colombia. To this day they remain true to the moral, ecological and spiritual dictates of
the Great Mother, who spun the world into existence. They are still led and inspired by a ritual priesthood
of *mamos*, whose training is austere in the extreme. The young acolytes are taken from their families as
infants and sequestered in a shadowy world of darkness inside the *kan'kurua*, the men's temple, or in the
immediate environs for eighteen years—two nine-year periods that explicitly recall the nine months of
gestation in a mother's womb. Now they are in the womb of the Great Mother, and for all that time the
world will exist only as an abstraction as they are taught the rituals and prayers they believe alone maintain
the cosmic and ecological balance of the earth. Finally, when the initiate is ready, he is led into the light of
dawn to see the world as it really is, in all its transcendent beauty. He then sets off on a sacred pilgrimage
that takes him from the mountains to the sea, and back to the ice and snow that lies at the heart of the
world. With him are his spiritual teachers, the *mamos*, and with each solemn step they remind him that
everything he sees is his to protect.

A small circle of Arhuaco men serves as a sentinel at the entrance of a hamlet, high in the Sierra Nevada de Santa Marta.

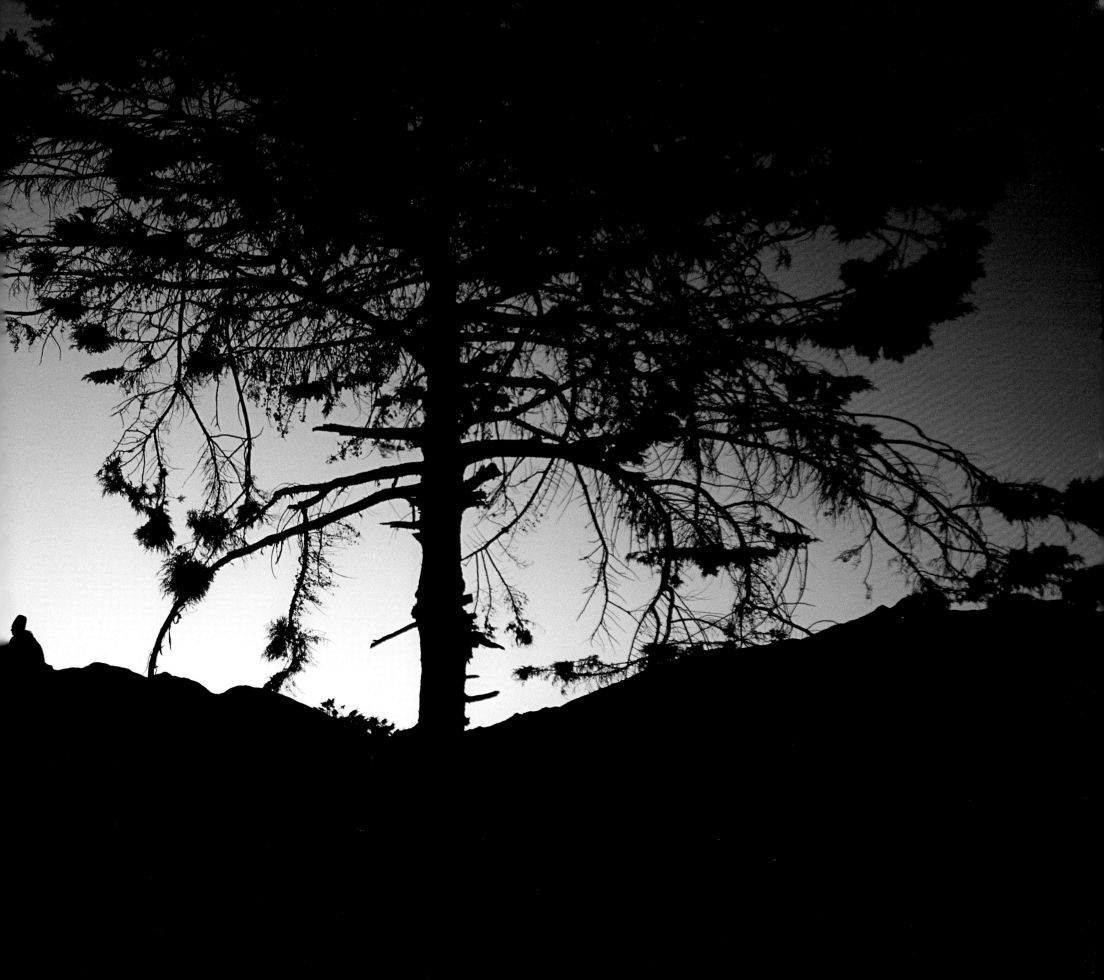

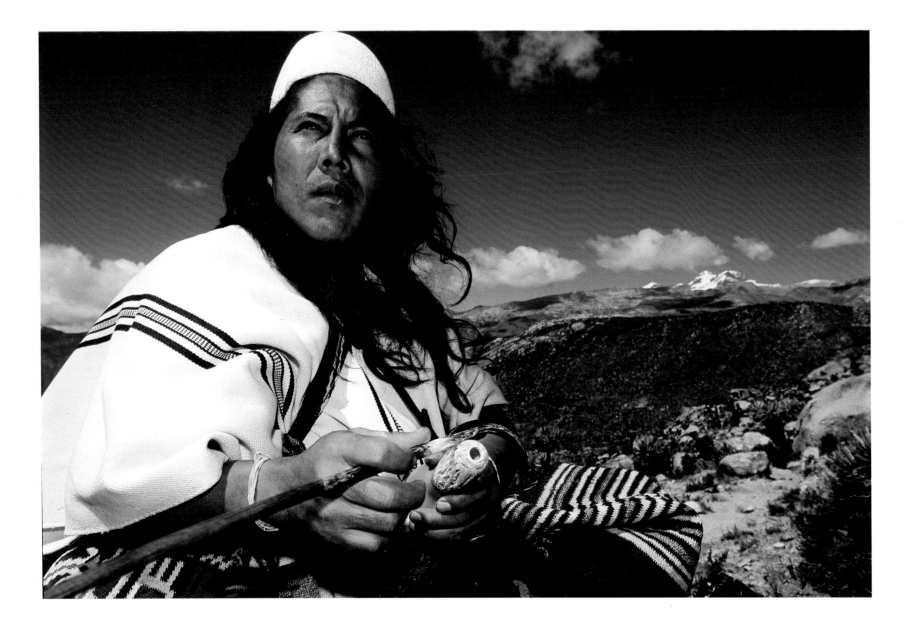

ABOVE: In the hands of Danilo Villafaña, a political leader of the Arhuacos, is a *popuro*, a gourd containing lime used to potentiate *hayu*, or coca, their most sacred plant. The conical hats worn by Arhuaco men represent the snowfields of the sacred peaks. The hairs on a person's body echo the forest trees that cover the mountain flanks. Every element of nature is imbued with higher significance. Even the most modest of creatures can be seen as a teacher, and the smallest grain of sand is a mirror of the universe.

RIGHT: A party of Arhuacos climbs the flanks of the Sierra, with the snowfields of Colón and Bolivar rising to 18,700 feet on the horizon. According to myth the mountains were created when the Great Mother spun into existence the nine layers of the universe. To stabilize the world she thrust her spindle into its axis and lifted up the massif. Then, uncoiling a length of cotton thread, she delineated the horizons of the civilized world, tracing a circle around the base of the Sierra Nevada, which she declared to be the homeland of her children. The loom, the act of spinning and the notion of a community woven into the fabric of a landscape are vital metaphors that consciously guide the lives of the people of the Sierra.

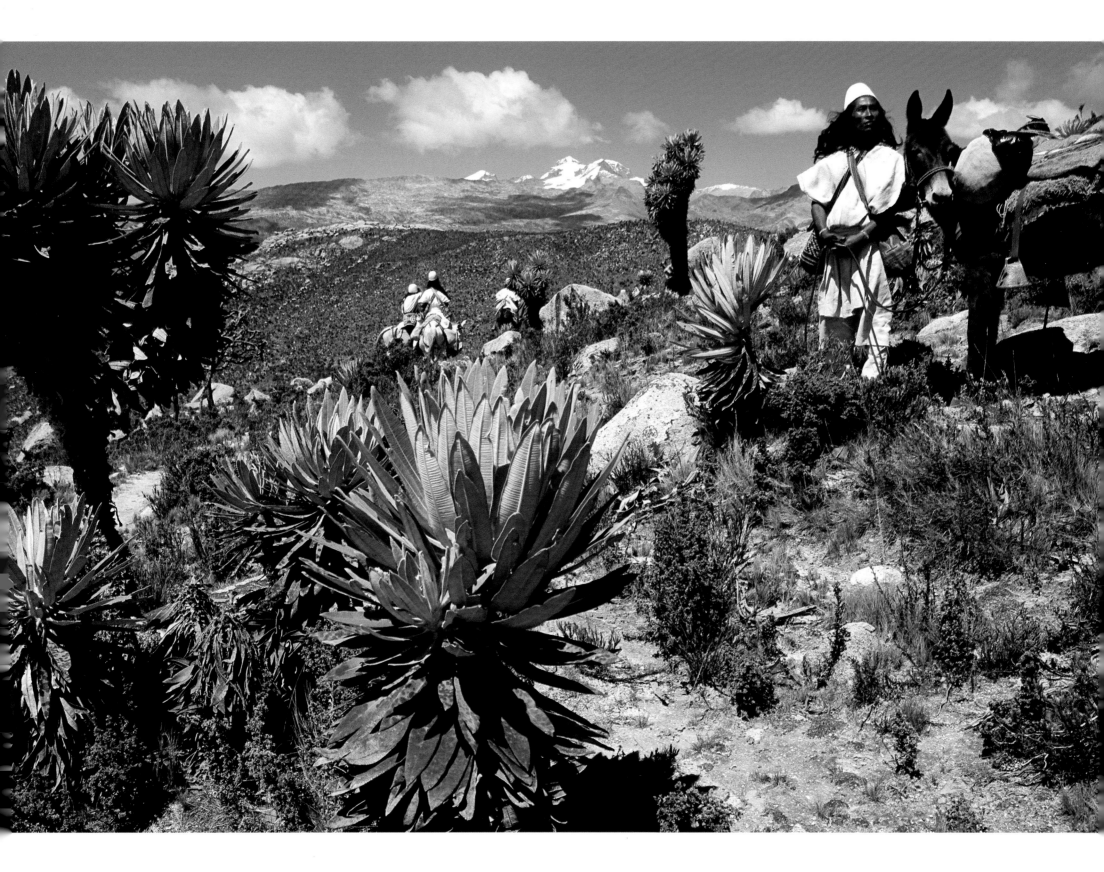

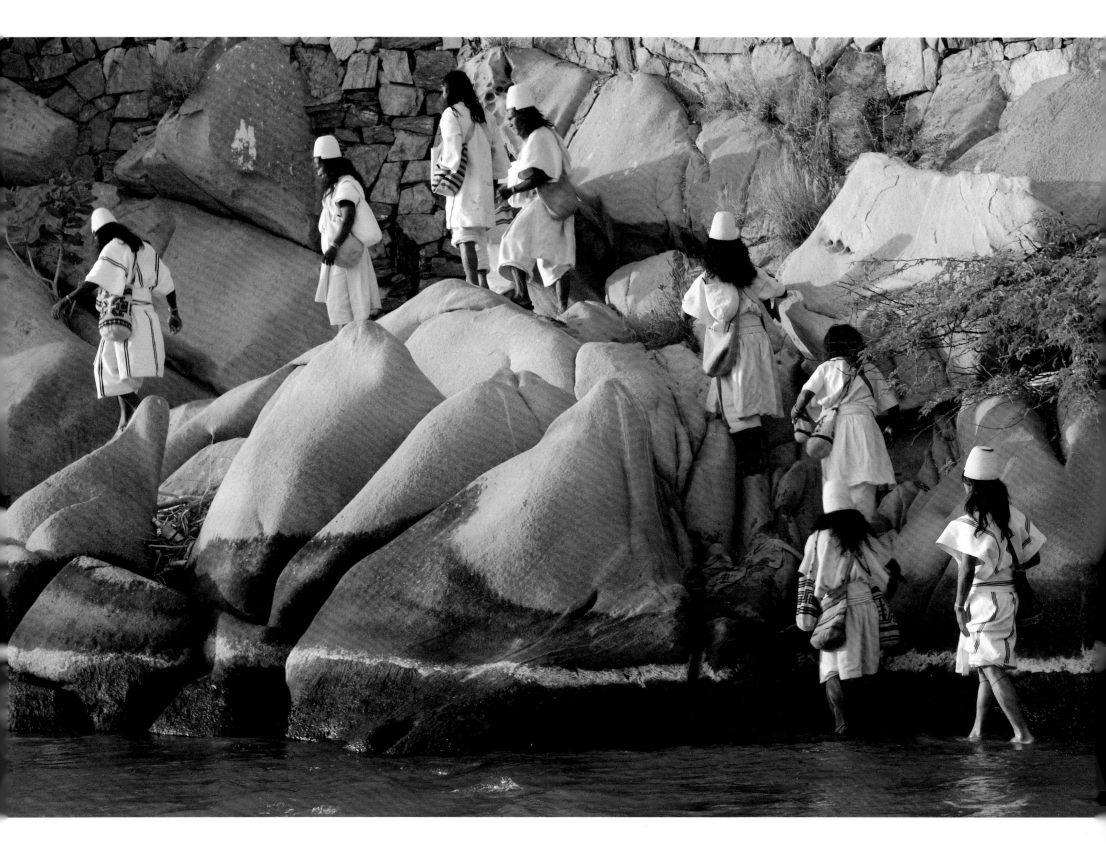

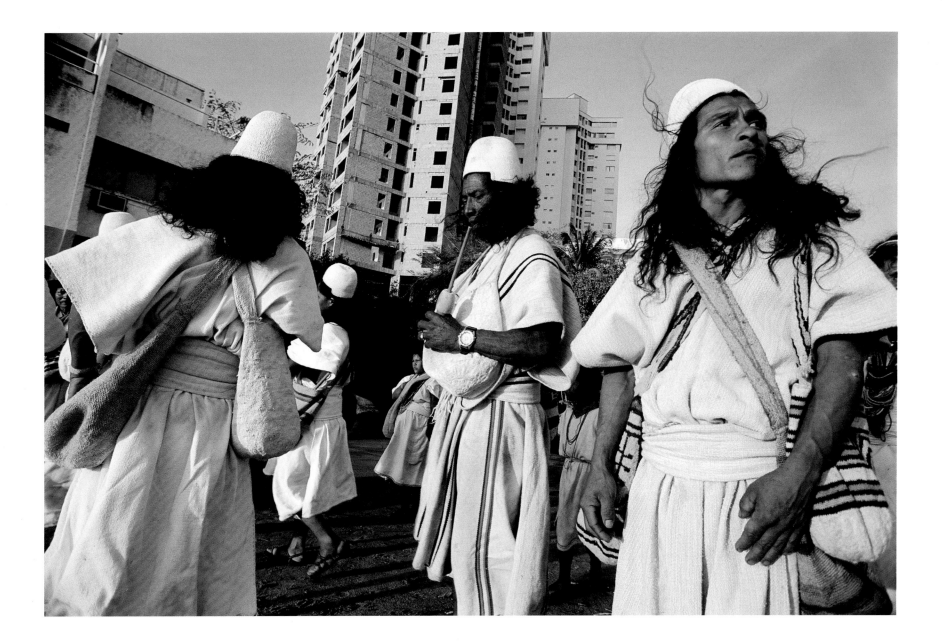

ABOVE AND LEFT: Arhuaco, Kogi and Wiwa people come as pilgrims to the coast, where many of their sacred sites have been violated by modern construction. In their cosmic scheme people are not the problem but the solution, for only through the human heart and mind can the Great Mother become manifest. They call themselves the Elder Brothers and consider their mountains to be the "heart of the world." We outsiders who ravage the earth through our ignorance of the sacred law are dismissed as the Younger Brothers. Living just two hours by air from Miami Beach, the Elder Brothers stare out to sea from the heights of the Sierra Nevada, praying for our well-being and that of the entire earth.

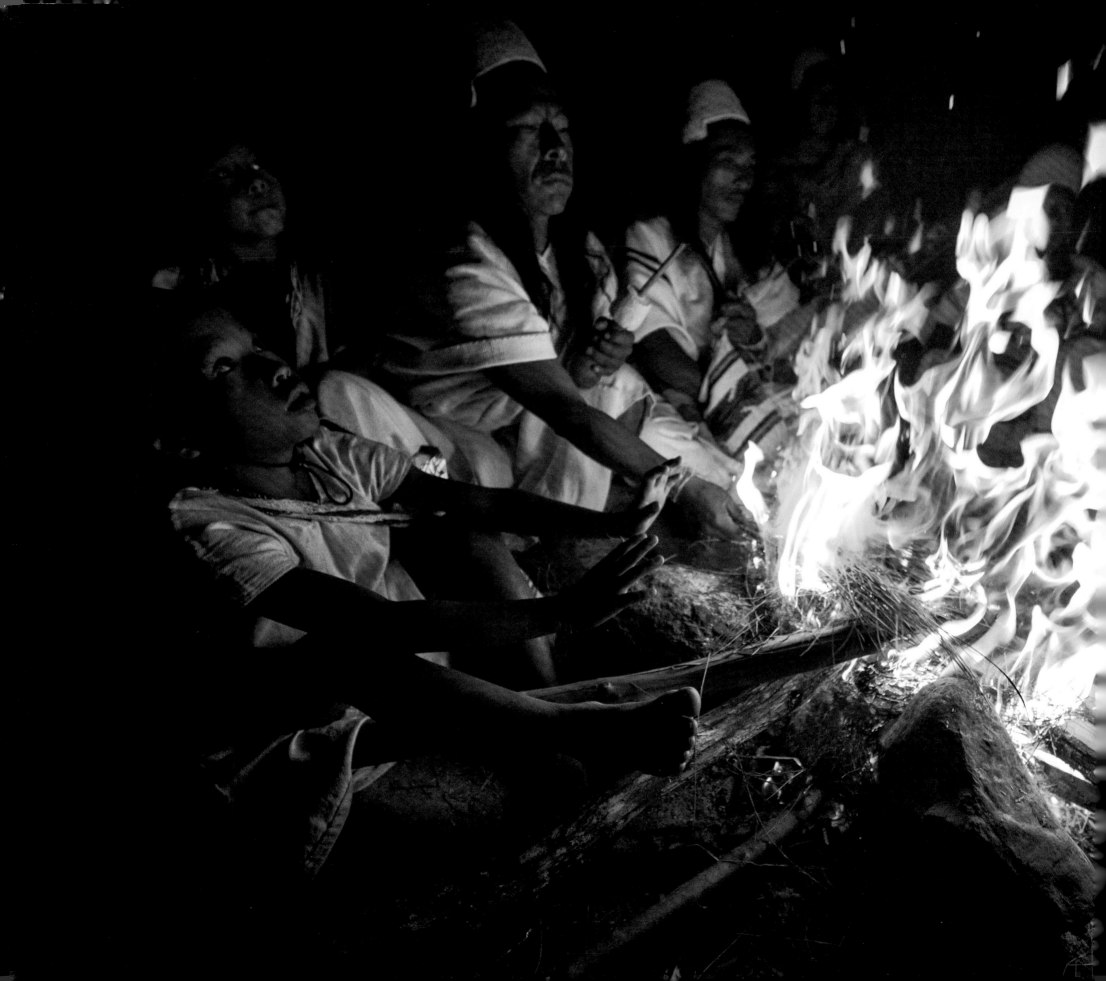

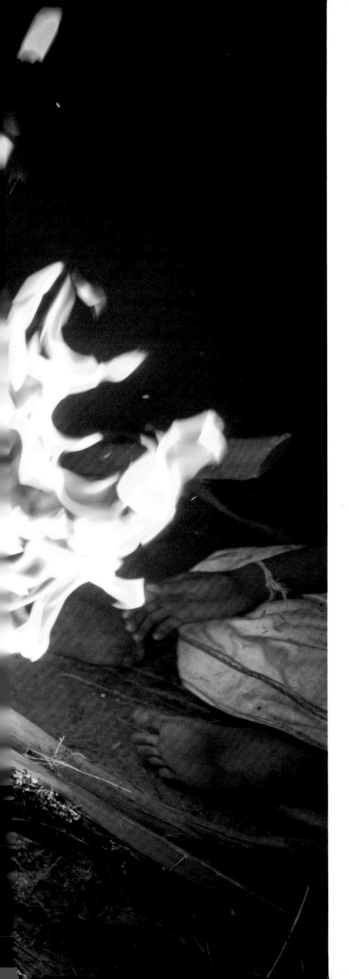

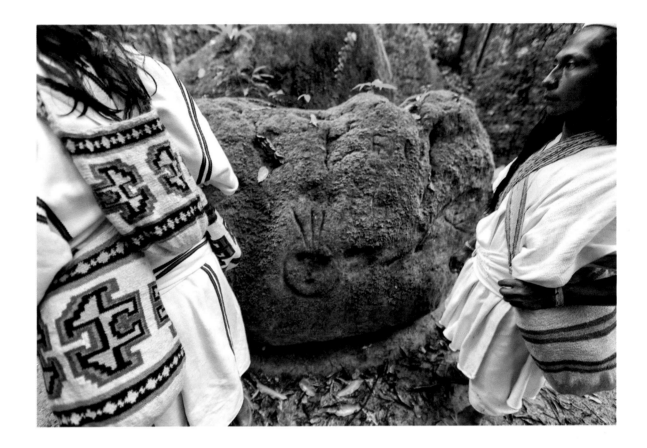

ABOVE: Arhuaco men walk through the ruins of a settlement of their ancestors the Tairona, who waged a fierce but futile war against the Spanish invaders in 1591. Retreating into their mountain redoubt, lost to history for at least three centuries, the survivors chose deliberately to transform their civilization into a devotional culture of peace. For generations they have watched in horror as outsiders have violated the Great Mother, tearing down the forests, which they perceive to be the skin and fabric of her body. They speak directly of our need to change the way we think about our place in the natural world.

LEFT: An Arhuaco family on pilgrimage has gathered around an evening fire. As they travel up and down the mountain slopes they refer to their movements as threads, so that over time a community lays down a protective cloak over the earth. When Arhuacos pray they clasp small bundles of white cotton, moving their hands in slow circular movements that recall the moment when the Great Mother spun the universe into being. Her commandment was to protect everything she had woven. This was her law.

THE STAR SNOW PILGRIMAGE

FOR THE PEOPLE OF THE ANDES THE EARTH IS ALIVE, and every wrinkle on the landscape, every hill and outcrop, every mountain and stream has a name and is imbued with ritual significance. The high peaks are addressed as *apu*, meaning "lord." Together the mountains are known as the *tayakuna*, the fathers, and some are so powerful that it can be dangerous even to look at them. Other sacred places—a cave or mountain pass, a waterfall where the rushing water speaks as an oracle—are honoured as the *tirakuna*. These are not spirits dwelling within landmarks. Rather the reverence is for the place itself.

These notions of the sanctity of land were ancient in the Andes. The Spanish did everything in their power to crush the spirit of the people—destroying the temples, tearing asunder the sanctuaries, violating the offerings to the sun. But it was not a shrine that the Indians worshipped, it was the land itself: the rocky outcrops and mountain peaks, the rainbows and stars. Every time a Catholic priest planted a cross on top of an ancient site he merely confirmed in the eyes of the people the inherent sacredness of the place. In the wake of the Spanish Conquest, when the last of the temples lay in ruins the earth endured, the one religious icon that even the Spanish could not destroy.

Men return with a harvest of barley in Chinchero, a traditional community not far from Cusco, a beautiful city in southern Peru that was once the capital of the Incan Empire.

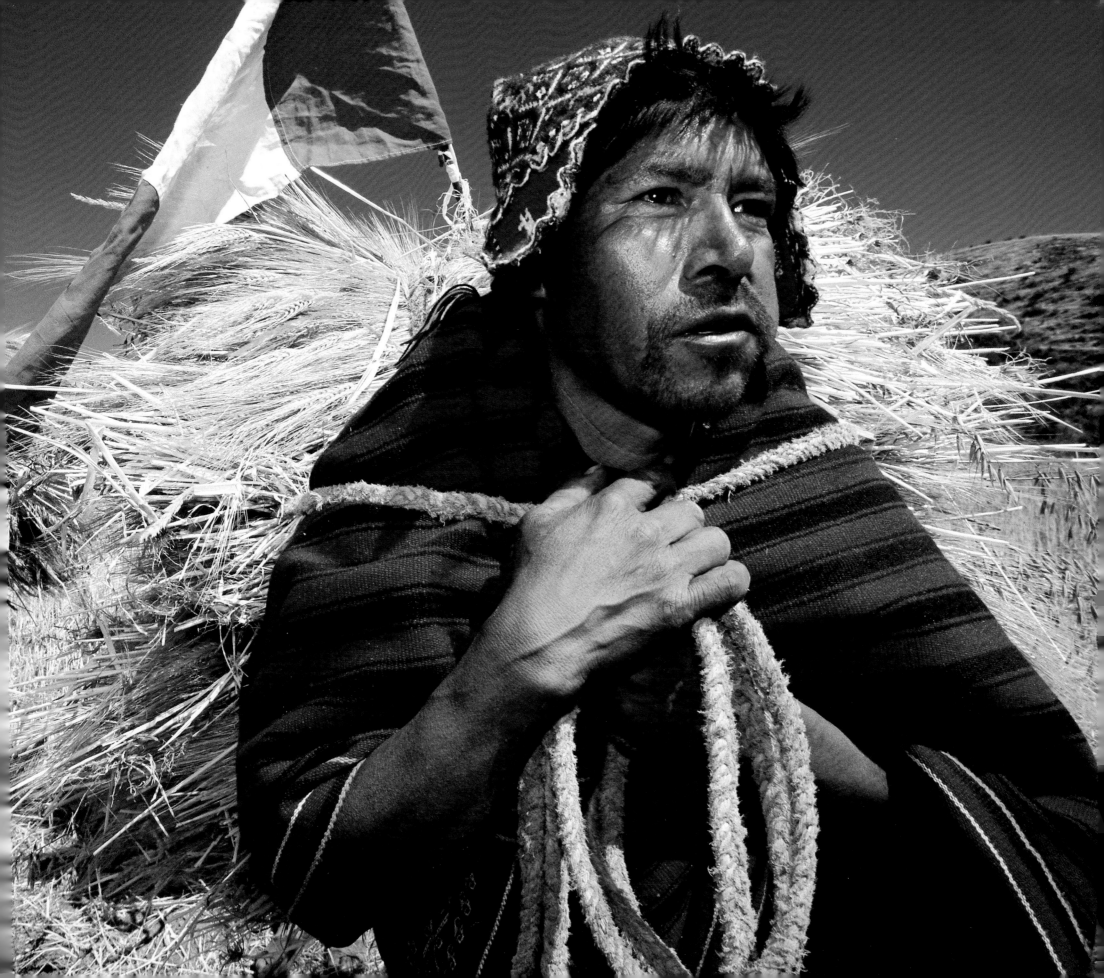

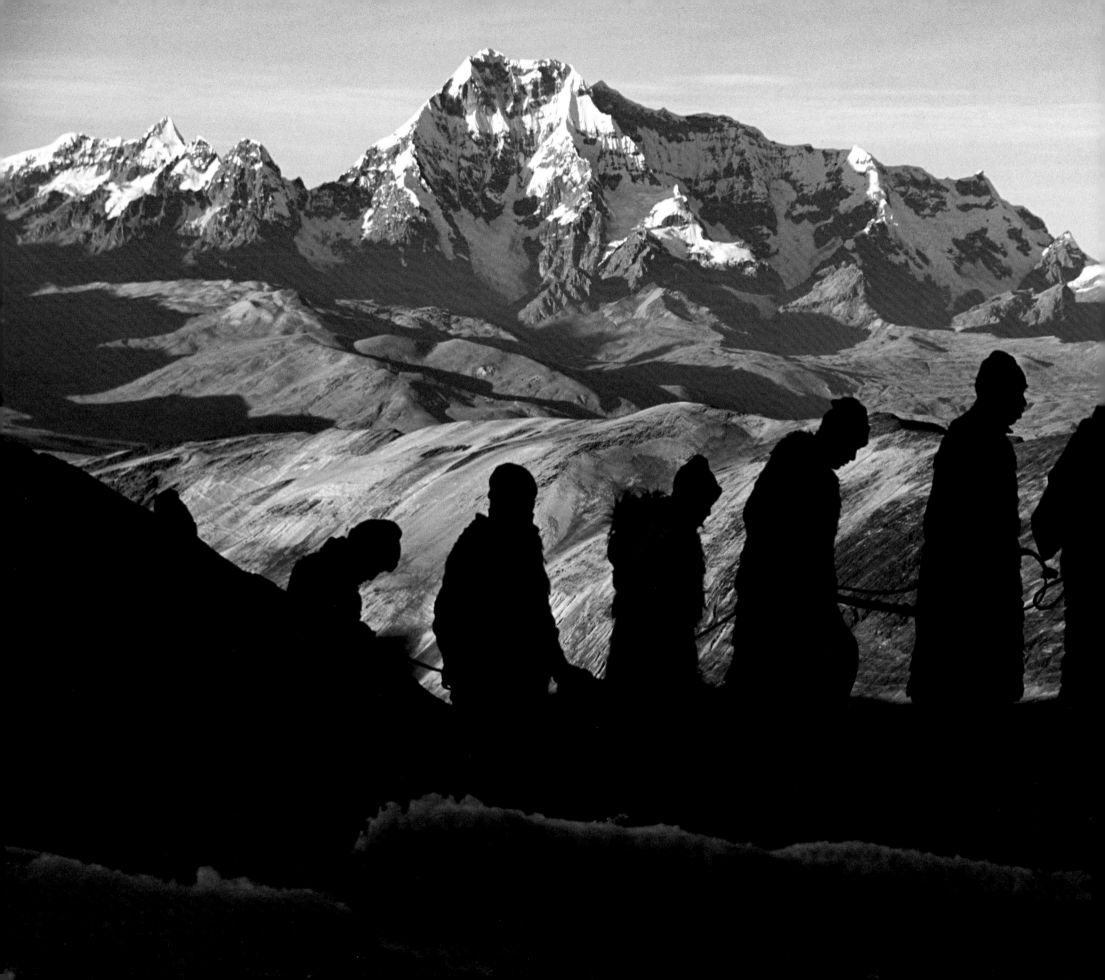

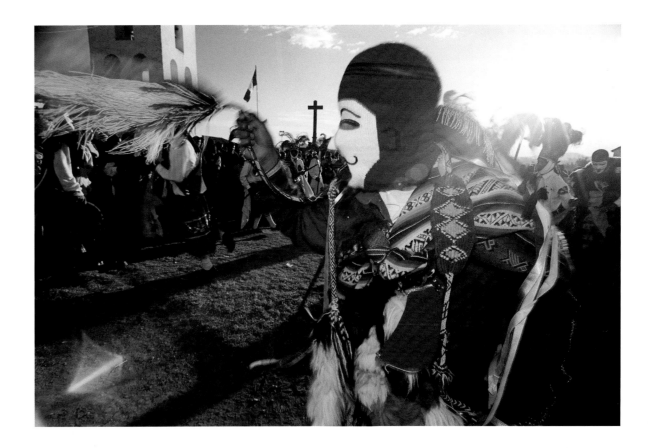

ABOVE AND LEFT: For most of the year the Sinakara Valley, located at an altitude of 15,500 feet, 100 miles due east of Cusco, is cut off from the world. But in June as the Pleiades re-emerge in the night sky following the feast of Corpus Christi, as many as forty thousand men and women converge on the valley for the Qoyllur Rit'i, the Star Snow Festival, the most arduous and spiritually illuminating of all Andean pilgrimages. From the base of the mountain they make their way up a six-mile trail that climbs steadily past a series of stone altars, where pilgrims pause to pray and make offerings. Each carries a bundle of small stones, a symbolic burden of sin; one is left at each altar as the valley comes near. Above the skyline to the west hovers Ausangate, the most sacred mountain of the Inca. The festival is a perfect expression of the syncretic reality of religious life in the Andes—five centuries of Christian faith fused with pre-Columbian beliefs that go back to the birth of civilization in South America.

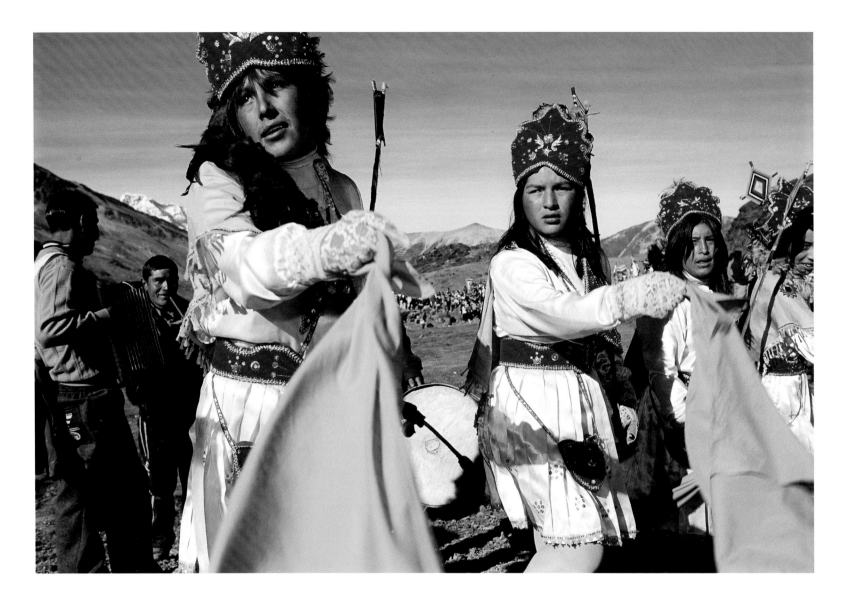

ABOVE: As the men dance and bluff, pose and posture, the women gather. Beneath the gaiety of the festival lies an intensely serious purpose. Mountain deities can be wrathful or beneficent. Ice and snow are both a source of power and a miasma of disease. The glaciers are fearful domains not because of physical danger—though pilgrims do die of cold and exposure each year—but because they are the abode of the *condenados*, souls cursed until the end of time.

RIGHT: Jungle warriors, or *chunchus*, wear headdresses festooned with parrot feathers and tunics dyed crimson with cochineal. The mountains are represented by the *ukukus* (seen here)—masked men dressed as bears and charged with keeping the peace, controlling the crowds and performing the most essential of all the rituals. These symbolic embodiments of mountain and jungle stage mock struggles in set theatrical pieces that play out the constant tension between the two oppositional poles of Andean existence and Incan cosmology: upper and lower, mountain and forest, civilized and savage.

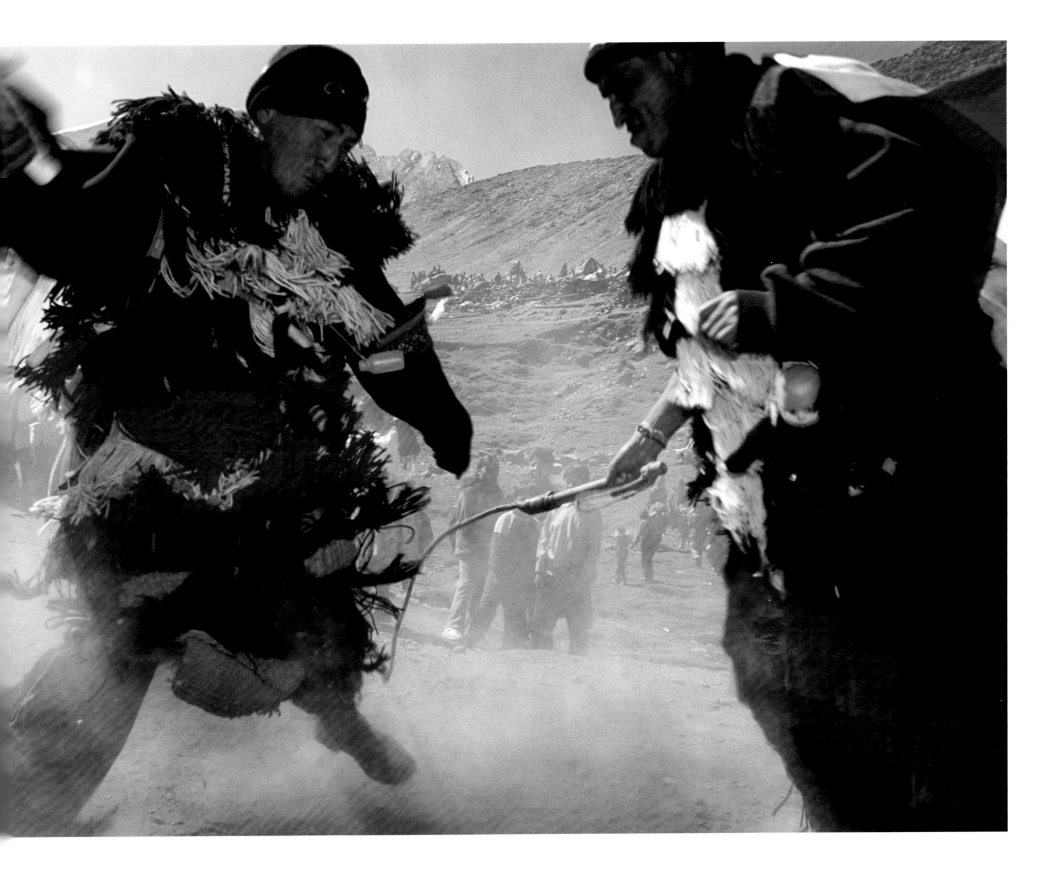

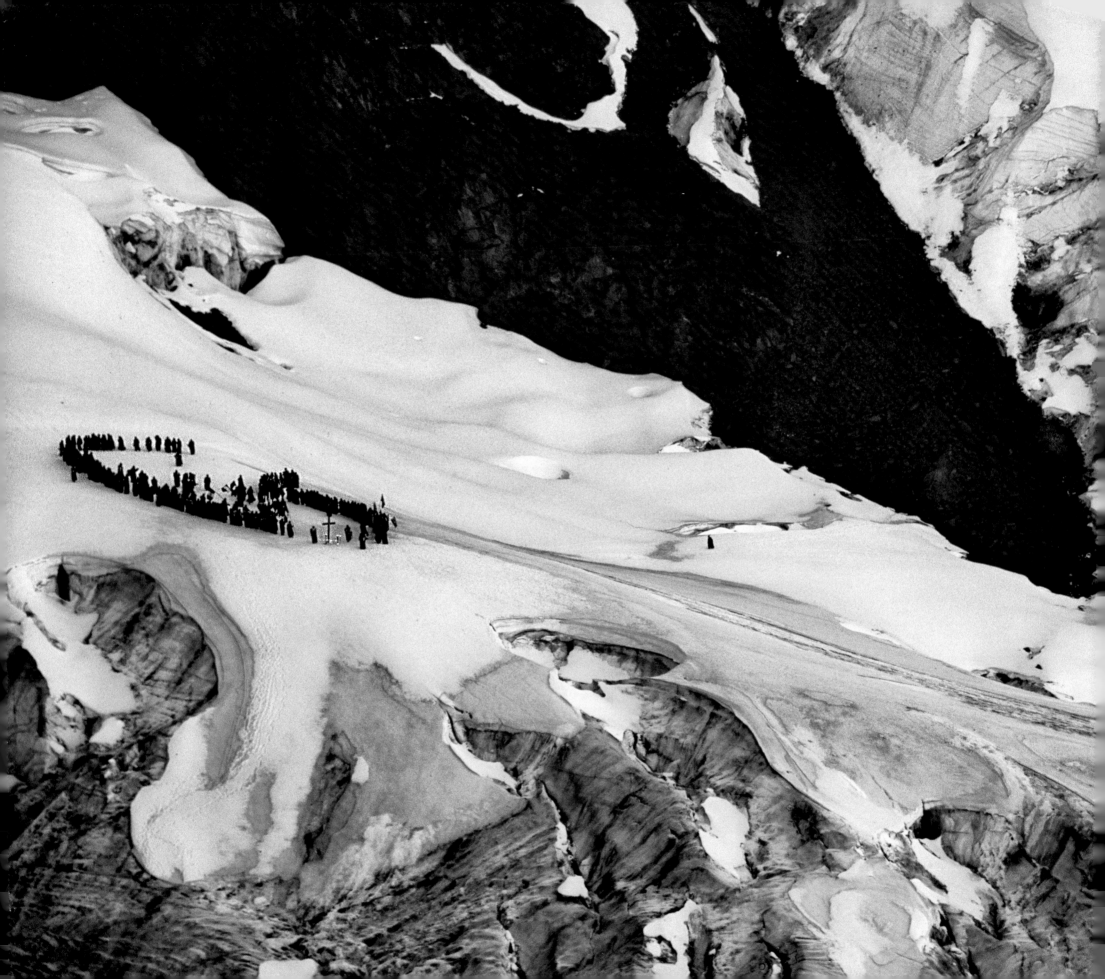

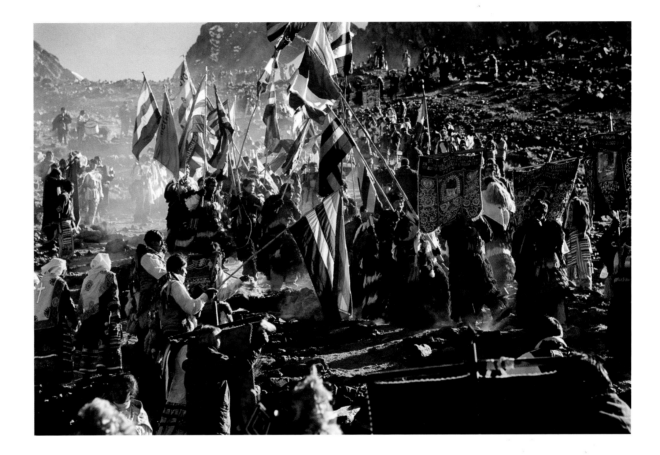

ABOVE: The atmosphere at the Qoyllur Rit'i is both festive and charged with meaning, a pageant of colour, prayer, dance and song. Ritual banners and flags decorate the hillsides. Along the valley floor each community stakes its ground and blankets and ponchos of a dozen hues form a quilt that spreads on both sides of the small stream that nourishes everyone. There is a constant cacophony of brass bands, flutes, harps and drums, along with the high falsetto voices of the dancers and the explosion of fireworks. For three days and nights no one sleeps. The very ground shakes with the movement of the dancers and the slow throbbing tone of the ritual processions.

LEFT: The *ukukus* perform the most dangerous and solemn act of the Qoyllur Rit'i. Like Christ they must bear the burden of the cross. They carry their crosses from their village churches 2,500 feet up the flanks of Colquepunku, where they implant them in the glaciers to be charged by the energy of the mountain. Then before dawn on the morning of the third day, as thousands of pilgrims kneel in silent prayer, they climb back to the ice to retrieve them. The men also bring blocks of ice down from the mountain and back to the villages to bring fertility to the fields. This completes the devotional cycle: people, mountains and gods, a reciprocal trinity of trust and renewal that becomes a prayer for the cultural survival of the entire pan-Andean world.

71

THE KILLING FIELDS

CULTURE IS NOT TRIVIAL. It is not decoration or artifice, the songs we sing or even the prayers we chant. It is a blanket of comfort that gives meaning to our lives. It is a body of knowledge that allows the individual to make sense out of the infinite sensations of consciousness, to find meaning and order in the universe. Culture is a body of laws and traditions, a moral and ethical code that insulates a people from the barbaric heart that history suggests lies just beneath the surface of all human societies, and indeed all people. Culture alone allows us to reach, as Abraham Lincoln said, for the better angels of our nature.

If you want to know what happens when the constraints of culture and civilization are lost, simply look around the world and consider the history of the last century. Anthropology suggests that when peoples and cultures are squeezed, extreme ideologies often emerge, inspired by strange and unexpected beliefs.

In Cambodia, Pol Pot, humiliated at home by the French colonialists and in Paris when he went abroad to study, created a fantasy of a renewed Khmer empire, a nation purged of all things Western. All things, that is, save the Marxist-Leninist ideology that rationalized murder in its pursuit of pseudoscientific theories about the social malleability of human nature. Thus while the great twelfth-century temples of Angkor Wat were spared destruction during the civil war, all people who wore reading glasses or had the soft hands of scholars, poets, merchants and priests were liquidated in the killing fields. In less than five years the dystopian regime of Pol Pot slaughtered some 2.5 million men, women and children, fully a quarter of all Cambodians alive when the Khmer Rouge took power in 1975.

Every morning before dawn in the Laotian city of Luang Prabang, Buddhist monks in procession move through the streets as residents and visitors wait to offer rice and other food, which will be the only meal of the day for these ascetics. This daily ritual dates to the flowering of the Theravada tradition in Southeast Asia in the twelfth century.

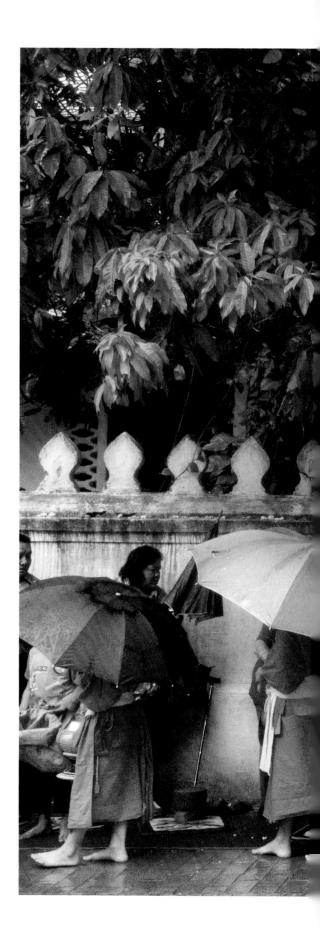

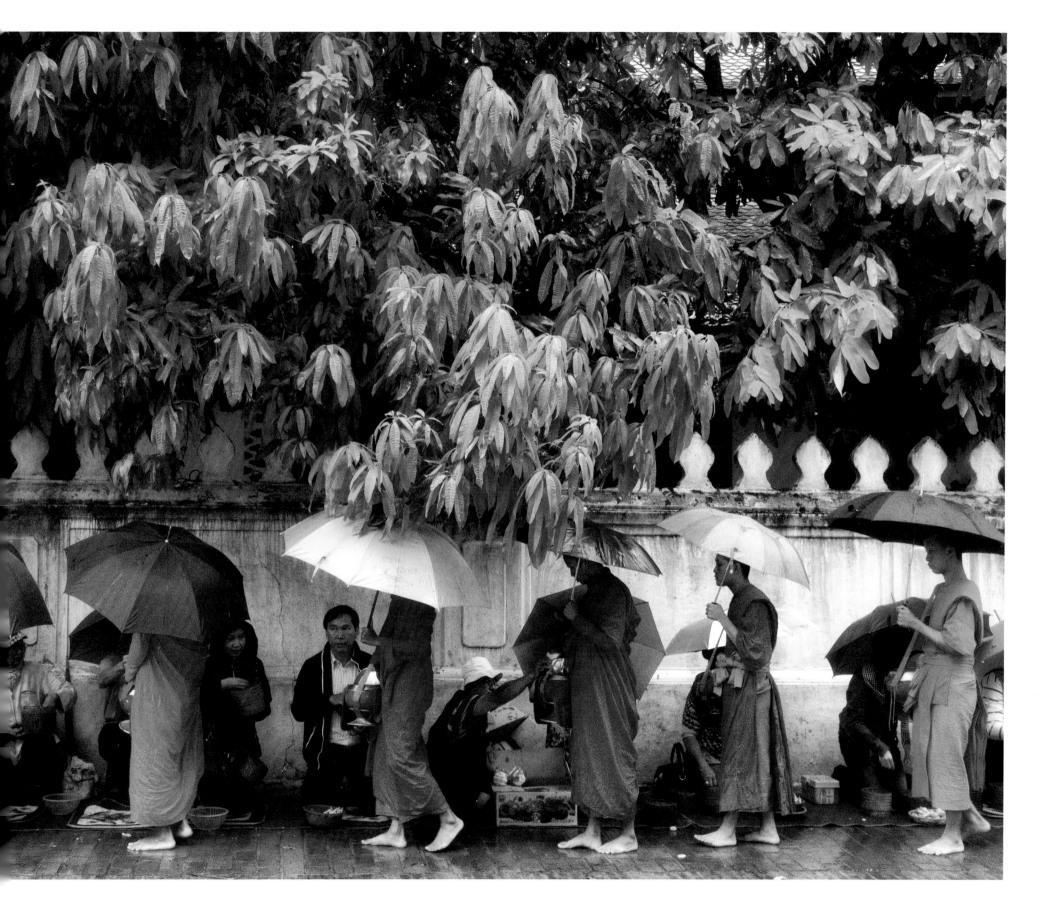

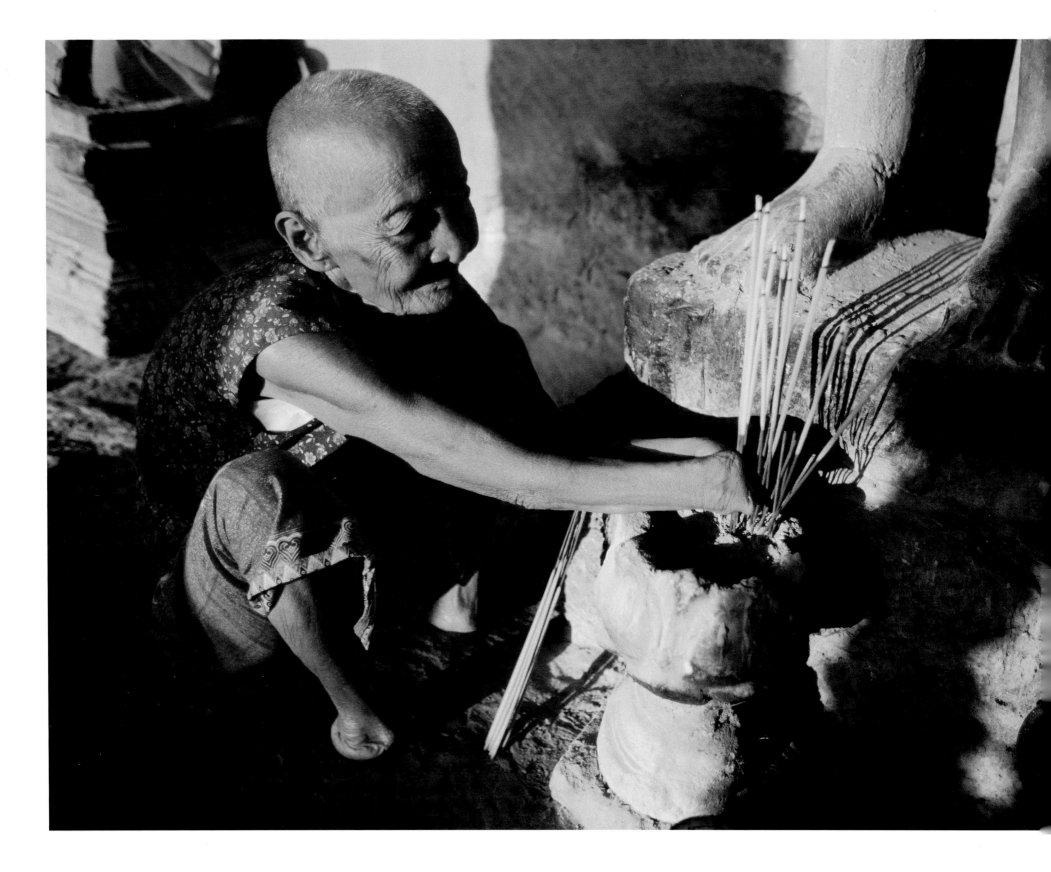

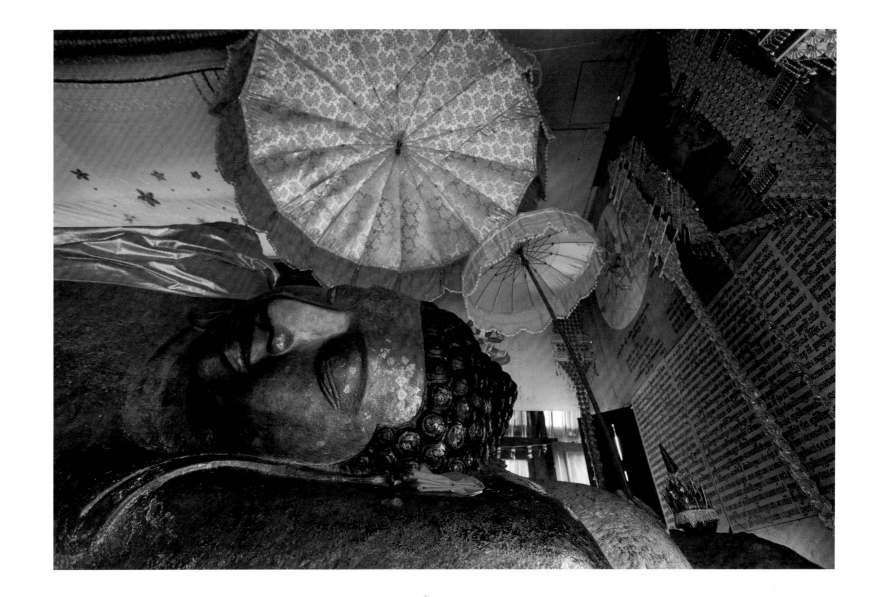

ABOVE: A reclining Buddha at Wat Preah Ang Thom, a sixteenth-century temple-monastery on Phnom Kulen, the sandstone massif near Siem Reap that was the site of the quarries for the temples at Angkor.

LEFT: In the ruins of Angkor Wat, an elderly Buddhist nun peddles incense, allowing visitors to make offerings. Her feet and hands have been severed from her body, perhaps by a land mine, possibly through torture during the era of Pol Pot.

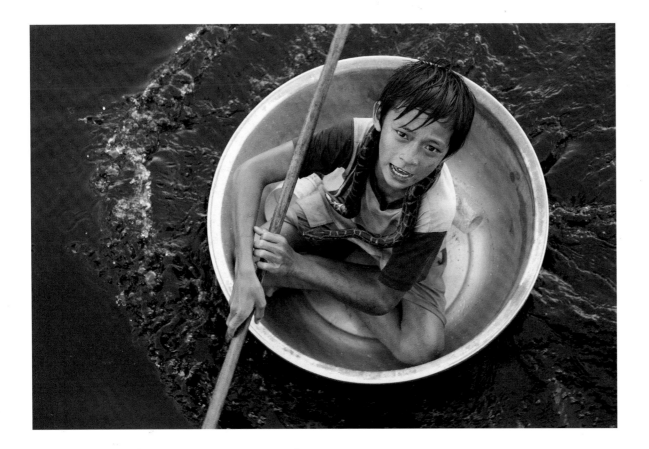

ABOVE: A young boy from a floating fishing village on the Tonle Sap impresses passing tourists with his snake-handling bravado. The Tonle Sap is a freshwater lake linked to the hydrological cycle of the Mekong River. In the rainy season its size increases tenfold. As waters recede they leave rich deposits of sediments, which allowed the ancient Khmer to harvest three crops of rice a year. This was the wealth upon which an empire was built. The snake around the boy's neck is the harmless Tonle Sap water snake *Enhydris longicauda*. Found nowhere else in the world it is today being hunted to extinction, with some seven million snakes being sold each year to the crocodile farms that ring the lake.

RIGHT: In Cambodia today 70 per cent of the national population is younger than thirty. The dearth of people in their sixties and seventies—the cohort that would have been young adults during the height of Pol Pot's regime—is as obvious as it is haunting. This man survived, having lost the better part of his left leg.

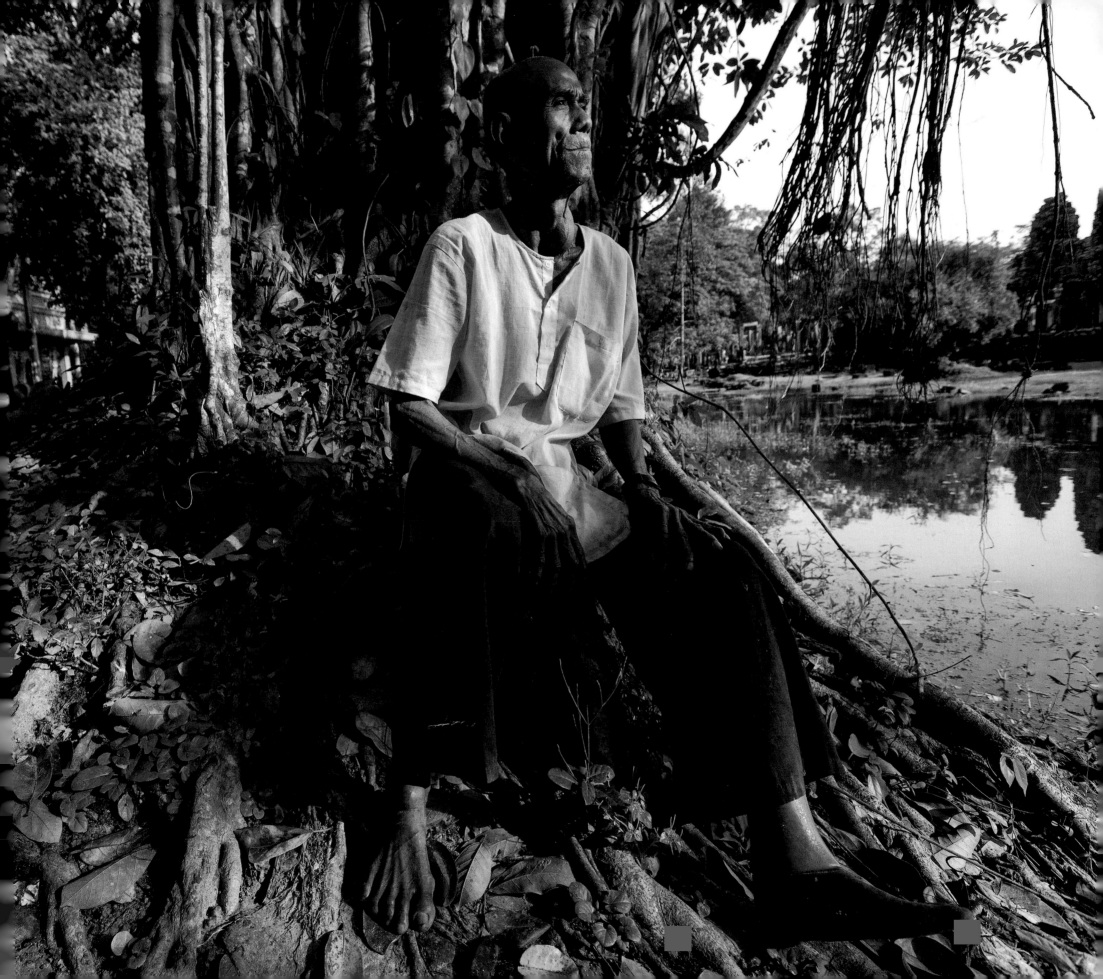

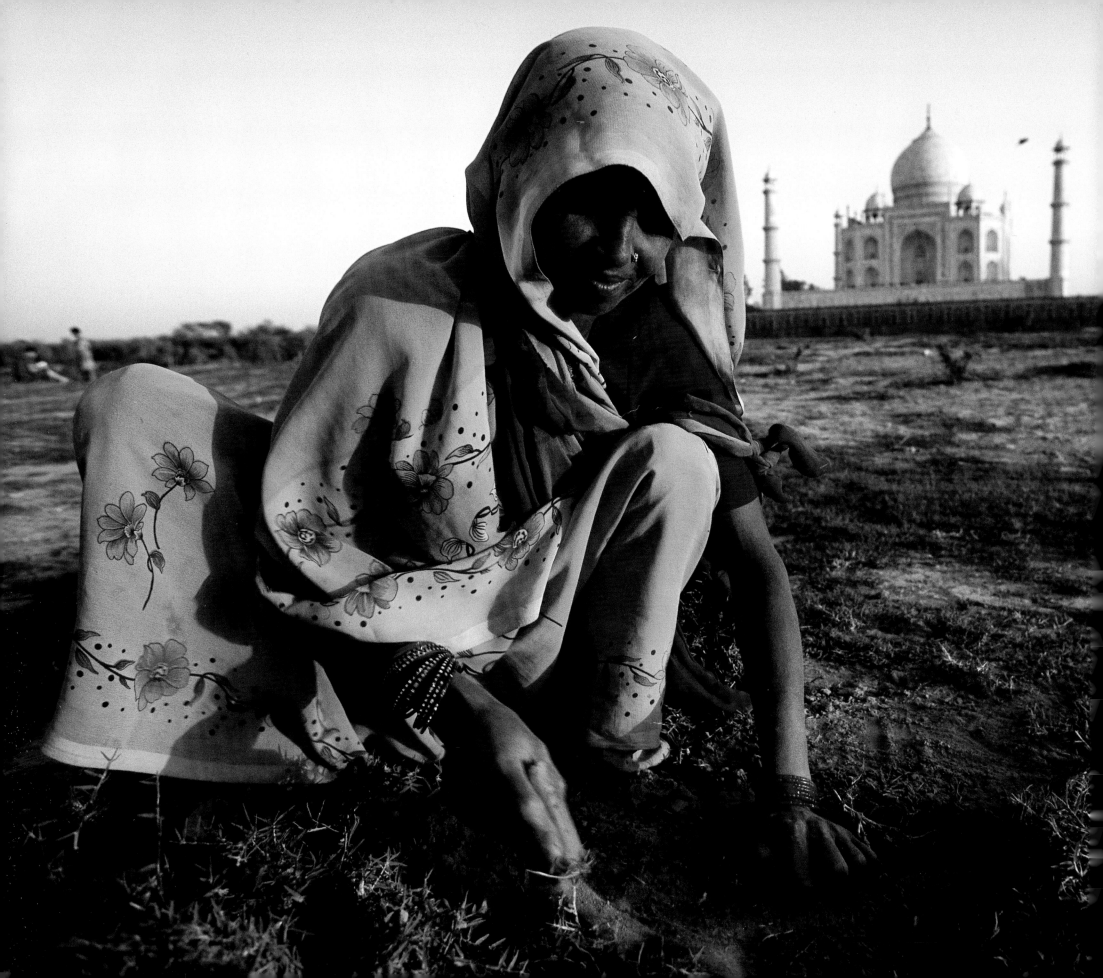

MOTHER INDIA

INDIA IS MORE A STATE OF MIND THAN A NATIONAL STATE, a civilization that has endured for four thousand years as an empire of ideas rather than territorial boundaries. Time and again it has yielded to the onslaught of invaders but has always won in the end, absorbing foreign impulses and through the sheer weight of its history prompting mutations that inevitably transform every novel influence into something indelibly Indian.

The country is a paradox of wisdom and folly, generosity and greed, a land that invented monasticism yet passionately celebrates the sensual. Among the world's most ancient civilizations India is one of the youngest nations. A sea of immense poverty it supports a prosperous middle class larger than the entire population of the United States, and no nation produces more PhDs. The motherland of Hindu and Buddhist, Sikh and Jain, it is home to ten thousand faces of the divine—Rama, Vishnu, Shiva, Krishna and Ganesh. And yet, having shown the world the universal possibility of non-violence, it remains a cauldron of unrelenting violence between Islam and other creeds.

Thanks to India we reckon from zero to ten and use a decimal system without which our computer age would hardly be possible. Indians were the first to spin and weave cotton, gamble with dice, and domesticate chickens, elephants and mangoes. They taught us to stand on our heads for good health and to believe in the coexistence of contradictions.

With fifteen official languages and more than sixteen hundred distinct dialects the entire subcontinent is a cacophony of sound. The average Indian market is more wondrous and strange than any museum. The average village pulsates with more vitality, colour and scent than any carnival. Every day India bears witness to millions of small dramas worthy of Shakespeare, all enacted free of charge on countless stages beneath the laughter and sorrow of all the heavens.

A woman gathers forage for her goats on the bank of the Yamuna River. Behind her is the Taj Mahal, the white marble mausoleum built between 1631 and 1648 by the Mughal emperor Shah Jahan as a memorial to his beloved wife Mumtaz Mahal.

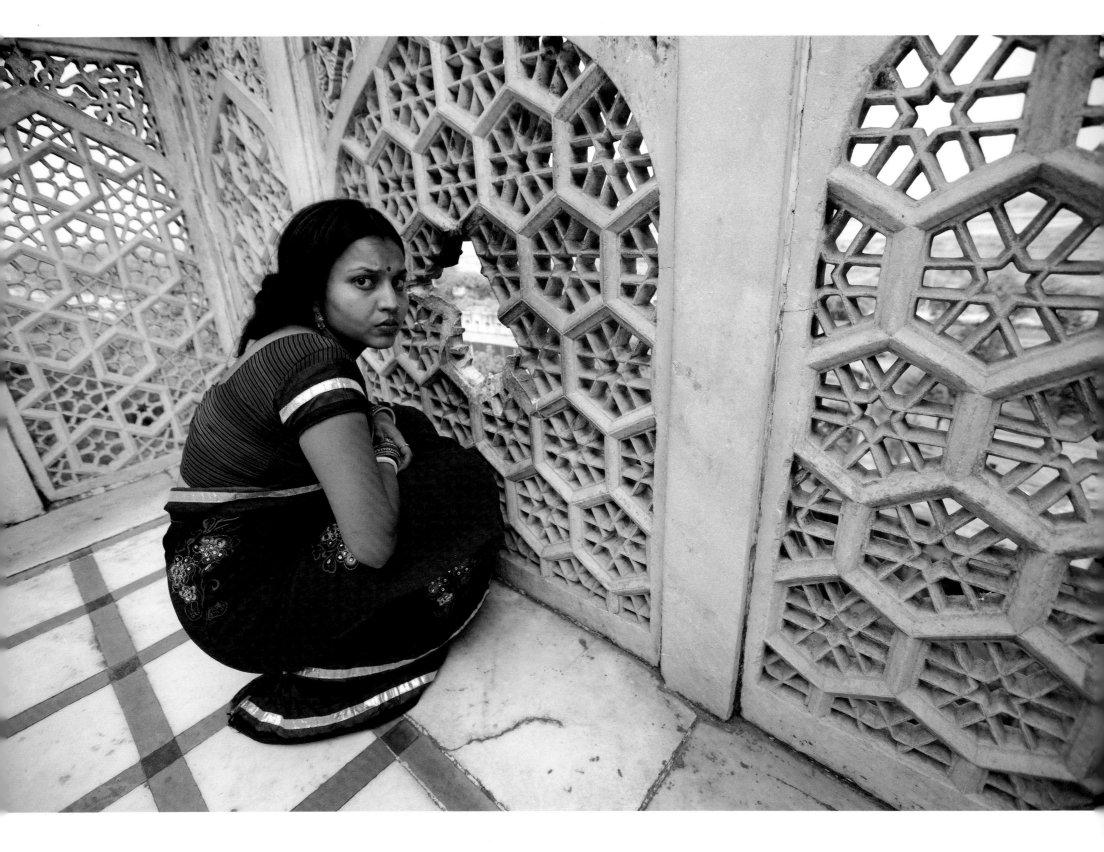

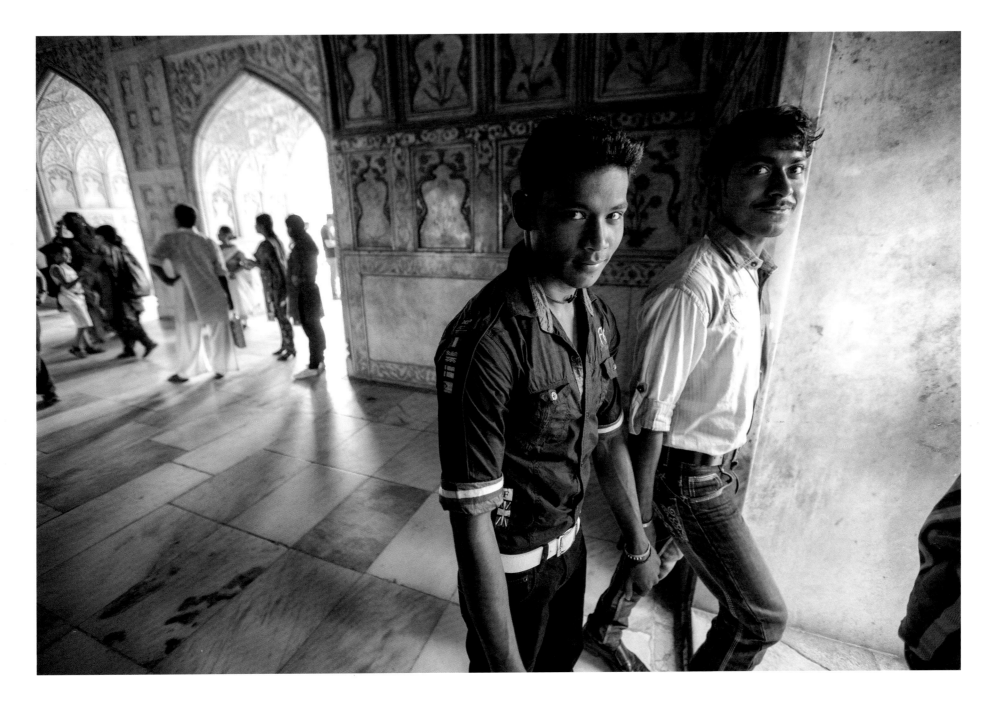

ABOVE: Two young friends hold hands at Fatehpur Sikri. Founded by Akbar the Great in 1569 it served as capital of the Mughal Empire for only sixteen years before being abandoned in 1585.

LEFT: A young bride peers warily through broken marble at Agra Fort. The next frame was a joyous snap of her and her husband and father-in-law.

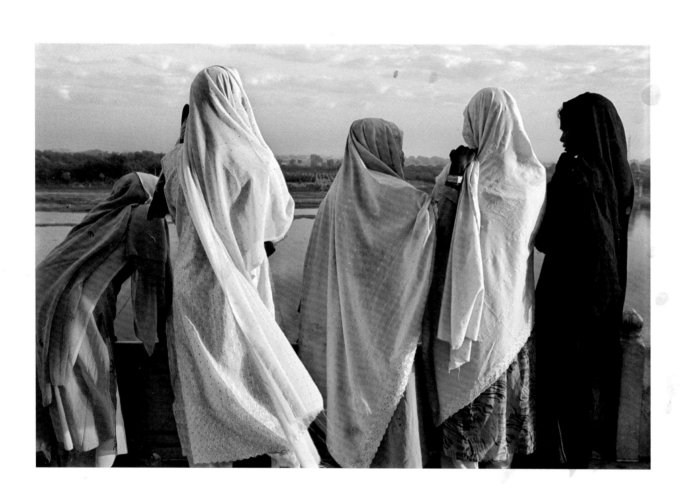

ABOVE: On the south terrace of the Taj Mahal a group of young women in colourful saris gaze over the great bend of the Yamuna River.

RIGHT: The exquisite gardens of Fatehpur Sikri appear in the dawn mist.

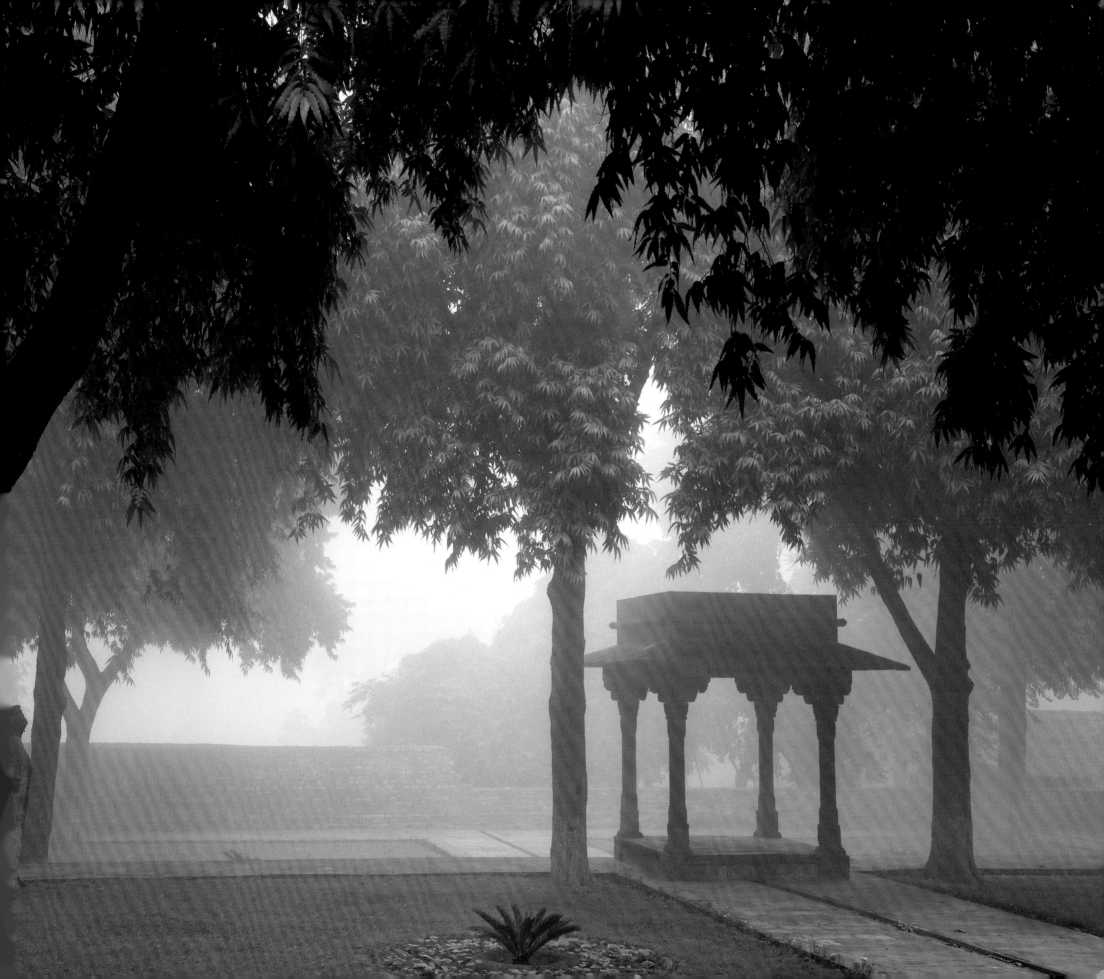

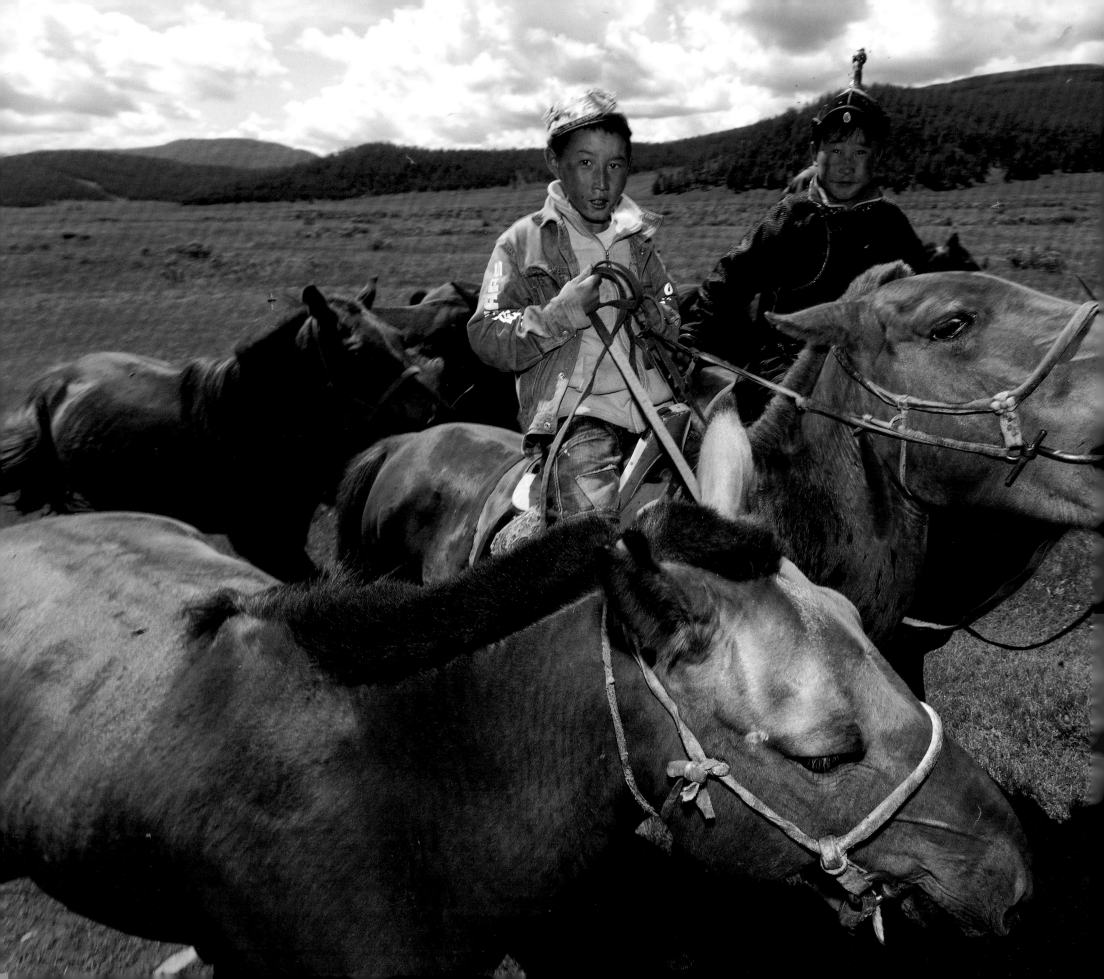

THE WINDHORSE

IN THE GRASSLANDS OF MONGOLIA MOBILITY IS THE KEY TO SURVIVAL, just as it was in the time of Genghis Khan. Beginning in 1206 the Mongols swept across Asia from the Black Sea to the Pacific, from Manchuria to the gates of Europe. In twenty-five years they conquered more land than the Romans did in four centuries. By the mid-thirteenth century Genghis had one grandson leading an army at the gates of Poland; a decade later another conquered Hanoi. One of every two hundred men alive today is a direct descendant of Genghis Khan.

What made it all possible was the Mongol horse, with its unique gait and unequaled endurance. Mongol armies remained on the move for weeks on end, each soldier living on blood drawn from the neck of one of his four mounts and horsemeat that he tenderized by placing it beneath his saddle as he rode. Across an empire the size of Africa, Genghis Khan established ten thousand staging posts, each with four hundred horses, half of which were ready to go at all times. Messages reached Damascus from the Mongol capital of Karakorum, a distance of more than three thousand miles, in just over two weeks.

Mongols today still invoke the spirit of the Great Khan, just as they celebrate the horse as a messenger between humans and the gods and thus the true symbol of freedom. In their language "horse" is *takh*, meaning spirit. A person's innermost soul is *hiimori*, his "windhorse"—a heavenly horse riding on the wind. In death a man's windhorse ascends to the sky to join Father Heaven, while the soul that resides in the flesh seeps back into the ground to become one with Mother Earth.

With great herds of sheep and horses the pastoral nomads of Mongolia must move four times a year to seek fresh pasture. They live in *ghers*, circular framed tents that can be dismantled, moved and set up in a day. Each *gher* is a model of the universe—the air vent represents the sun, the roof beams are the sun's rays, the walls are the mountains that hold up the sky and the floor is the earth. Every *gher* has a dangling rope symbolizing the umbilical cord of the universe. The loops represent karma, each twist a bend in the personal fortunes of the family. The sheer scale of the landscape, the immensity of the sky and the harshness of the winters gave meaning to Buddhist notions of impermanence. Mongolians pursue the Buddhist dharma, even as their religious practices remain powerfully influenced by ancient animistic beliefs.

In the Bunkhan Valley of Arkhangai, young Daluunbayer (left) and a friend return from the Mandal Mountain pilgrimage, having made offerings and prayed for victory in the upcoming Naadam, an annual festival in which he is competing. In Mongolia there are eight horses for every person. Children learn to ride as infants. To master a horse is to become the master of life itself.

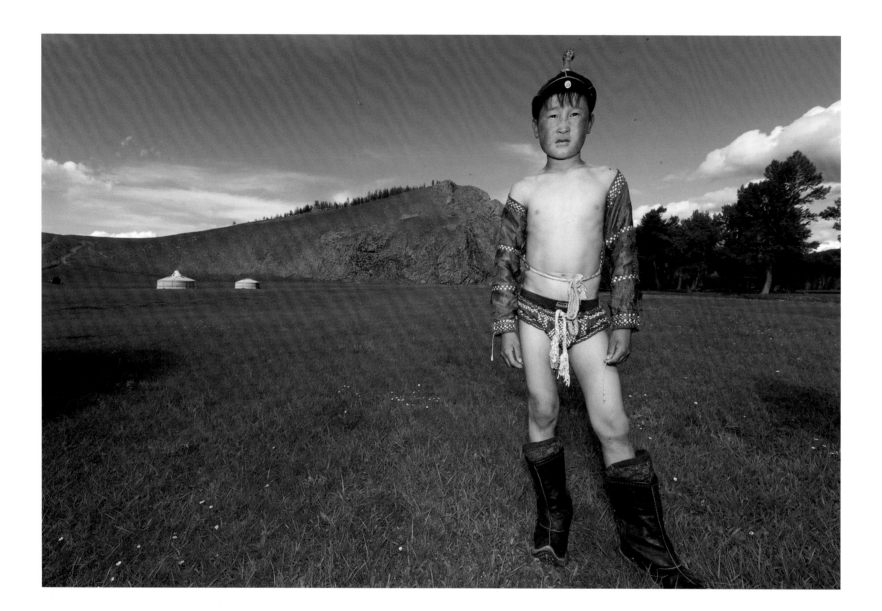

ABOVE: A young boy wears the traditional wrestling garb. Folklore has it that a girl in disguise once won a prestigious match. Since then participants must bare their chests to display proof of gender. Archery, wrestling and horsemanship, the national sports of Mongolia, are all powerfully evocative of what allowed Genghis Khan to vanquish enemies and bring peace, stability and religious tolerance to the nations of the ancient Silk Road. Archery recalls the technological achievement of the Mongol bow, the most powerful and deadly weapon of its time. Wrestling is about strength and holding ground, boots firmly planted, arms outstretched like the wings of an eagle, linking heaven and earth. Horse racing represents the courage and decisiveness necessary for survival on the vast steppes of Central Asia.

RIGHT: At the site of the ancient Mongol capital of Karakorum, a young man guards his prized hunting eagle.

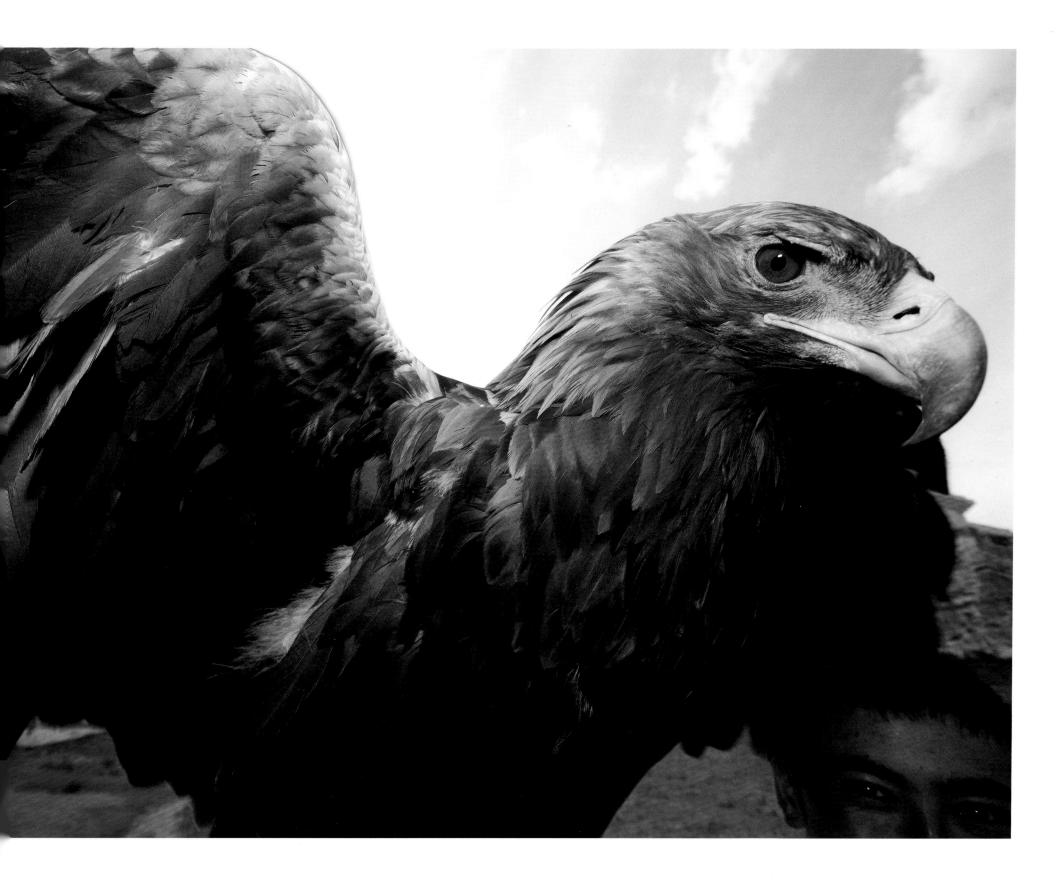

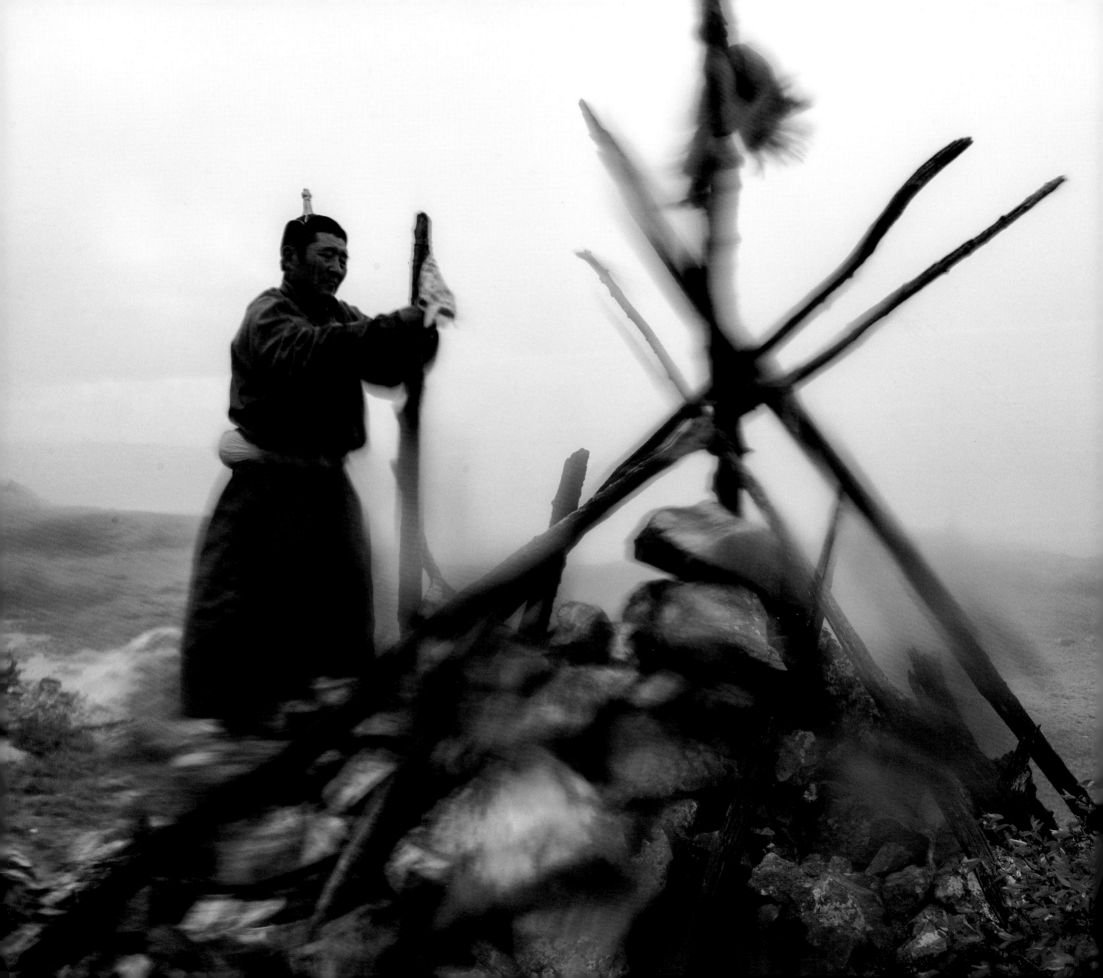

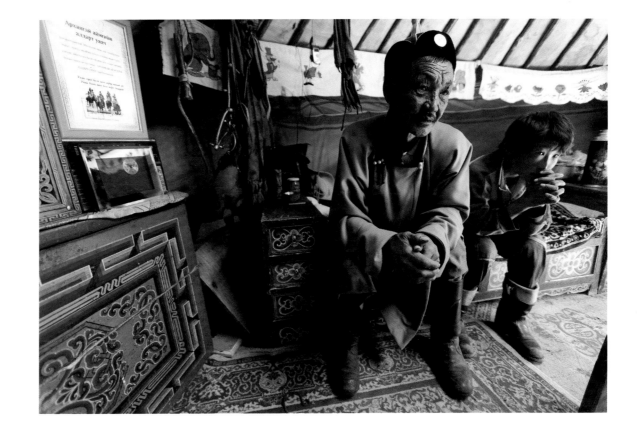

ABOVE: The horse trainer Mukhdalai rests in his *gher* with his protégé Janjivdor, the reigning champion of the Bunkhan Valley. At the core of the Naadam festival is an astonishing horse race that features jockeys aged eight to ten—mostly boys but some girls—who ride bareback flat out over the roughest of terrain for some fifteen miles. Out of sight of the adults anything goes and almost invariably serious injuries occur. As much as a race this is an ordeal and rite of passage, and the first across the finish line is as much a survivor as a winner. Yet all glory goes to the horse, which is celebrated as the symbol of Mongol culture, an earthly embodiment of the spirit horses of heaven. Thus the victory of any horse and rider in the Naadam is ultimately a victory for all.

LEFT: Before the Naadam, Namjin and his rider Daluunbayer embark on a pilgrimage to Mandal Mountain to seek spiritual blessings and strengthen their *hiimori*. At the summit (seen here) is a cairn of stones called an *ovoo*, a shaman's altar inhabited by all the local deities. Each pilgrim adds a stone to the pile, makes an offering of mare's milk—a symbol of purification—and then on horseback circles the shrine three times, calling out to the gods. The *ovoo* is the axis linking man and horse to the mountain, the wind and rain, and the lapis-blue sky. The most heavenly being is a horse flying on the wind, a windhorse linking the people directly to their gods.

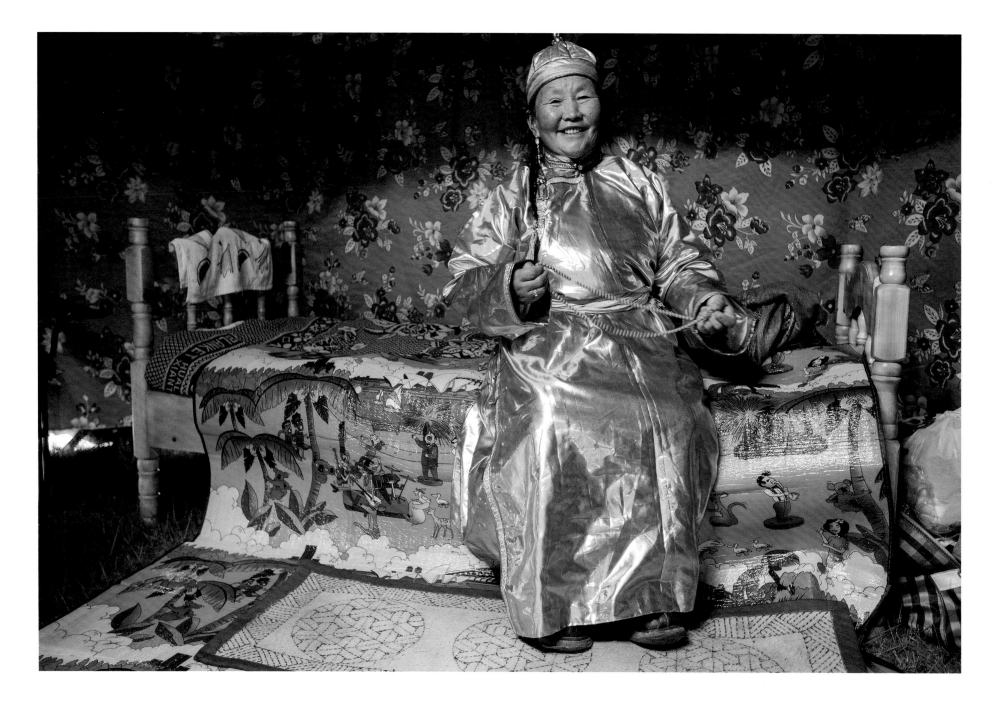

On the day of the race the Green Tara, a tantric deity, is channelled through the body of this joyous woman, who then blesses the horses. The Buddhists liken the mind to a horse. It is only useful if trained. The saddle is seen as a seat for meditation. Riding a horse is a metaphor for riding your mind and taming the endless stream of thoughts. You hold the reins neither too tight nor too loose, cultivating awareness by being neither too relaxed nor obsessively vigilant. Mongolians believe that the dharma is carried on the back of a horse.

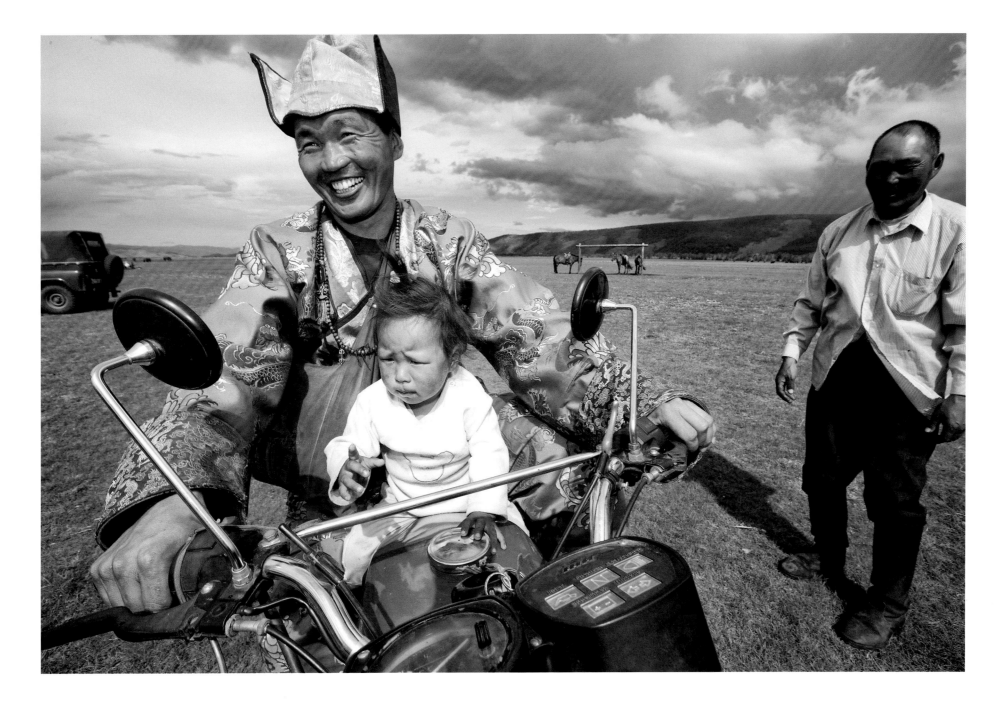

Namjin, seen here in his training grounds with his grandson on the handlebars and with the nephew of the Green Tara, a Buddhist monk, the day following the Naadam. Namjin is as stolid and steady as his close friend and rival Mukhdalai is clever, dissolute and wily. Naturally Mukhdalai's rider, Janjivdor, a boy who had never lost, has once again won, crushing Namjin's protégé, Daluunbayer. But this night Mukhdalai's luck will run out. Returning on another motorcycle, his iron horse, he breaks his leg, which has to be set by the monk with only vodka to quell the pain.

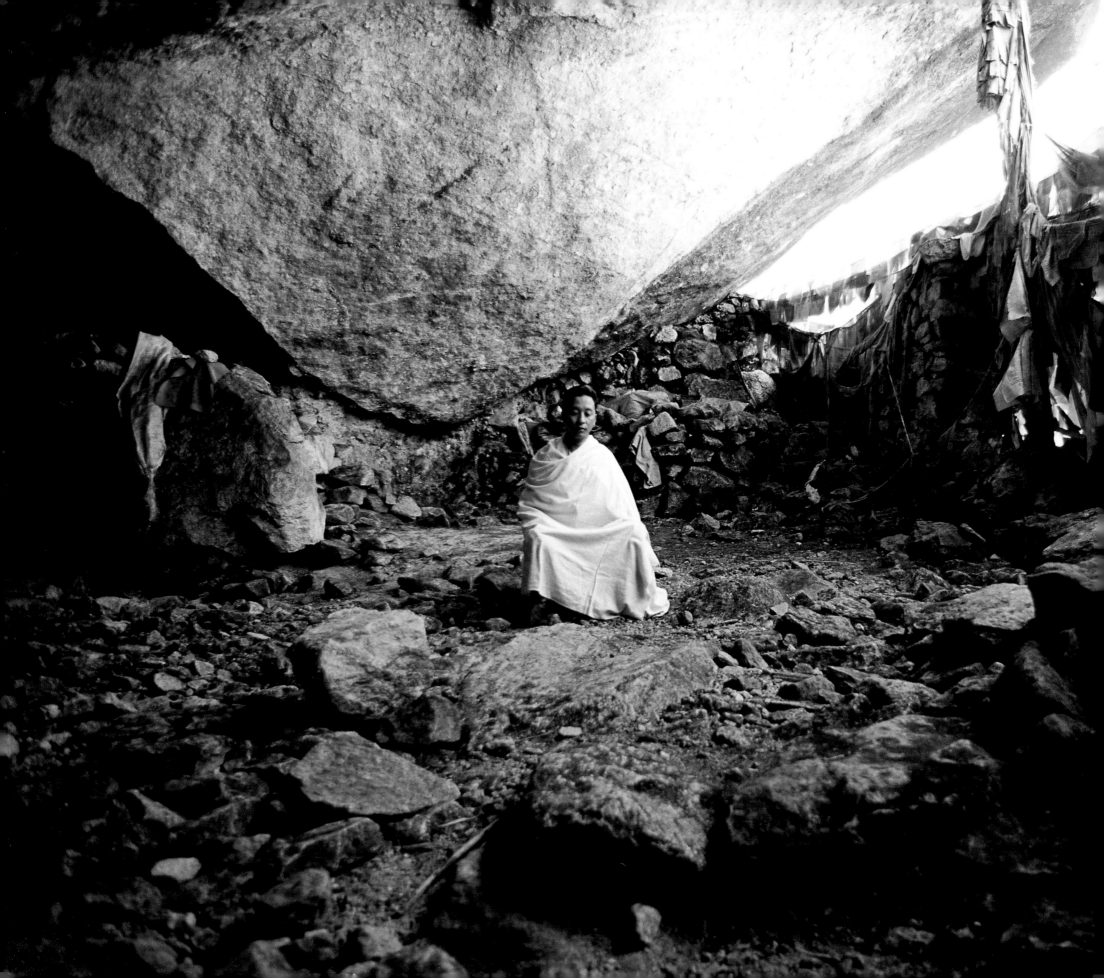

THE BUDDHIST SCIENCE OF THE MIND

THE BUDDHISTS SPEND THEIR TIME GETTING PREPARED FOR A MOMENT we in the West spend most of our lives pretending doesn't exist, which is death. We dwell in a whirlwind of activity, racing against time, defining success by measures of the material world—wealth and achievements, credentials of one sort or another. This to the Buddhists is the essence of folly. They remind us that all life grows old and that all possessions decay. Every moment is precious and we all have a choice—to continue on the spinning carousel of delusion, or to step off into a new realm of spiritual possibilities. They offer an alternative that is not a dogma but a path, long and difficult but in so many ways irresistible.

The essence of the Buddhist dharma, or teachings, is distilled in the Four Noble Truths. All life is suffering. By this the Buddha did not mean that all life was negation but only that terrible things happen; evil is not exceptional but part of the existing order of things, a consequence of human actions, or karma. Second, the cause of suffering is ignorance. By ignorance the Buddha did not mean stupidity. He meant the tendency of human beings to cling to the cruel illusion of their own permanence and centrality, their isolation and separation from the stream of universal existence. The third Noble Truth is the revelation that ignorance can be overcome. And the fourth and most essential is the delineation of a contemplative practice that promises an end to suffering and a true liberation and transformation of the human heart. The goal is not to escape the world but to escape being enslaved by it. The purpose of practice is not the elimination of self, but the annihilation of ignorance and the unmasking of the true Buddha nature, which like a buried jewel shines bright within every human being, waiting to be revealed. The Buddha's transmission, in short, offered nothing less than a road map to enlightenment.

As part of his seven-year training as a traditional Tibetan doctor, Sherab Barma spent twelve months in solitary retreat in this cave, to which he returns each year for a month of silent meditation. The meditative process allows the individual to gain mastery over the mind, which is like a lake swirling with waves of thought. As long as the mind is not still, the water will remain murky. Still the mind, clear the lake. The goal is inner simplicity and mindfulness, freedom not of thoughts but of the clutter of thoughts.

ABOVE: Men, women and children light votive candles as they circumambulate the Boudhanath Stupa in the Tibetan quarter of Kathmandu, Nepal.

RIGHT: In the early morning men and women cross the Yarlung Tsangpo in a traditional coracle, which is simply a wooden frame wrapped in yak hide. Here in Linzhi Prefecture the Yarlung, the highest major river on earth, is about to plunge into the Tsangpo Gorge, the world's deepest and most mysterious canyon. When it emerges on the southern side of the Himalaya, it will be known as the Brahmaputra, one of the great rivers of India.

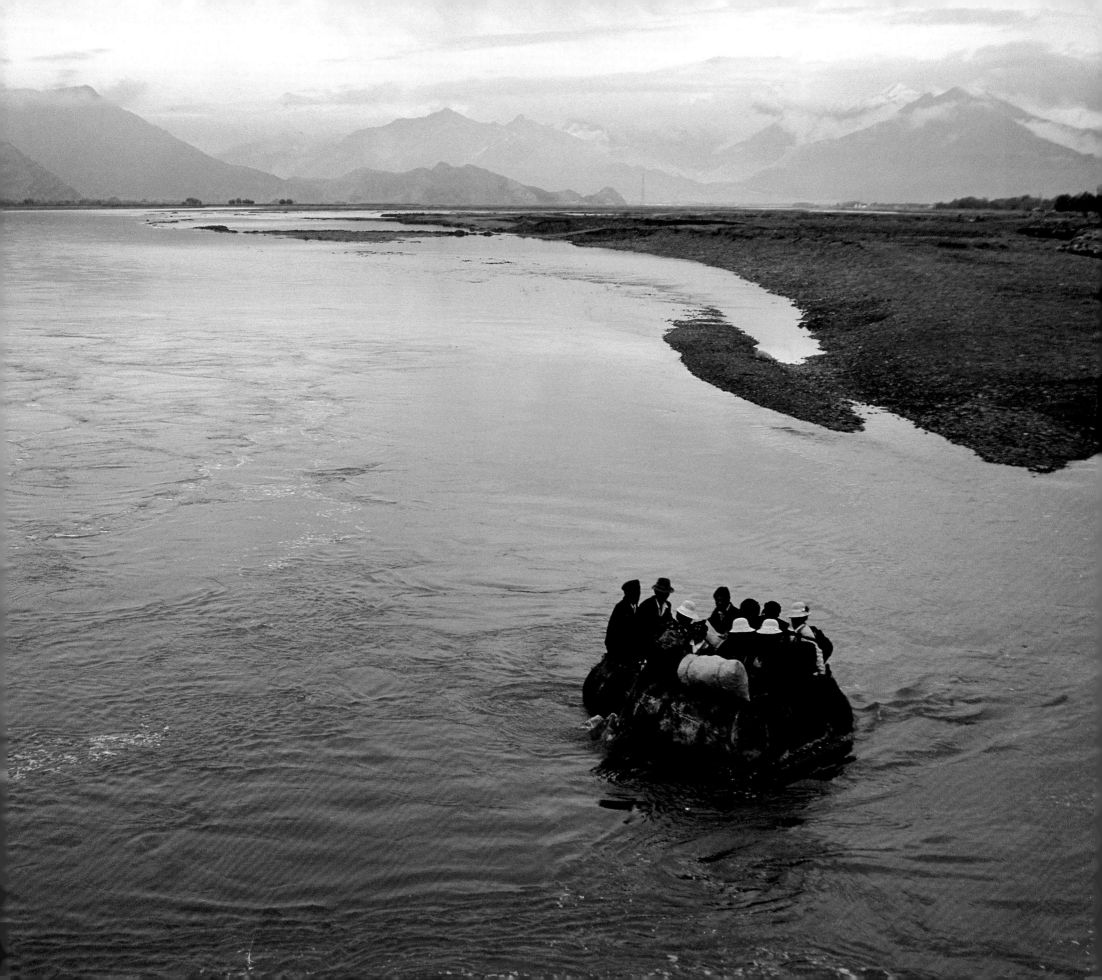

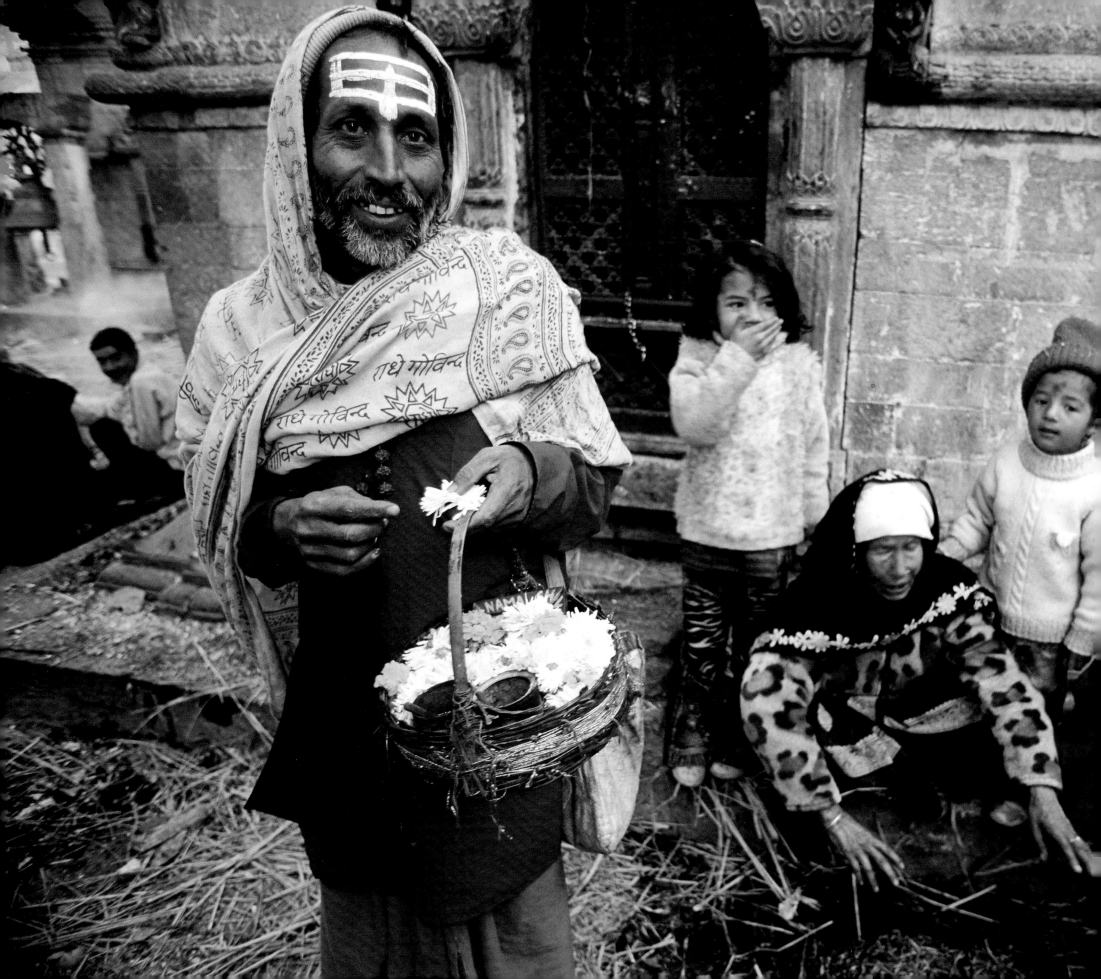

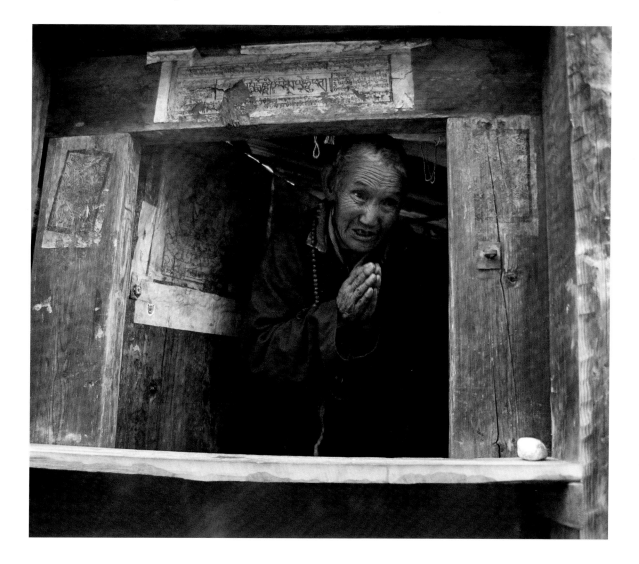

ABOVE: For forty-five years this radiant and serene Buddhist nun has lived alone in a single room, devoting her life to contemplative practice and the recitation of a single mantra. With each breath she moves that much closer to her goal, which is not a place but a state of mind, not a destination but a path of salvation and liberation. Finding serenity through the dharma is the experimental proof that validates the Buddhist science of the mind, just as a falling apple proves to us the existence of gravity. Many Tibetans do not believe that we went to the moon, but we did. We may not believe that they achieve enlightenment in this lifetime, but they do.

LEFT: The Pashupatinath Temple in Kathmandu is one of the holiest destinations for the Hindu pilgrim. Men and women from all over Nepal and India come here to spend the last weeks of their lives in order to die and be cremated on the banks of the Bagmati River, a tributary of the Ganges. To have one's ashes dispersed into the holy waters of the Bagmati ensures being reborn as a human, whatever the circumstances of one's past life.

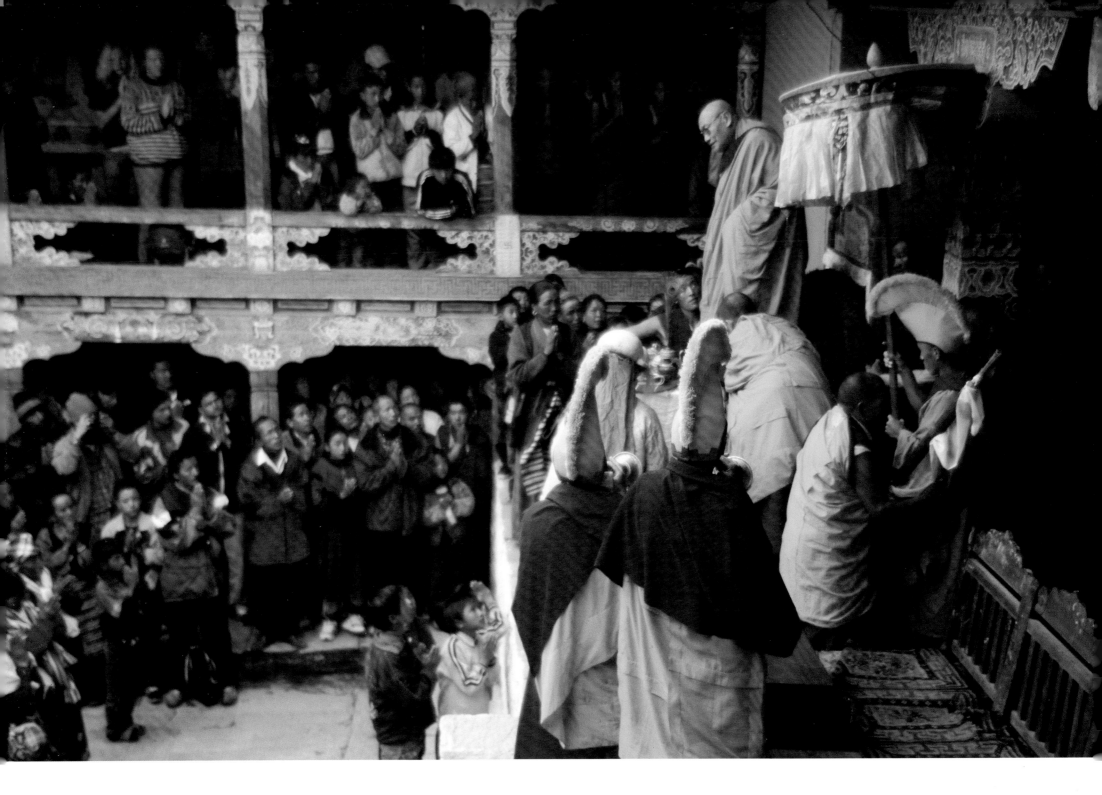

At Chiwong Monastery, Trulshik Rinpoche, then head of the Nyingma sect of Tibetan Buddhism, orchestrates the Mani Rimdu, which culminates in a day of spiritual empowerment and a day of masked dances, both open to the public. Trulshik Rinpoche, who passed on in 2011, embodied the Bodhisattva ideal, a realized being who has found enlightenment and yet chooses to remain in the realm of samsara, of suffering and ignorance, to help all sentient beings achieve their own liberation.

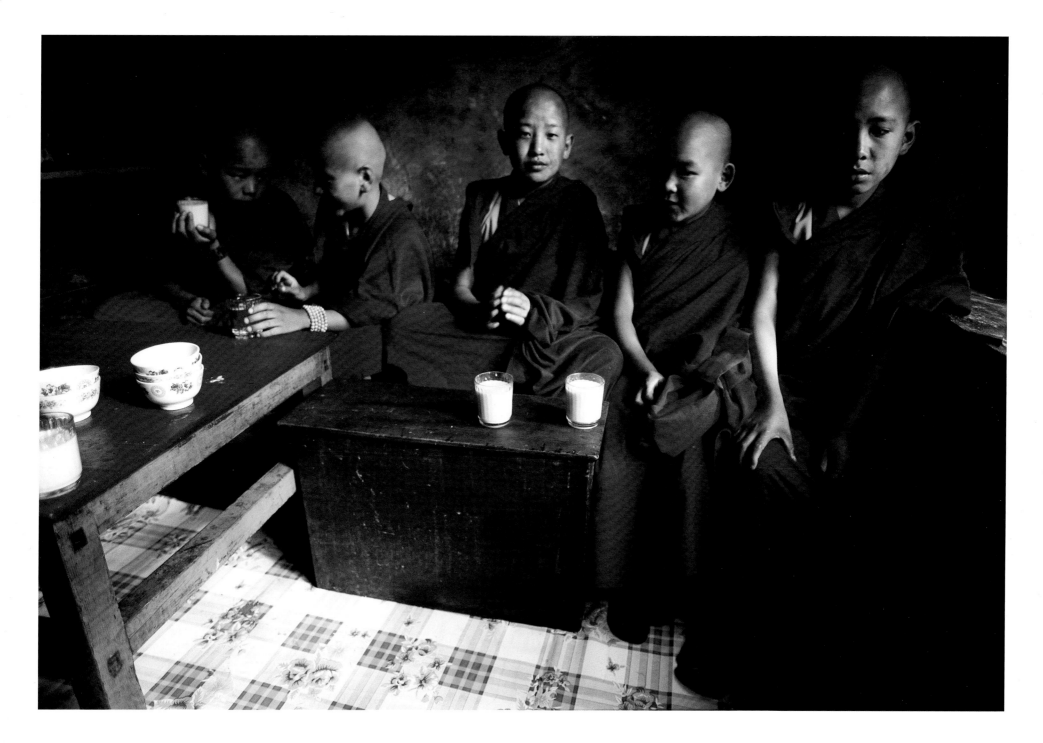

Traditionally in Tibet a son from every family would take vows and begin training at an early age, much like these young monks at the Thubten Chöling Monastery in Solu Khumbu. The esoteric Tantric teachings consume years if not decades, but the essence of the faith is accessible to all. And to take refuge in the Buddha implies no mandate to go out and persuade the rest of the world to think as you do. Unlike evangelical religions, Buddhism doesn't seek to remake the world by destroying it. The point is not to convert people but to contribute to their well-being. A Buddhist thinks of himself as ill, the Buddha as the doctor, his teachings as the treatment, and spiritual practice as the process of being cured.

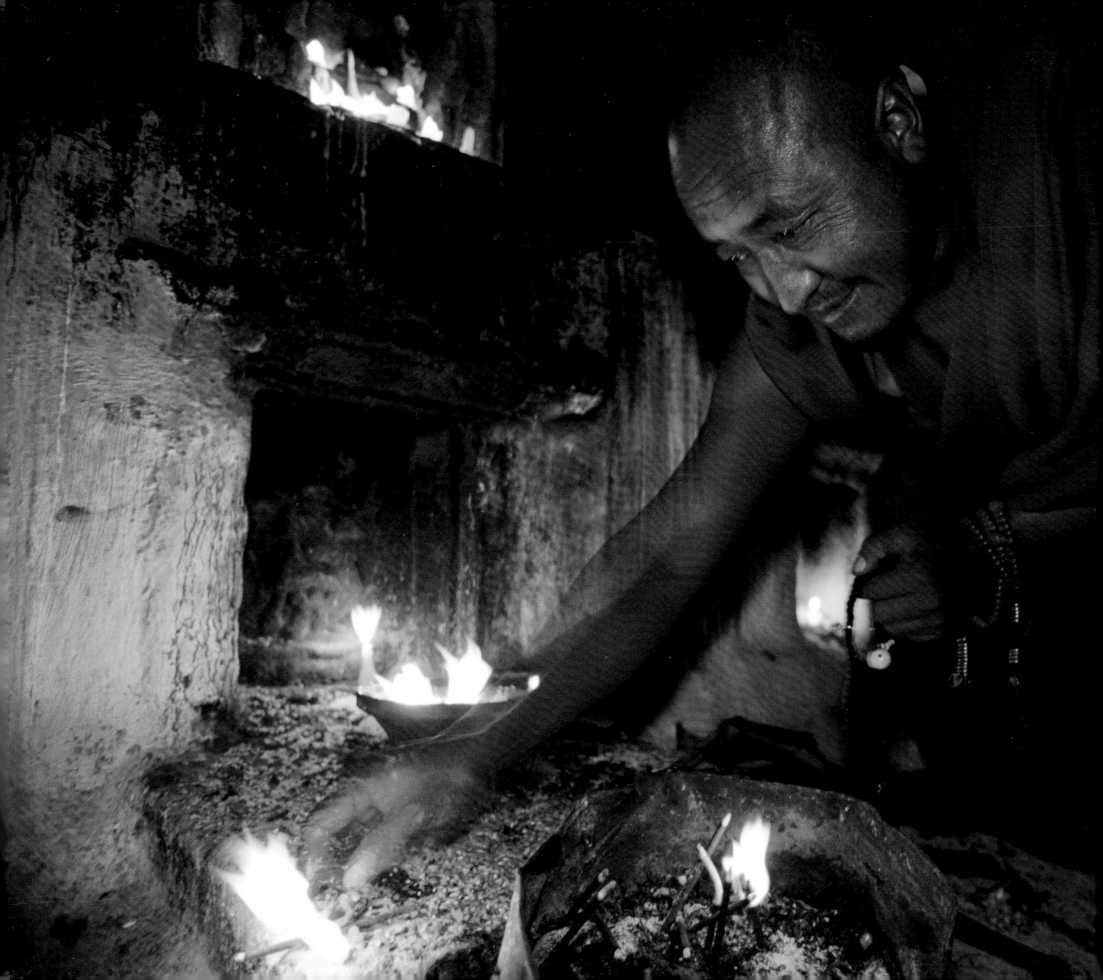

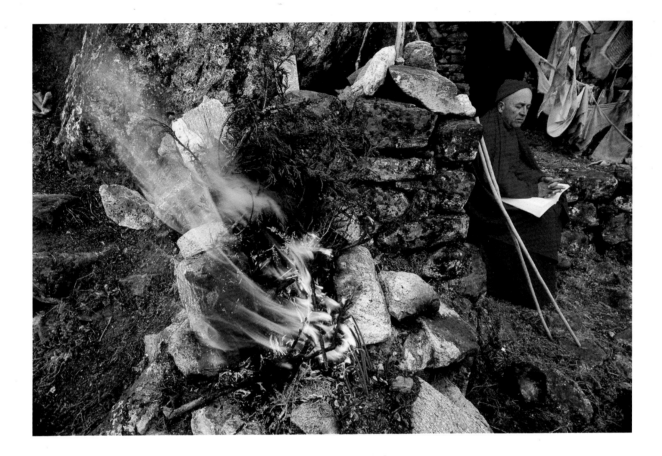

ABOVE: Matthieu Ricard, seen here chanting prayers, was a molecular biologist working in the laboratory of a Nobel laureate at the Pasteur Institute in France when one day he realized that there was no correlation between wealth, fame and happiness. So he returned to the Himalaya, the one place he had always been content, and became ordained as a Tibetan monk. Western science, Matthieu once remarked, has made major contributions but often to minor needs. We spend all of our lifetimes trying to live to be a hundred without losing our hair or teeth. The Buddhists spend their lifetimes trying to understand the nature of existence.

LEFT: A Tibetan monk lights butter lamps at the Boudhanath Stupa in Kathmandu. The Buddhists speak not of sin and judgment, good and evil, but only of ignorance and suffering, with all emphasis being on compassion. The goal is to dissolve through spiritual practice all the layers of delusion that conceal our deep and true Buddha nature. To seek happiness through worldly pursuits alone can never bring true inner peace. It is as hopeless, the Buddha observed, as casting a fish net into a dry riverbed.

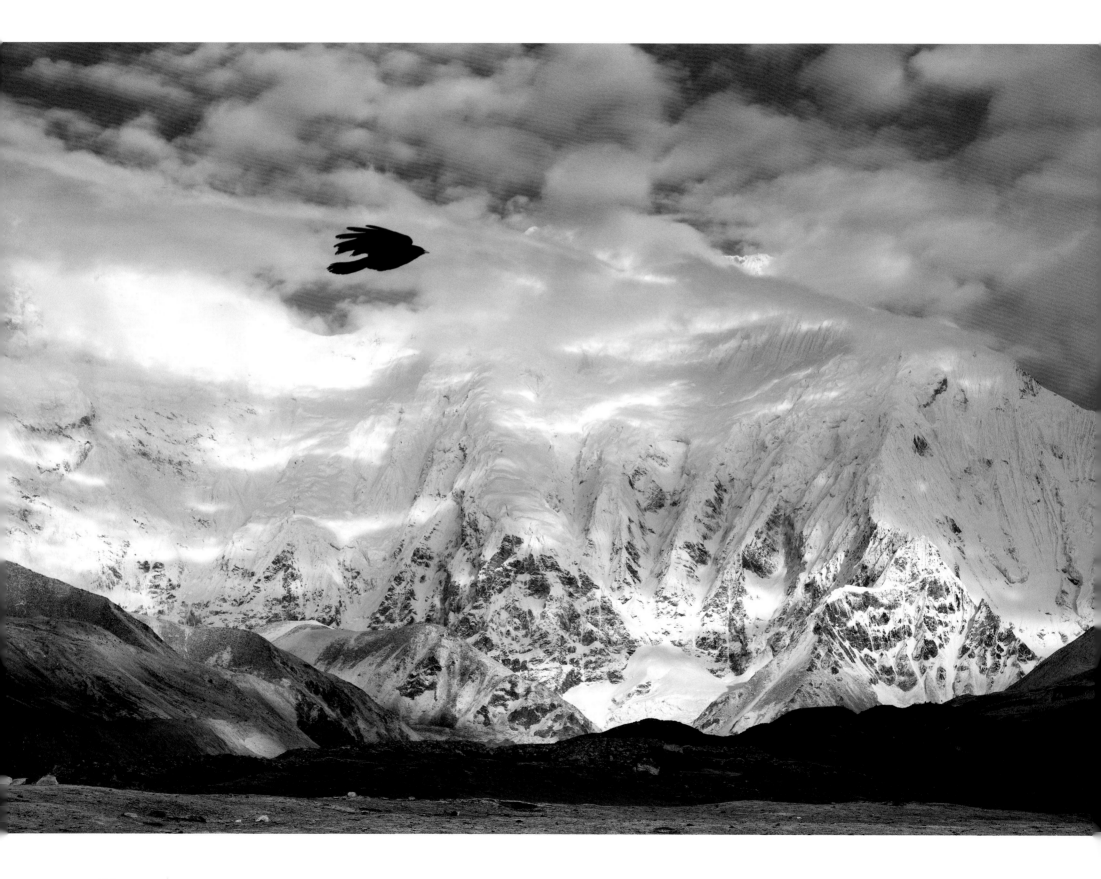

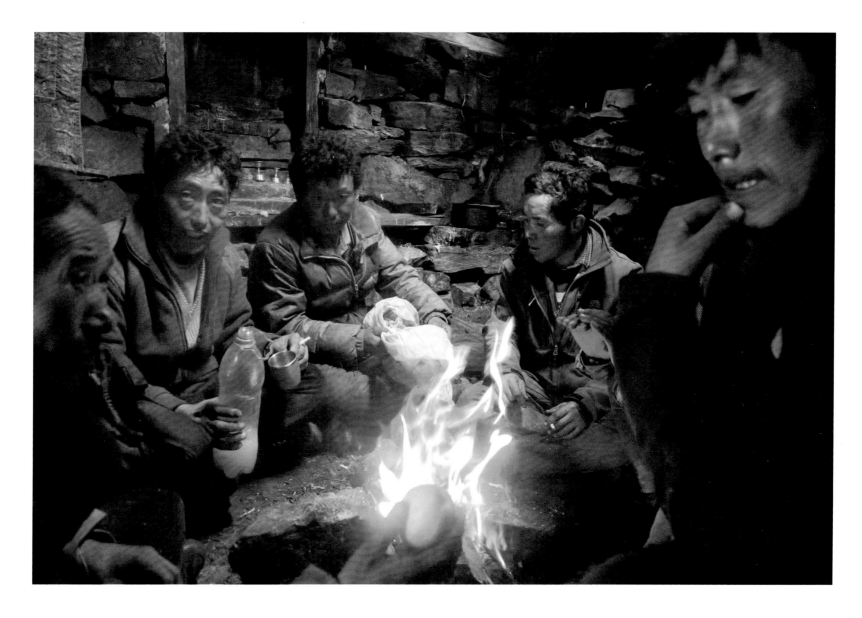

ABOVE: Yak herders take refuge in the cave of Guru Rinpoche. As Padmasambhava, deified as Guru Rinpoche, introduced the Buddhist teachings to Tibet in the eighth century, his wanderings were like prayers, his very presence a sign of the sacred imprinted on the landscape for all time. Along his path he planted sacred texts as spiritual treasures, even as he scattered throughout the Himalaya secret lands of fertility and blessings, mystical places known as beyuls, where simply to be born and to live was to be liberated from the endless cycle of life, death and rebirth.

LEFT: A yellow-billed chough flies directly above the South Col and the Kangshung Face of Chomolungma (Everest). The northern and southern approaches to the mountain are barren and stark. But from the east, passing through Kharta, there are three routes, all high passes, that lead to the Gama Valley, Khenbalung, one of the most sacred of beyuls and perhaps the most beautiful place in the Himalaya. Here the monsoon sweeps up the Arun Gorge from India, allowing silver firs the size of redwoods to grow not ten miles from Pethang Ringmo—meadows in the shadow of four of the tallest mountains on earth: Makalu, Chomolonzo, Lhotse and Chomolungma. There, standing on ground higher than any summit in Europe, one looks up at two vertical miles of ice rising to the South Col of Everest.

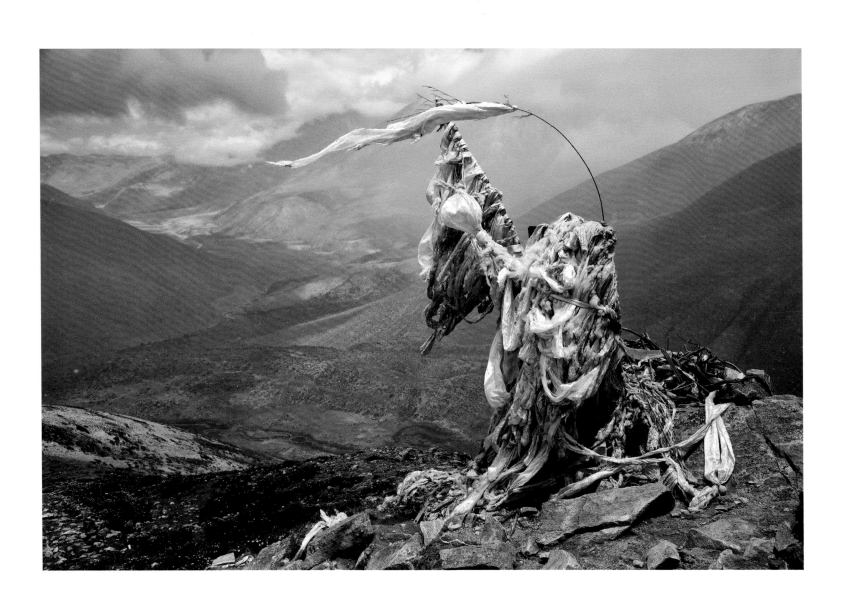

ABOVE AND RIGHT: Prayer flags mark a low pass on the route to the Chog La, the valley of the fifteen Turquoise Lakes, and the Samchung La, the most eastern of the three routes into the Gama Valley. Yak herders and pilgrims alike carry small stones as offerings to the guardians of the mountains, and at the major divides they pause to string prayer flags printed with mantras and images of the windhorse, generally in the colours of the five elements. Yellow represents the earth, green is for water, red for fire, white the air and blue for space or ether. With each flutter the prayers are carried to the universe. As Tibetans cross a divide they shout *Lha gyel-lo so so*, "May the gods be victorious." Every summit recalls the triumph of Guru Rinpoche, when he tamed the resident deities and quelled the malignant forces of the mountains.

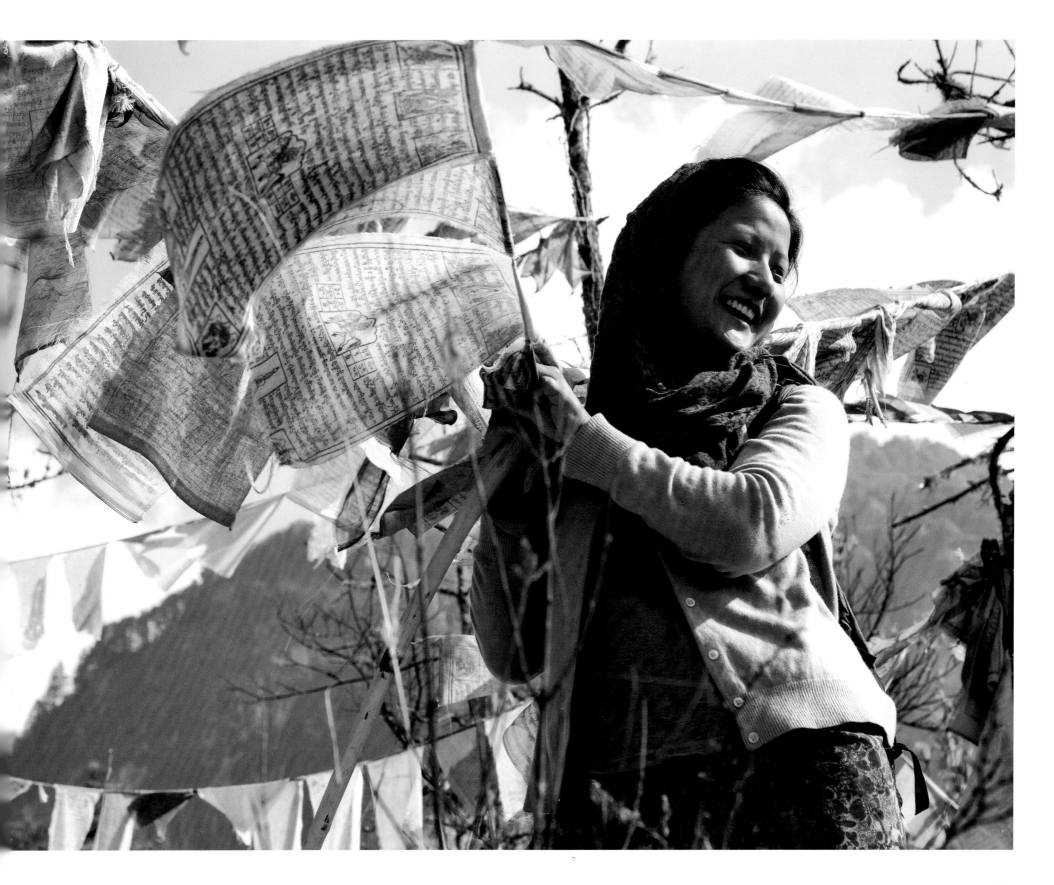

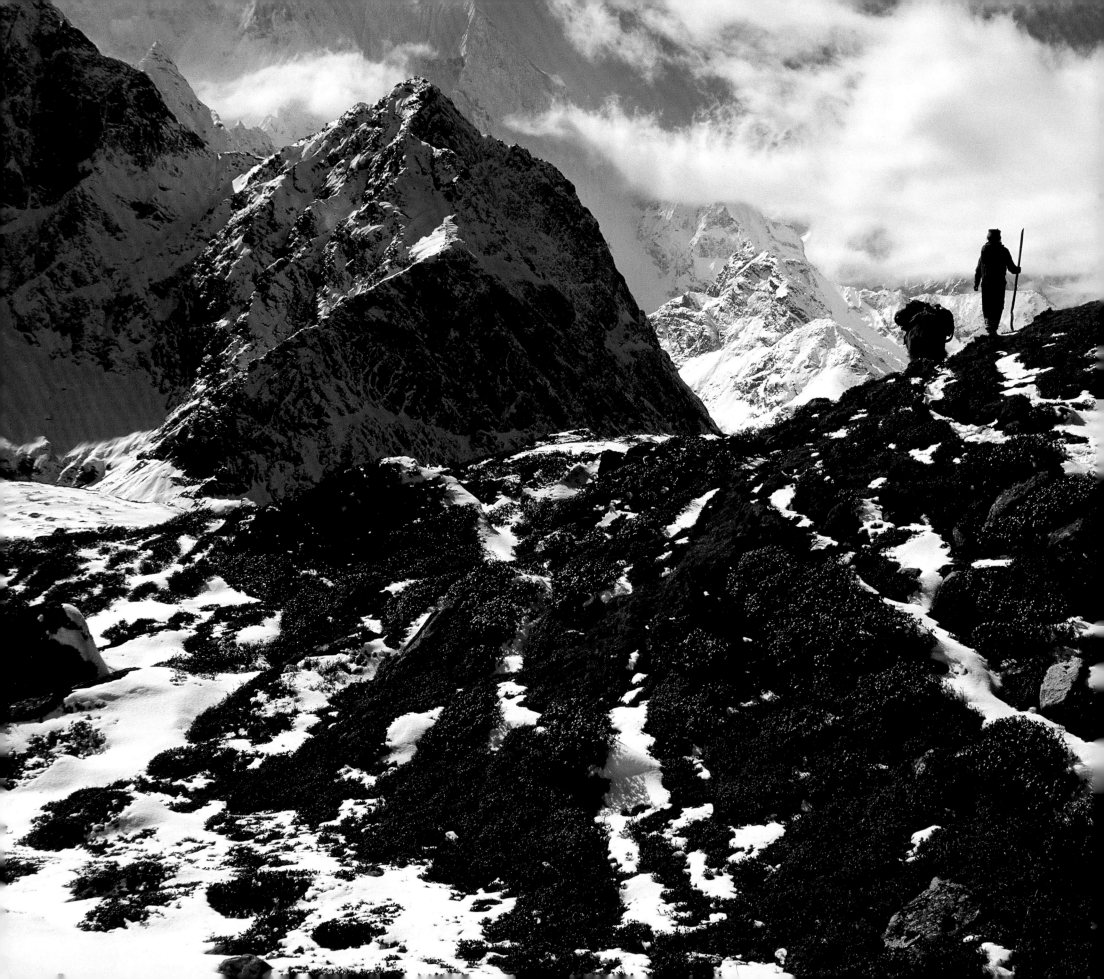

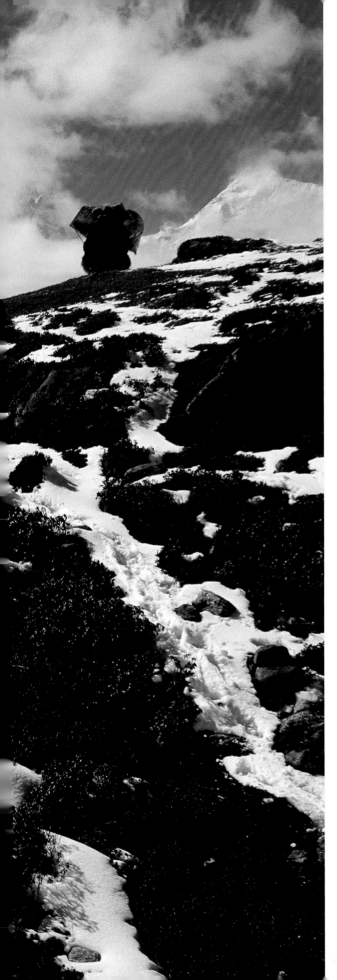

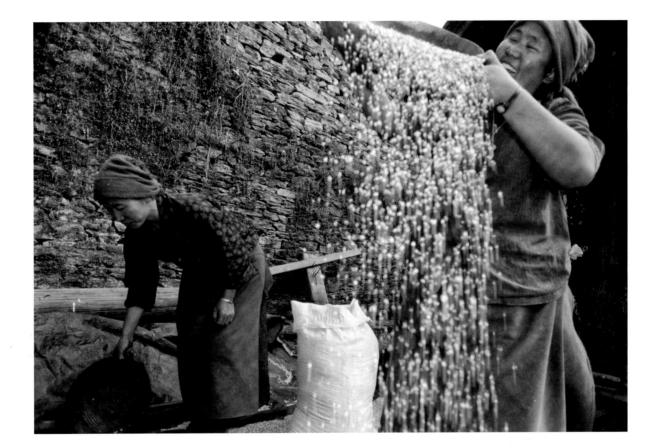

ABOVE: Nuns winnow barley at the Thubten Chöling Monastery in Nepal. When the 14th Dalai Lama was forced to flee to India in 1959, thousands of Tibetans followed him into exile. Trulshik Rinpoche, then abbot of the Rongbuk Monastery on the north side of Everest, led his entire spiritual community over the ice-clad, 23,000-foot Nangpa La, a pass that led to freedom in Solu Khumbu, Nepal, where in time they established Thubten Chöling.

LEFT: Tibetans saw the Gama Valley as one vast cosmic mandala, the points of which were defined by sacred peaks—the home of mountain deities—with the centrifugal heartland itself being a single Buddha energy field of such beneficence that merely to be there on the land was to know and embrace ever-deeper levels of compassion, wisdom and loving kindness. The waters of Khenbalung were said to cure all maladies of the mind, body or spirit. Women who drank from any of the hundreds of snowmelt streams of the valley became instantly more beautiful, certain to give birth to an unbroken line of descendants. Men became as strong as the mythical warriors of the ancient Tibetan kings, as swift and skillful as the most brilliant of birds. Plants knew no seasons and cured all diseases. Fruits and flowers were scented with the essence of the Buddha, the sweat from his skin. To meditate for one year in Khenbalung brought greater merit than what might be secured by a thousand years of prayer in any other land.

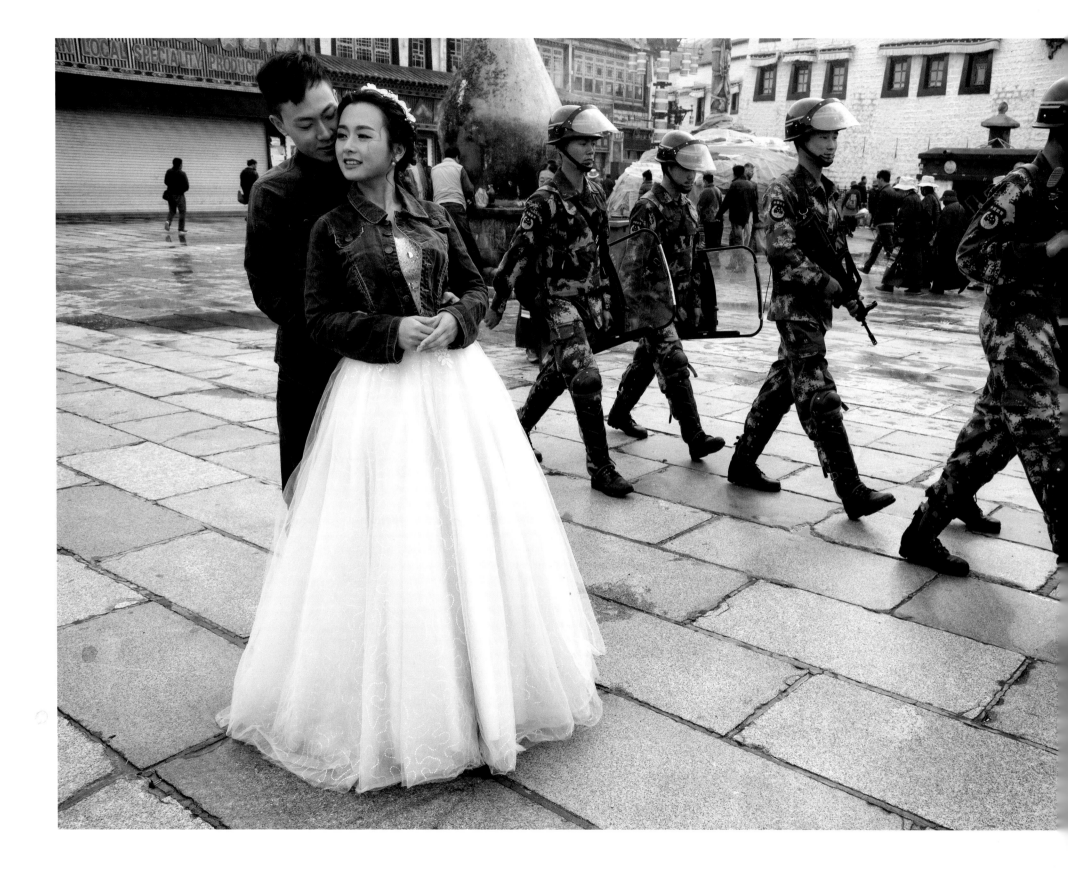

ABOVE: A Tibetan woman walks past a Chinese depiction of the Potala Palace, former seat of His Holiness the 14th Dalai Lama. In the Diamond Sutra, the Buddha cautions that the world is fleeting, like a candle in the wind, a phantom, a dream, the light of stars fading with the dawn. It is upon this insight that Tibetans measure their past and chart their future. They leave the rest of the world to ask how we could have allowed such a blast of sorrow to sweep through their land, and why to this day we continue to tolerate the wrath of China, even as it pursues the dismantling of Tibetan culture and the violation of a people and a nation that has given so much to humanity.

LEFT: In Barkhor Square in front of the Jokhang Temple, the most holy site of Tibetan Buddhism, a couple celebrate their marriage while a Chinese military patrol marches by. Mao Zedong bears the dark distinction of being the political leader most successful in killing his own people. When Mao famously whispered into the ear of a young Dalai Lama that all religion was poison, the Tibetan spiritual leader knew what was coming. In 1959 the People's Liberation Army marched into Lhasa, intent on the destruction of the Tibetan Buddhist tradition. Ideological fanaticism reached a watershed during the Cultural Revolution, unleashed by Mao in 1966. Create the new by smashing the old—this was the official slogan. Tibet exemplified the old, China the new. Thus the Cultural Revolution both implied and demanded a total assault on every facet of Tibet's ancient civilization. Over a million Tibetans were killed, and in time six thousand monasteries and religious monuments were reduced to rubble.

THE SHELTERING SKIES OF AFRICA

IN EAST AFRICA SURVIVING DROUGHT IS THE GREAT CHALLENGE for all pastoral nomads such as the Masai, Samburu and Rendille. The key is to maintain herds large enough that in the event of severe loss at least some animals will survive, providing living capital from which the wealth of the family can be rebuilt. To a great extent, this adaptive imperative determines the structure of the society; it makes the people who they are.

To maintain large herds it is useful for a patriarch to have large numbers of children, and thus these societies are typically polygamous. But when men take multiple wives, the challenge arises of what to do about the virile young men of marriageable age who may not find partners to marry. The elders solve this problem essentially by getting rid of the young men—dispatching them for a period of ten years to remote encampments where they are charged with protecting the herds from enemy raiders. To make this separation desirable, it is enveloped in prestige.

The greatest event of a young man's life—a ritual for which he trains for months—is his public circumcision, marking his entry into the privileged world of the warrior. The ceremony is held only once every fourteen years, and those who endure it together are bonded for life. Should a lad flinch as the nine slits are made to the foreskin, he will shame his clan forever. But few fail, for the honour accorded his stoicism is immense. Transformed physically, socially and spiritually the warriors move to the open plains and grasslands where they live together on a diet of herbs mixed with milk and blood drawn each night from the jugular of a heifer.

Still there remains the problem of the human libido. To resolve this dilemma the warriors are allowed to return periodically to the community, provided they go nowhere near the married women. They are, however, permitted to approach unmarried maidens. Premarital sexual liaisons are open and tolerated until the moment the young woman is betrothed to an elder, at which time the relationship must cease. But the warrior is encouraged, and indeed expected, to attend the wedding of his former lover and publicly mock the virility of the old man who has taken his place at his lover's side. Thus a single adaptive challenge, surviving drought, reverberates through the entire culture, defining for these nomadic tribes what it means to be human.

Dusk in the Ngorongoro Crater, Tanzania, with hippos in the water and marabou storks silhouetted in an acacia tree.

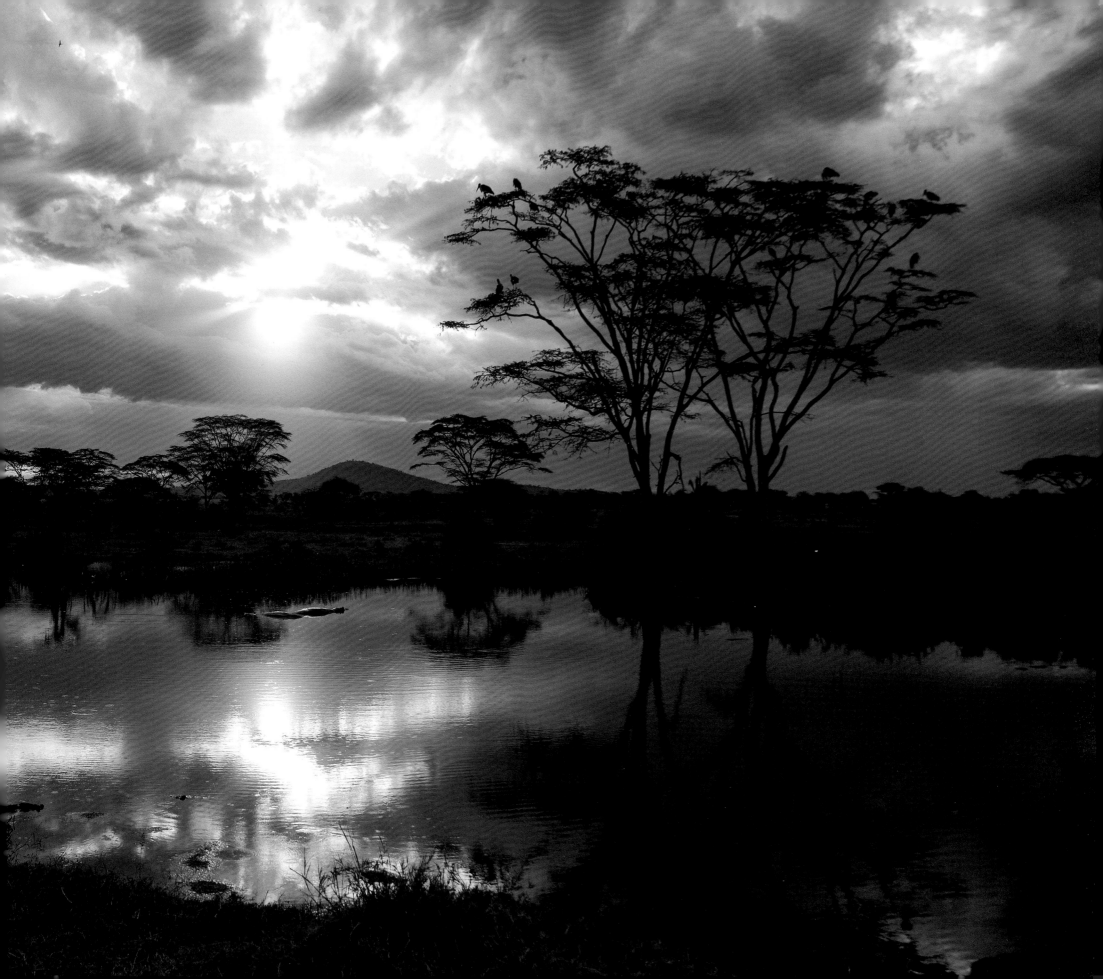

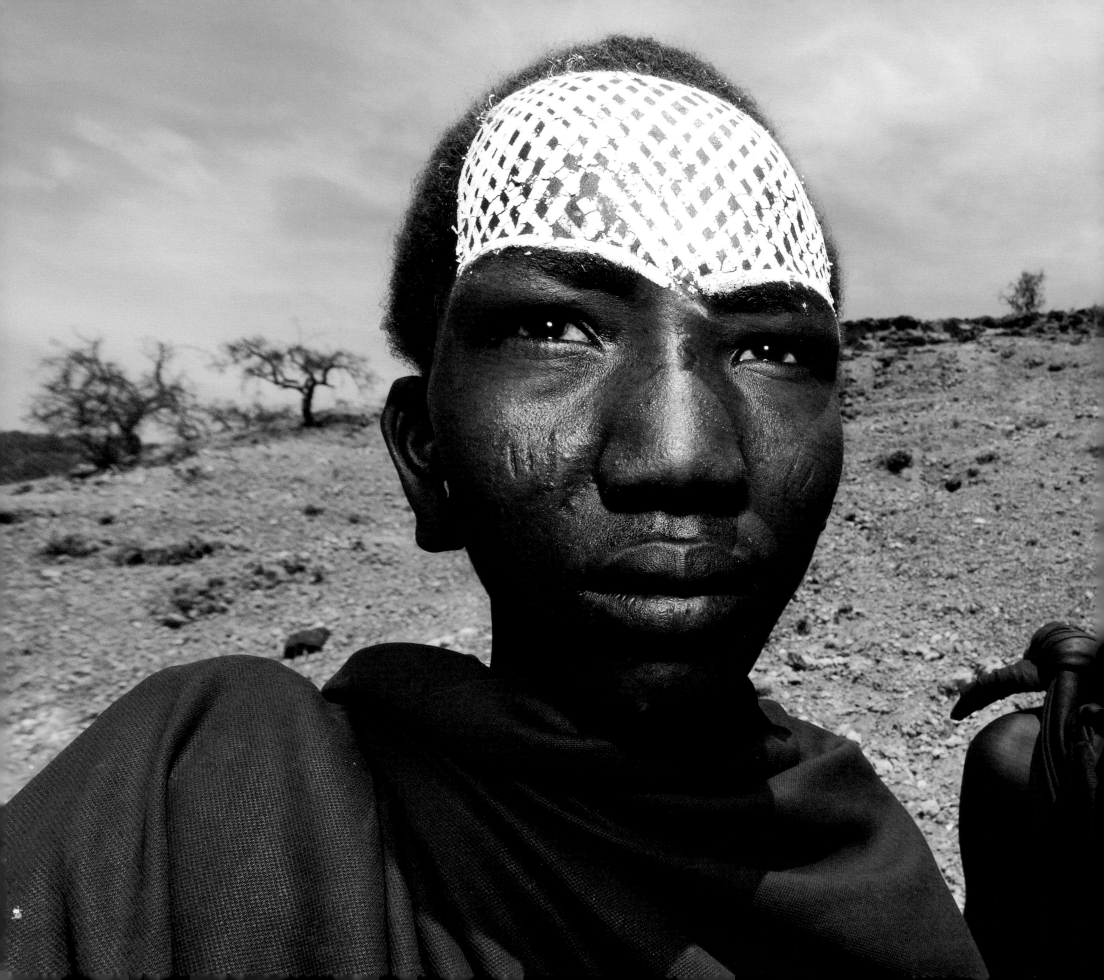

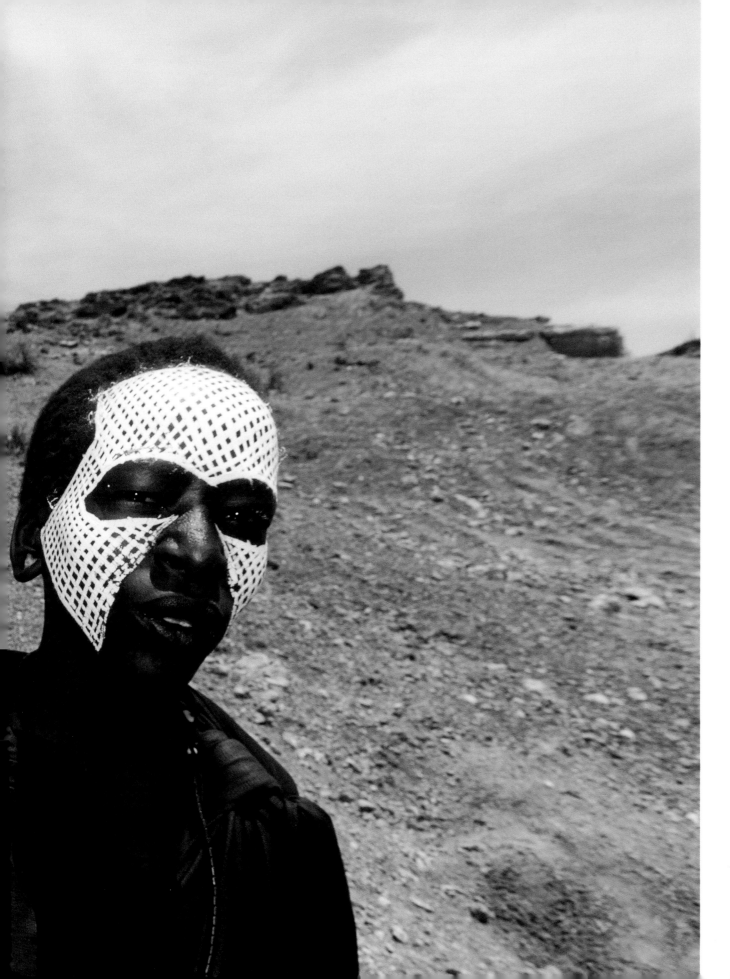

These Masai initiates in Olduvai Gorge, Tanzania, stand near the very spot where Mary Leakey in 1959 found *Zinjanthropus boisei*, the hominid remains that along with other fossil discoveries convinced paleoanthropologists that humans had indeed evolved in Africa.

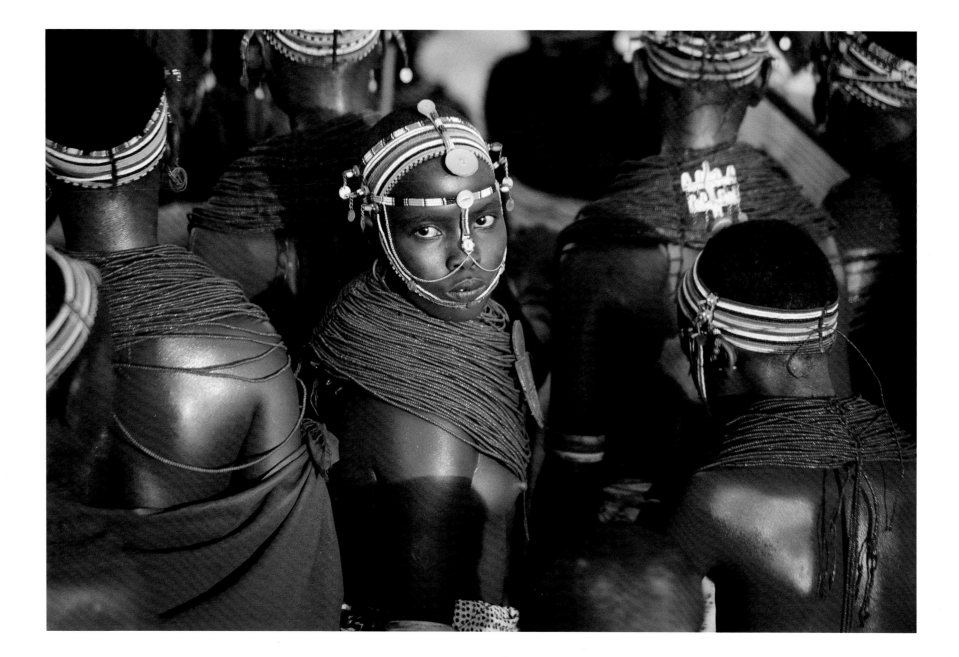

ABOVE: Young women gather at sunset on Marsabit Mountain, Kenya. From the shadows emerge the warriors, tall and thin, their long hair woven in tight braids dyed red with ochre and fat. Their songs attract the young girls, equally beautiful in beads and ochre. The warriors move forward, slapping the girls with their hair and leaping into the air, their spears flashing in the sunlight. The singing and dancing last long into the night. With the end of the rains, grass is abundant and milk plentiful. It is a time of great joy, a season of celebrations.

RIGHT: An Ariaal warrior on Marsabit Mountain embodies the notion that culture is never static. The Ariaal are descendants of a splinter group of Rendille, camel herders from the Kaisut Desert, who adopted the ways of the cattle-raising Samburu tribe. They became a fusion of the two, speaking both languages and celebrating the traditions of each people. As Kenyans say, the Ariaal have the bones of Rendille and the flesh of the Samburu.

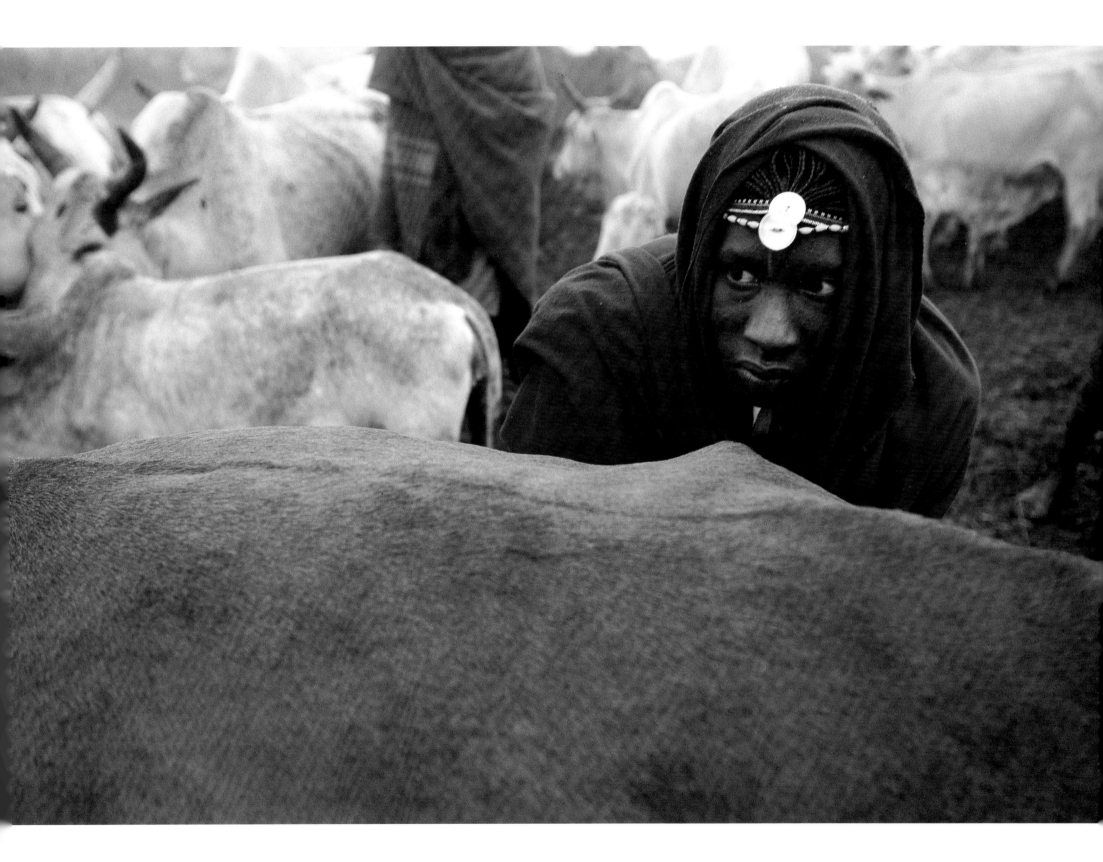

ABOVE AND RIGHT: Living today in the searing sands of the Kalahari—55,000 strong scattered across Botswana, Namibia and southern Angola—the San have long been considered the descendants of a people who at one time inhabited the entire subcontinent and much of East Africa. Displaced by successive waves of agriculturalists and pastoral herders they survived as nomadic hunters and gatherers, men and women whose precise and exacting knowledge allowed them to survive in one of the most forbidding desert landscapes on earth. This extraordinary body of adaptive information, this intellectual toolbox, is encoded in the words and sounds of a native tongue that is a linguistic marvel—a language totally unrelated to any other known family of languages. In everyday English we use 31 sounds. The language of the San has 141, a cacophony of cadence and clicks that many linguists believe echoes the very birth of language. Indeed the genetic data suggests that the San were the first people in what became the family tree of humanity. If the Irish and the Lakota, the Hawaiian and the Maya are the branches and limbs, the San are the trunk, and quite possibly the oldest culture in the world. When the rest of us decided to travel, the San elected to stay home.

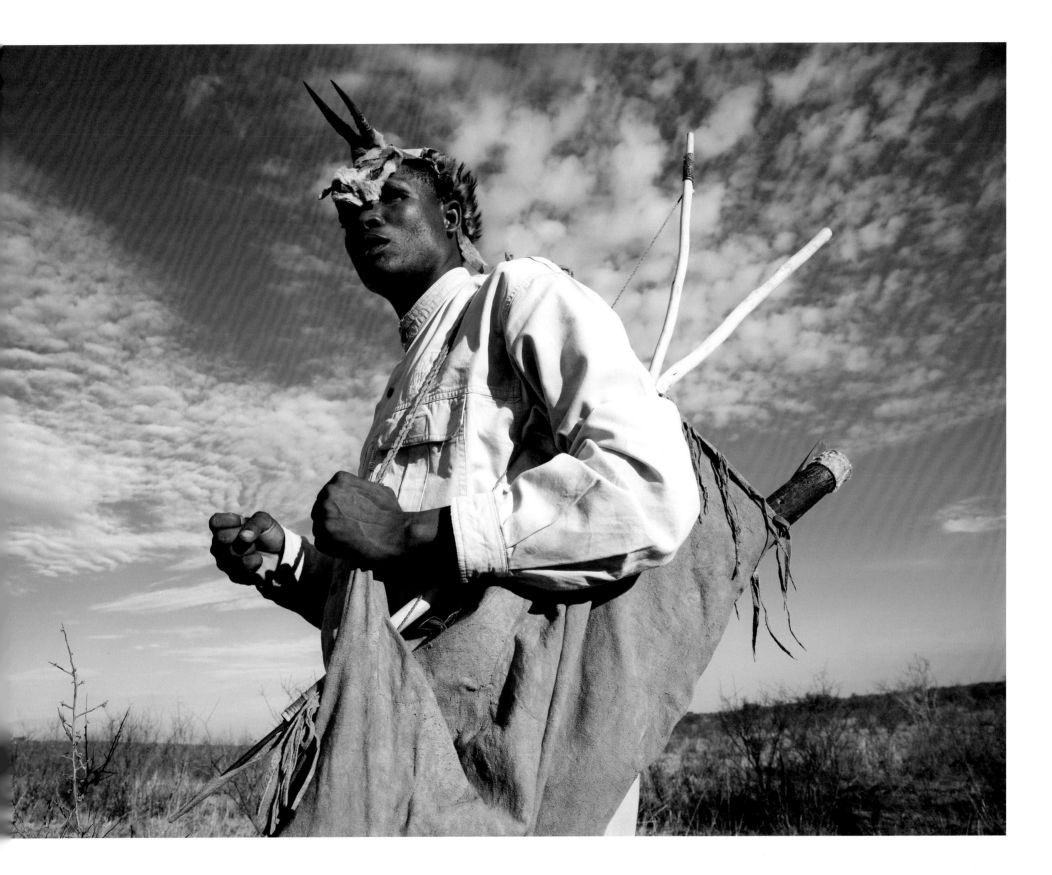

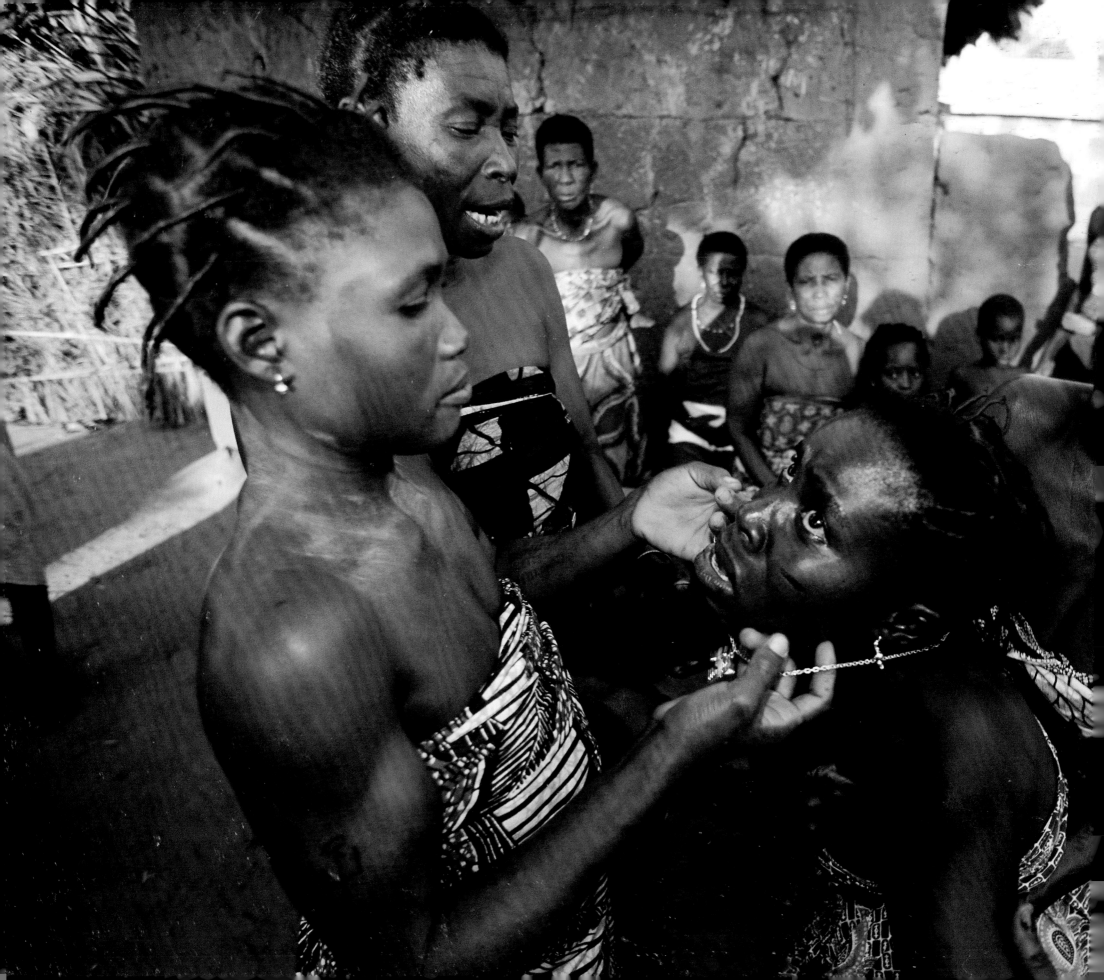

IN LISTS OF THE GREAT SPIRITUAL TRADITIONS OF THE WORLD one region is usually left out: equatorial West Africa. The assumption is that Africans south of the Sahara had no religion, but of course they did. Vodoun, too often cruelly dismissed as a black magic cult, is a Fon word meaning simply "spirit" or "god." Like all metaphysical world views it addresses the relationship between humans, nature and the supernatural forces of the universe, fusing the unknown to the known, creating order out of chaos, rendering the mysterious intelligible.

The essence of Vodoun is a sacred cycle of life, death and rebirth. For the acolyte, death is feared not for its finality but as a crucial and vulnerable moment in which the spiritual and physical components of the individual separate. A year and a day after a death the spirit of the deceased is ritualistically reclaimed by a priest and placed in a protective vessel. That soul, initially associated with a particular relative, in time becomes part of a vast pool of ancestral energy from which emerge the archetypes, which are the individual spirits of the Vodoun pantheon.

To the African this reclamation of the dead is considered as fundamental and inescapable as birth itself. One emerges from the womb an animal. Spiritual birth at initiation makes one fully human. But it is the fusion with the gods that marks one's transition to sacred essence. Possession—the return of the spirits to the body—completes the sacred cycle: from human to ancestor, ancestor to cosmic principle, principle to personage and personage returning to displace the identity of man or woman.

Believers not only have direct access to the spirits, they actually receive the gods into their bodies. They are as horses mounted by the divine. Spirit possession is by no means a pathological event. On the contrary, it is the manifestation of divine grace. As West Africans often say, "White people go to church and speak about God; we dance in the temple and become God."

A woman is taken by the spirit in the small village of Ouatchi on the tablelands of central Togo. In a state of trance one becomes a god and the gods can never be harmed. Worshippers demonstrate the power of their faith by rolling about on cactus spines or by placing burning embers into their mouths with impunity, an astonishing example of the mind's ability to affect the body when in a state of spiritual ecstasy.

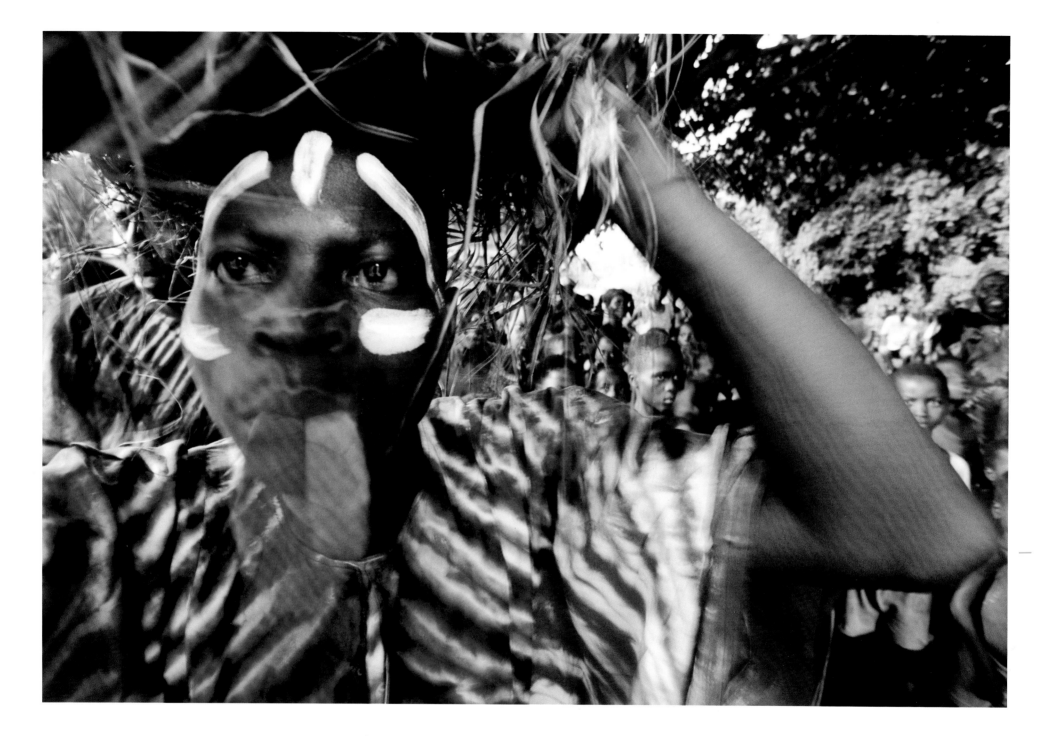

Throughout West Africa secret societies remain the most powerful arbiter of political and social life. In a tradition dating back to the fifteenth century the Yoruba people once a year come by the thousands to Cové, Benin, to bear witness as masked men of the Gelede Society for one day give form to immorality, mimicking licentious behaviours that are normally quite unacceptable only to subject them to public ridicule. By making the forbidden appear foolish and idiotic, they effectively reinforce what is proper and moral. The goal ultimately is to honour virtue, motherhood and the creative power of women, especially Nla, the first female of the Yoruba.

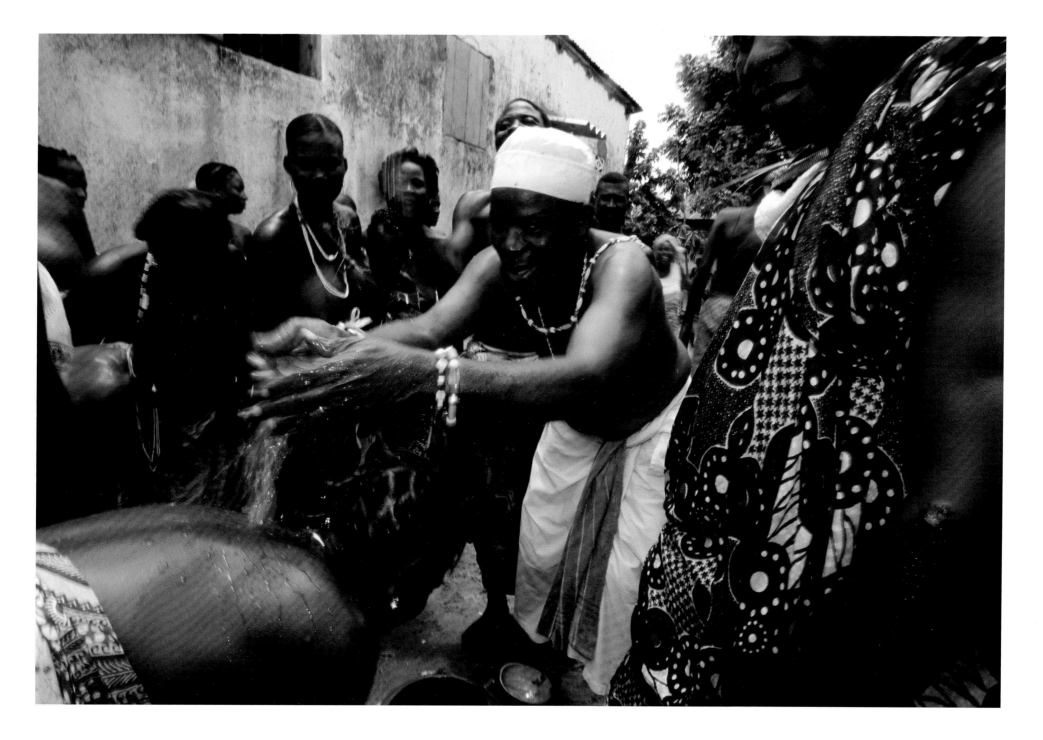

At the Epe-Ekpe celebration, an annual festival marking the beginning of the New Year for the Guen Kingdom of Togo, a priest passes healing waters over the bodies of supplicants. Vodoun embodies not only a set of spiritual concepts but a way of life, a code of ethics that regulates social behaviour. Just as one speaks of a Christian society, one can refer to a Vodoun society, within which one finds completeness: art and music, traditional medicine, education based on the oral transmission of knowledge and a system of justice derived from indigenous principles of conduct and morality.

ABOVE: Throughout the world education is celebrated. But too often children from tribal societies are dispatched to poorly equipped schools where they acquire certain skills and a modicum of literacy, but in an atmosphere that teaches them to have contempt for their families and cultural traditions. Caught between worlds, ashamed to go back and with no clear path forward, they have little choice but to drift to the cities and scratch a living from the edges of the cash economy.

RIGHT: A young girl joins her mother and aunts at the Epe-Ekpe. In a ceremony that dates to 1663 thousands gather in the village of Glidji and watch in trepidation as the priests enter a forbidden forest and return with a sacred stone, the colour of which reveals the promise of the coming year. Blue or white is cause for rejoicing, as rains and harvests will be abundant. Red or black warn of famine, disease and drought. As the good news is unveiled, jubilant men and women by the hundreds spin into a trance.

A SEA OF SAND

THE ANCIENT CITY OF TIMBUKTU, located just north of the great bend of the Niger River, was for centuries a thriving port on the sea of sand that is the Western Sahara. At a time when Paris and London were small medieval towns it was a thriving centre of Islamic culture, with 150 schools and universities, and some 25,000 students studying astronomy and mathematics, medicine, botany, philosophy and religion. The knowledge of the ancient Greeks survived to inspire the Renaissance only because it had been recorded and preserved by great Islamic scholars such as Avicenna, whose writings informed St. Thomas of the existence and philosophy of Aristotle. Until the discovery of the New World two-thirds of Europe's gold came from Africa, carried overland for fifty-two days across the Sahara from Timbuktu to Morocco. Out of the desert too came great slabs of salt, imbued with magical healing properties so valued that salt traded ounce for ounce with the gold of Ghana. Until an Arab boy endured the thirst and privation of a desert crossing he could not marry or be considered a man. The Tuareg people say that in the endless ocean of sand a young man realizes that there is something greater than himself, that he is but a small particle in the universe and that there is a higher being regulating the world. Thus is awakened a thirst for seeking. As the Tuareg travel to the salt they evoke the blessed names of God. The desert hones their devotion.

An imam about to lead sunset prayers stands outside the Great Mosque of Djenné, Mali. Built in 1907 during the French colonial administration, it occupies the site of a mosque originally constructed in 1240 by the sultan Koi Kunboro. For three centuries Djenné was a vital religious and trading centre of the kingdoms of Mali and Songhai, the greatest empires in the history of sub-Saharan Africa.

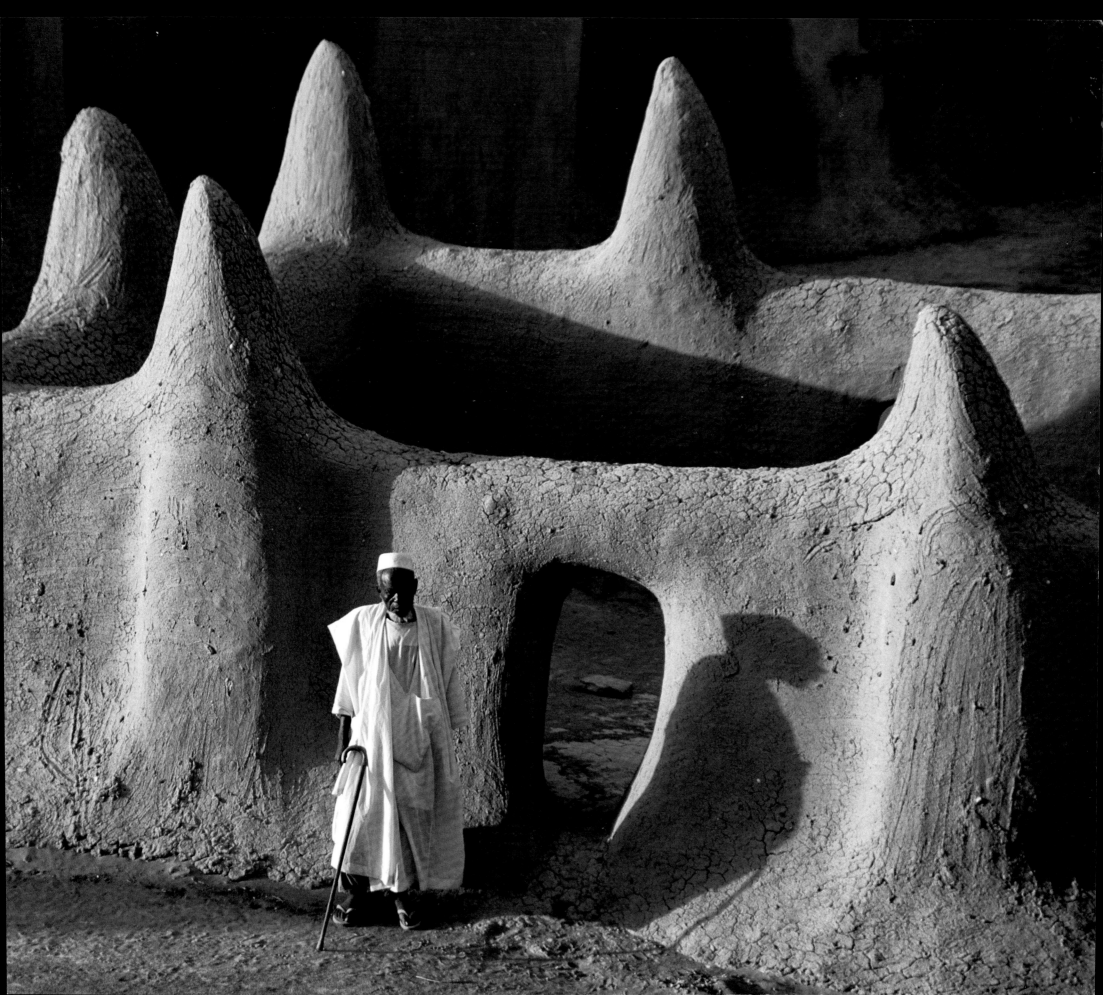

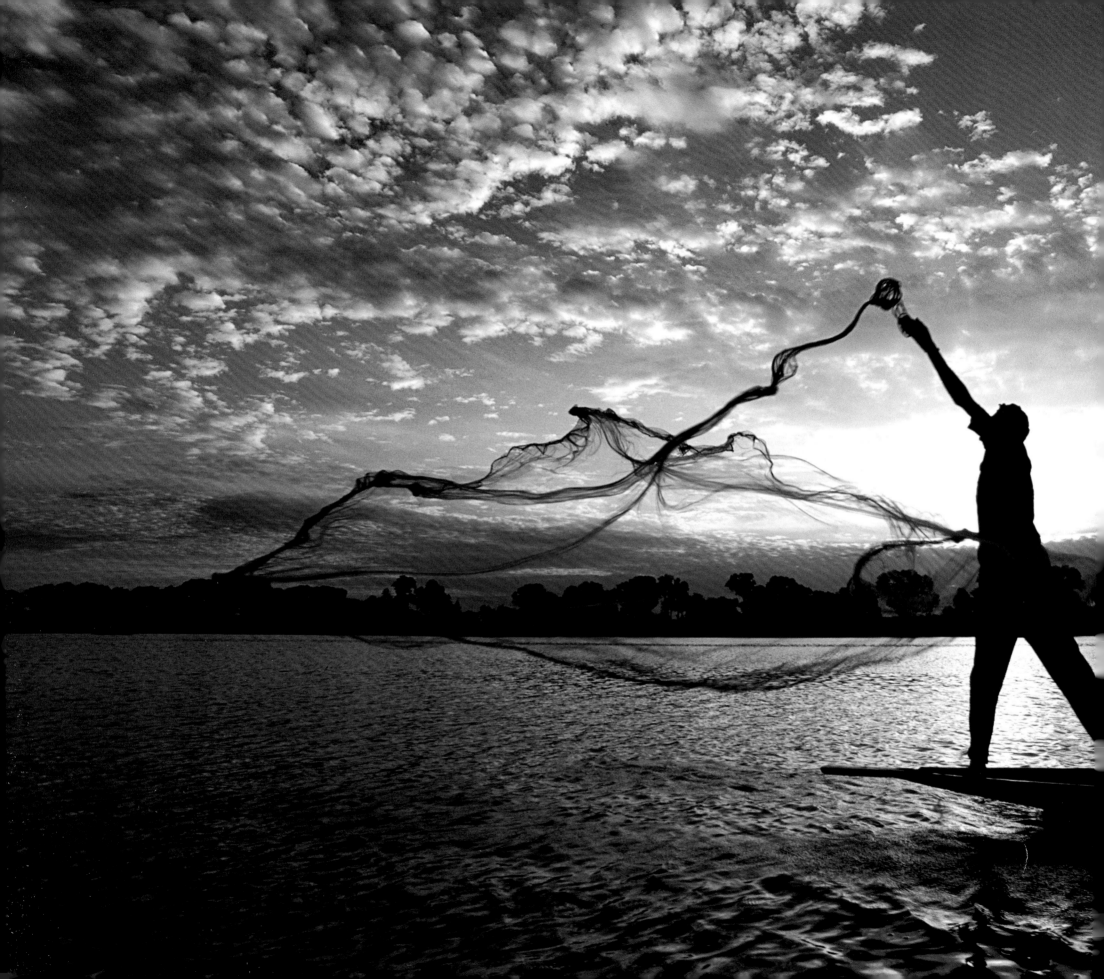

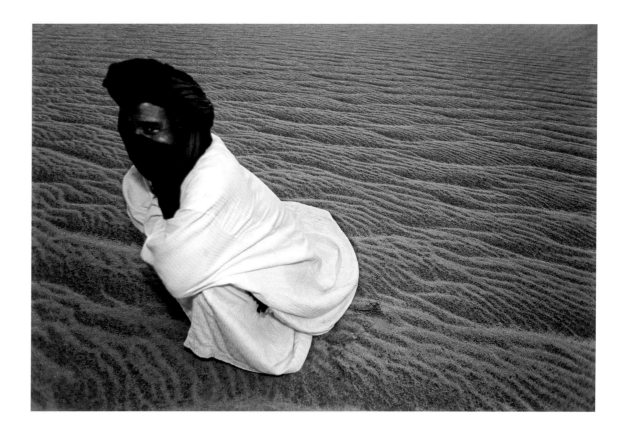

ABOVE: To navigate in the Sahara a Tuareg guide takes notice of the orientation of the dunes; the colour, texture and smell of the sand; the patterns of wind made in the lee of desert plants. Asked whether he had ever been lost this man replied that orientation in the desert was a gift given to few and that if he ever was uncertain, he simply sat still and waited for a sign from Allah.

LEFT: A fisherman at dawn casts a net on the Niger River, just off the shore of the port town of Mopti, Mali.

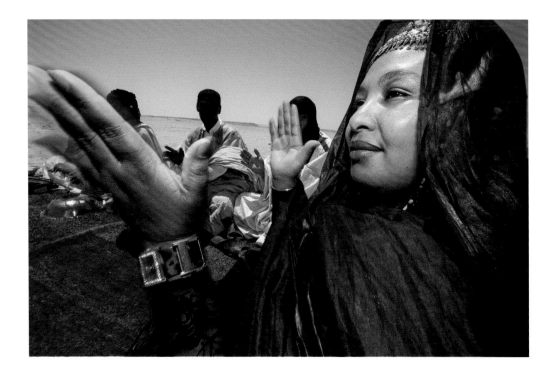

ABOVE: Women of the Sahrawi, a nomadic Bedouin people of the Western Sahara, defy many of the clichés about gender in Islamic cultures. Free and independent they exercise considerable power and influence in both public and private life.

RIGHT: A man kneels in prayer in one of the great mosques of Timbuktu. The town remains the repository of thousands of ancient manuscripts dating to a time when the city rivalled Damascus, Baghdad and Cairo as one of the great centres of Islamic culture and learning. One can cradle in one's hand a document embossed in gold and copied in the thirteenth century from an Avicenna manuscript written in the year 1037.

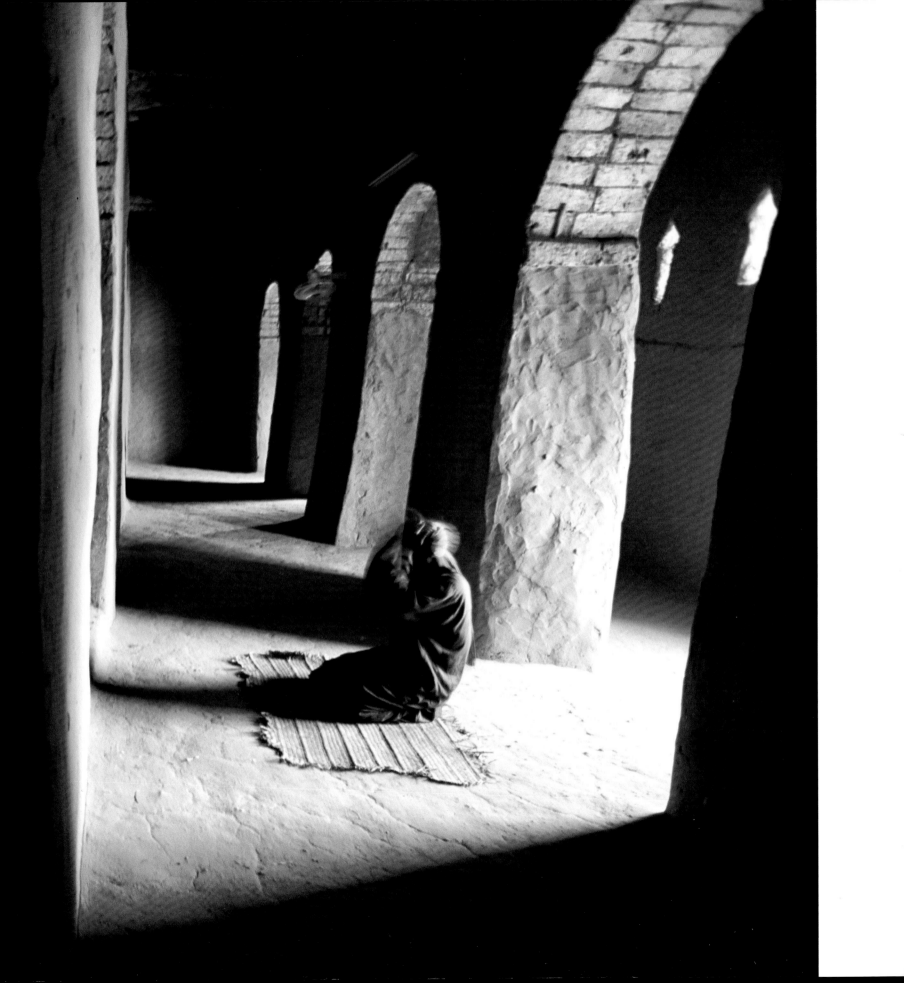

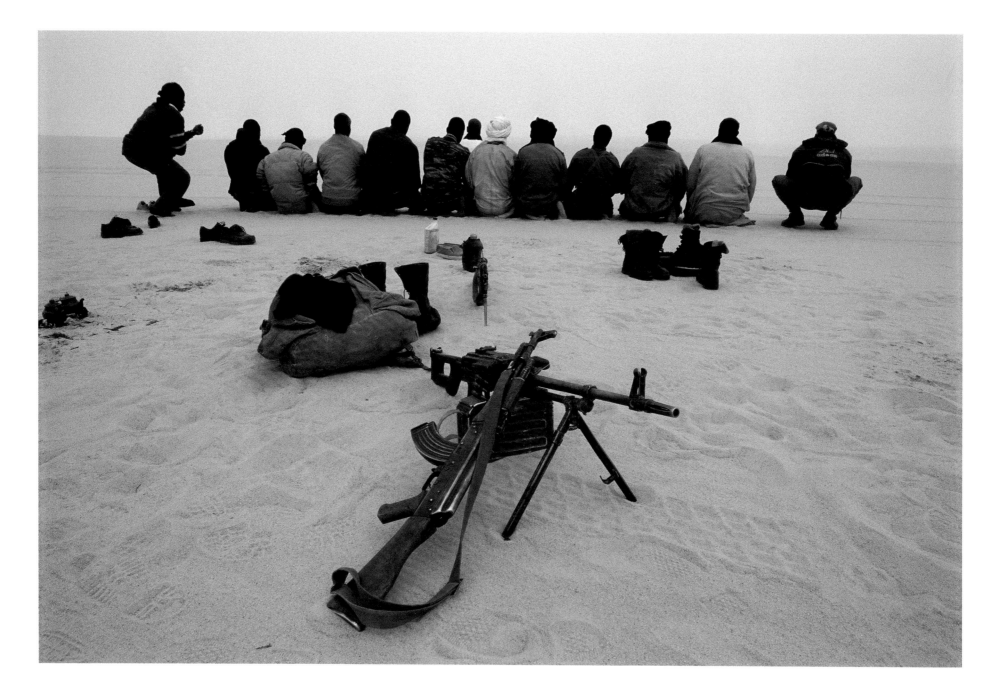

In the Sahara men turn to Mecca in prayer. Islam's appeal is in part its devotional simplicity. To embrace the religion one must honour its five pillars: faith, fasting, prayer, charity and participation in the Haj, the pilgrimage to Mecca. In the desert with water only for drinking, men wash their hands and faces with sand before kneeling in prayer.

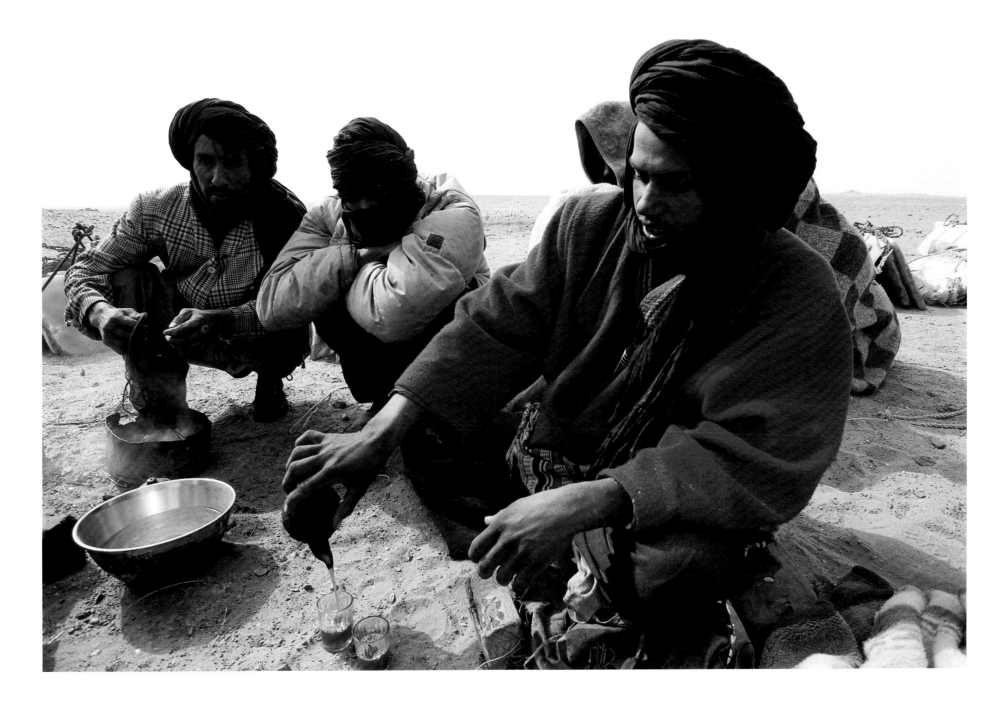

A camel caravan, forced to stop in the wake of a freak storm to dry out their cargo of salt, have lost three precious days and are down to their last quart of water. As we came upon them they immediately kindled a twig fire and brewed us tea. It is said in the Sahara that if a stranger turns up at your tent you will slaughter the last goat, which provides the only milk for your children, to feast your guest. One never knows when you will be that stranger turning up in the night, cold and hungry, thirsty and in need of shelter.

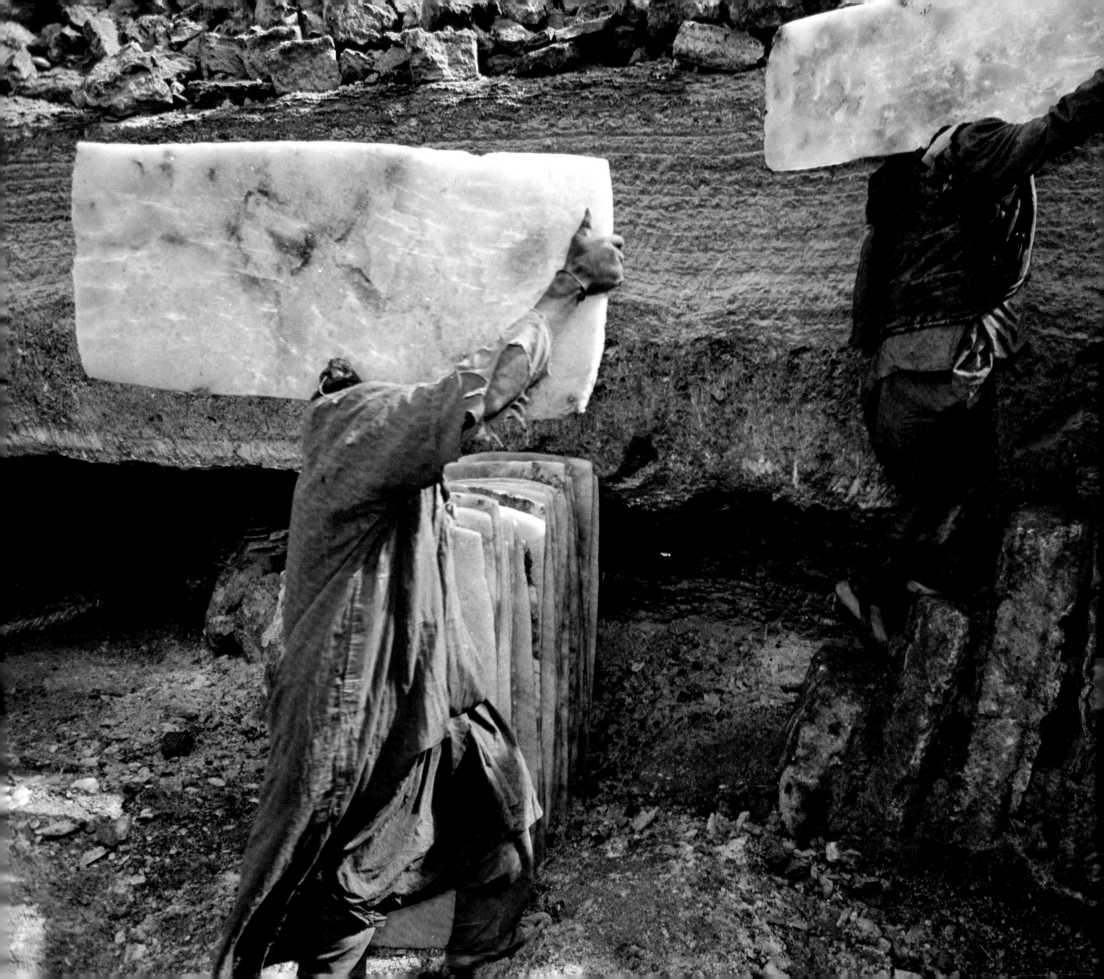

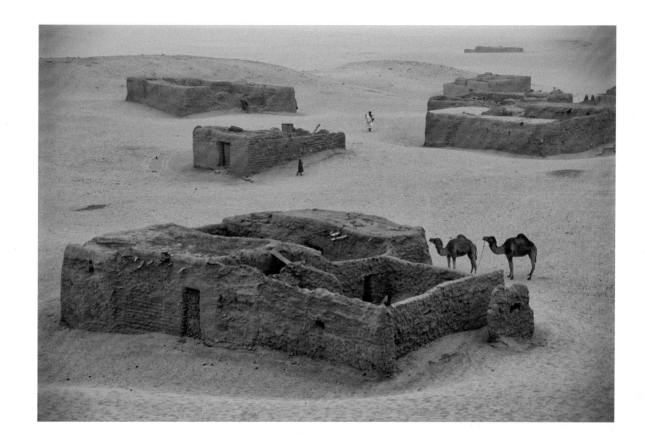

ABOVE: The small settlement of Araouane is but a cluster of shelters 150 miles north of Timbuktu. From here going north there is only desert. Without food one can live for weeks; without water mere days. In the desert, without water, delirium may come in an evening and by morning one's mouth is open to the wind and sand, even as the eyes sink into another reality and strange chants echo from the lungs. The truck smugglers of the Sahara say that the good thing about brake fluid is that it keeps you away from the battery acid.

LEFT: The salt of Taoudenni, an ancient mine some 400 miles north of Timbuktu, was the gold of the Sahara, valued throughout West Africa for its curative properties. Until a Tuareg or Tamashek boy crosses the desert to and from the mine, twenty days each way by camel, enduring thirst and privation, he could not marry or be considered a man. The journey was a test of strength, a physical and spiritual transformation that left the child a master of his senses.

RIGHT: In the Medina in Marrakech a worker tends the fire that creates the steam for a traditional *hammam*, or Turkish bath.

OPPOSITE: In the souk of Marrakech a musician of the Gnawa people, North Africans of sub-Saharan origins, plays a sinter, a three-stringed lute. The camel skin stretched across the body of the instrument is like the membrane on a banjo. The lowest string is a drone note and the second string, the highest in pitch, is tuned an octave higher. The third is tuned a fourth above the drone. A buzzing sound can be created by dangling metal rings off the metal feather attached to the end of the neck.

THE GREATEST CULTURE SPHERE EVER BROUGHT INTO BEING by the human imagination is Polynesia, an eighth of the surface of the planet, tens of thousands of islands flung like jewels upon the southern seas. Even today Polynesian sailors can name 250 stars in the night sky. Their navigators can identify the presence of distant atolls beyond the visible horizon simply by watching the reverberation of waves across the hull of the canoe, knowing that every island group in the Pacific has its own refractive pattern that can be read with the ease with which a forensic scientist reads a fingerprint. Sitting alone in the darkness they can sense as many as five distinct swells moving through the vessel at any given time, distinguishing those caused by local weather disturbances from the deep currents that pulsate across the ocean and can be followed as readily as a terrestrial explorer would follow a river to the sea. Indeed if you took all the genius that allowed us to put a man on the moon and applied it to an understanding of the ocean, what you would get is Polynesia.

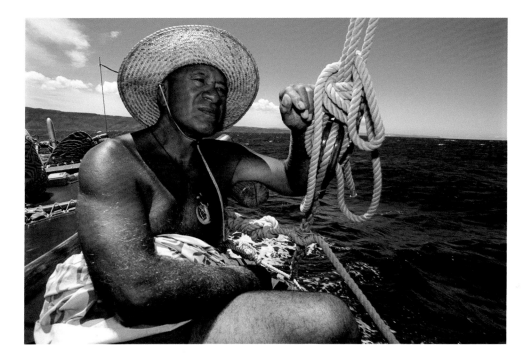

ABOVE: Traditional Polynesian navigation was based on dead reckoning: they only knew where they were by remembering precisely how they got there. Thus over the course of a long ocean voyage the wayfinder, or navigator, without benefit of the written word, had to remember every shift of wind, speed and current, every sign of the stars, moon and sun. It was the difficulty of dead reckoning that led most European sailors to hug the shores of continents, until the British solved the problem of longitude with the invention of the chronometer. Yet ten centuries before Christ the ancestors of the Polynesians sailed east into the rising sun, and in but eighty generations settled virtually every island group of the Pacific.

LEFT: The *Hokule'a*, named after the sacred star of Hawaii, is a replica of the great seafaring canoes of ancient Polynesia. Launched in 1975 it has since crisscrossed the Pacific, visiting virtually every island group of the Polynesian triangle, from Hawaii to New Zealand, and south and east to Rapa Nui, or Easter Island. On board is not a single modern navigational device. There are only the multiple senses of the navigator, the knowledge of the crew and the pride, authority and power of an entire people reborn.

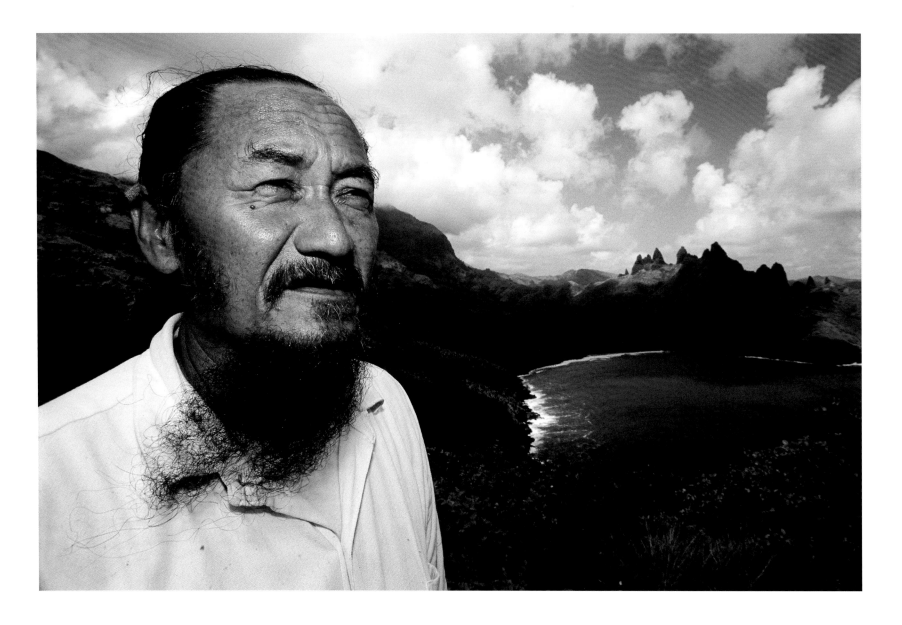

ABOVE: The entire mountain landscape of Nuku Hiva, the largest island in the Marquesas—seen here behind Alphonse Puhetini, a cultural expert from the village of Hatihe'u—was transformed with terraces, irrigation systems and great pits capable of storing an eight-month supply of breadfruit, enough food to allow the entire population of 100,000 to survive the most devastating of typhoons. When European diseases killed up to 85 per cent of the people on the Marquesas, the demographic collapse destroyed the traditional economy, even as it compromised the priests, who had no capacity to sanction foreigners who violated the sacred laws of *tapu* with impunity and were immune to pestilence.

RIGHT: By 1877 disease and slavery had reduced the original population of Rapa Nui, or Easter Island, from 15,000 to 111. Until the 1960s these people were confined within the small settlement of Hanga Roa, unable to leave without permission of Chilean authorities. The rest of the island was the private domain of a Scottish company that raised sheep. More recently an indigenous rights movement has sparked an astonishing cultural revival, a great symbol of which is the success of the Ballet Kari Kari, a dance troupe famous throughout the Pacific for having rescued an art form and rekindled in Rapa Nui a new dream of a nation.

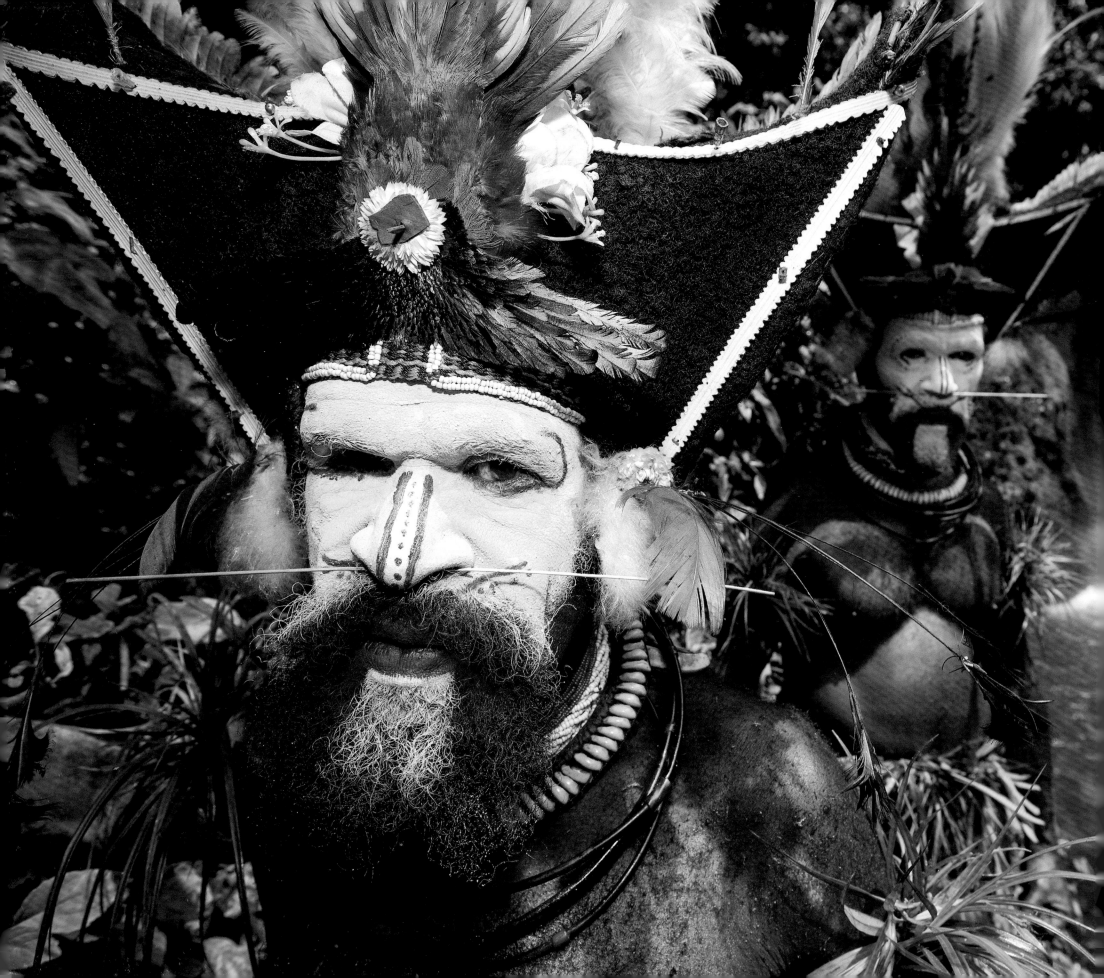

COMING OF AGE IS A JOURNEY FROM INNOCENCE TO EXPERIENCE, and almost all cultures see it as a heroic passage that must be acknowledged and celebrated through ritual. Death is the final transition, and how a people interpret the inexorable separation that death implies to a great extent determines their spiritual world view.

Nowhere are the rites of passage more astonishing than in New Guinea, home to a third of the world's languages, a land of mountains and dense tropical forests the highland heart of which was only reached by Europeans in the 1930s.

The Sambia, a warrior tribe numbering but two thousand people, believe that semen is not produced internally but must be artificially introduced into the body. The essence of their initiation rite is fellatio with the elders; only by consuming semen can boys become men and fathers. The ritual practice, which begins as early as age six and has nothing to do with pedophilia as Westerners define it, stops the moment the initiate takes a wife, as all do.

For boys to become men among the Matausa, another New Guinea tribe, they must be cleansed of impurities. The elders slide slivers of cane into the throats of the initiates, causing them to vomit blood. They then insert reeds into their nostrils, causing them to expel both blood and mucus. Ramming the reeds back and forth is said to cleanse them of any impurities they might have inhaled from the air. Finally the elders repeatedly stab the tongues of the initiates with an arrow-like tool, releasing contamination believed to have been absorbed from their mothers. Only by enduring this ordeal can a young initiate return to his community as a man.

Initiation rites involve pain, physical ordeal and tests of courage precisely because the message must be unequivocal: childhood is over. A completely new phase of life is about to begin and with it come new responsibilities and obligations—duties that contribute directly to the cultural survival of the people. Nothing will ever be the same again.

Among the Huli of the Tari Valley becoming a man is to join a fraternity of tribal brothers, all warriors believed to be descendants of a single male ancestor. Boys enter seclusion for three years, forbidden to have any contact with women. They sleep on headrests that prevent their hair from being flattened or tangled. After eighteen months the entire coif is cut close to the scalp and reformed into a tight headpiece festooned with parrot feathers and the iridescent-blue breastplate of the bird of paradise. The yellow and red face paints are derived from clay and ochre, both believed by the Huli to be sacred.

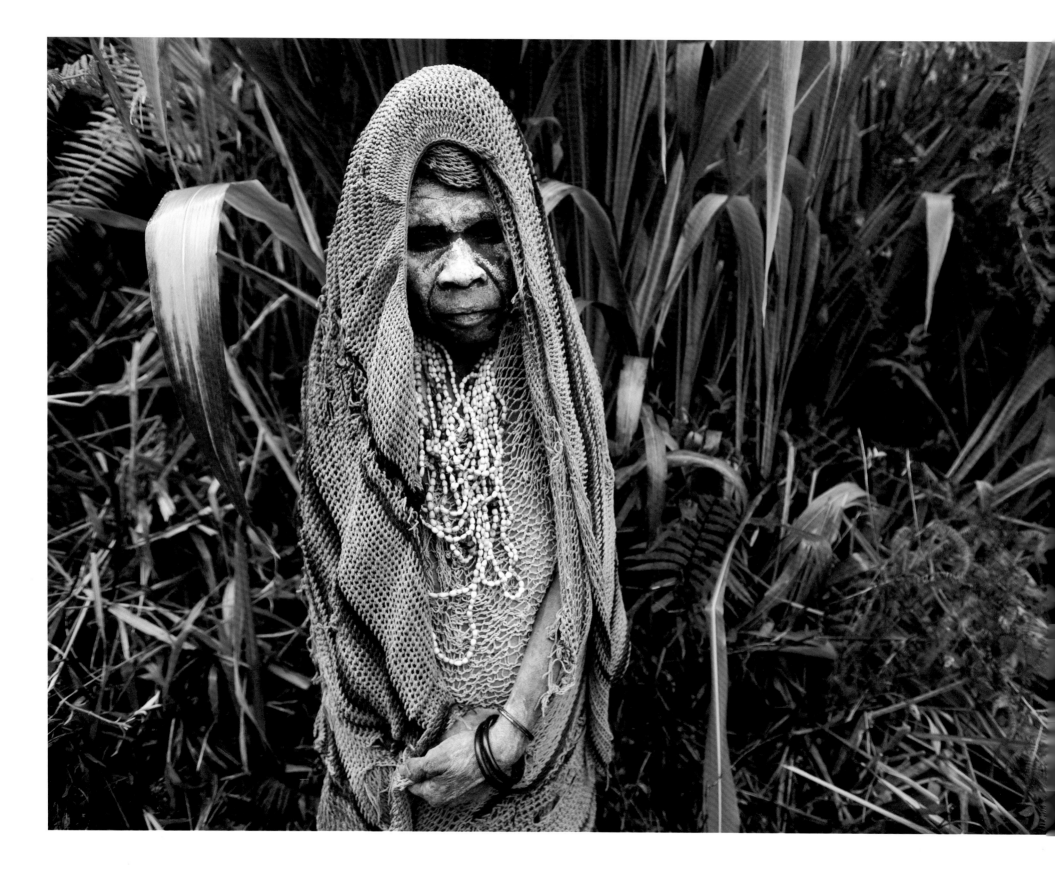

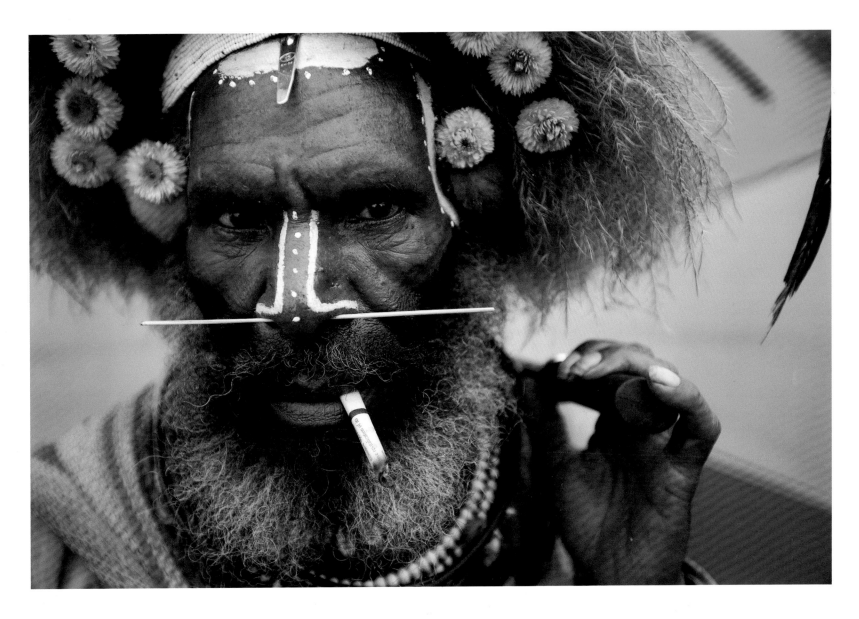

ABOVE: A man attends a local Sing-Sing Festival. Central to the social life of the New Guinea Highlands, Sing-Sings range from small village affairs to great gatherings that attract thousands. In a mountainous country of imposing physical barriers, historically beset by inter- and intra-tribal conflicts, the Sing-Sings are safe and sanctioned celebrations that facilitate trade and bride exchange, even as they mark important events—the passing of an elder, a marriage or birth, or simply the well-being of pigs and an abundant harvest.

LEFT: Near the city of Mount Hagen in the central highlands of New Guinea, a woman in mourning honours the deceased by covering her body in white clay and wearing several strands of beads—the seeds of Job's tears, a common weed. Only when the string rots away and the necklaces fall apart will she renew her normal daily life.

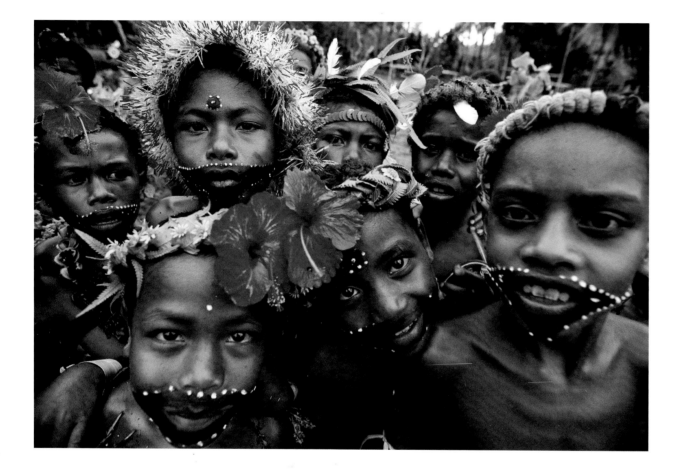

ABOVE: Young boys celebrate the yam harvest on Kitava, a small island in the Trobiand archipelago, Papua New Guinea.

RIGHT: Some three hundred languages are spoken in the lowland forests along the banks of the Sepik River, the longest in New Guinea. Throughout the basin saltwater crocodiles are seen as sacred beings. To secure a spiritual connection to these fearsome creatures, young initiates such as this Kaningara boy of the middle Sepik will have their skin transformed through scarification, an exceedingly painful process that leaves their backs looking like the skin of the beasts they so revere.

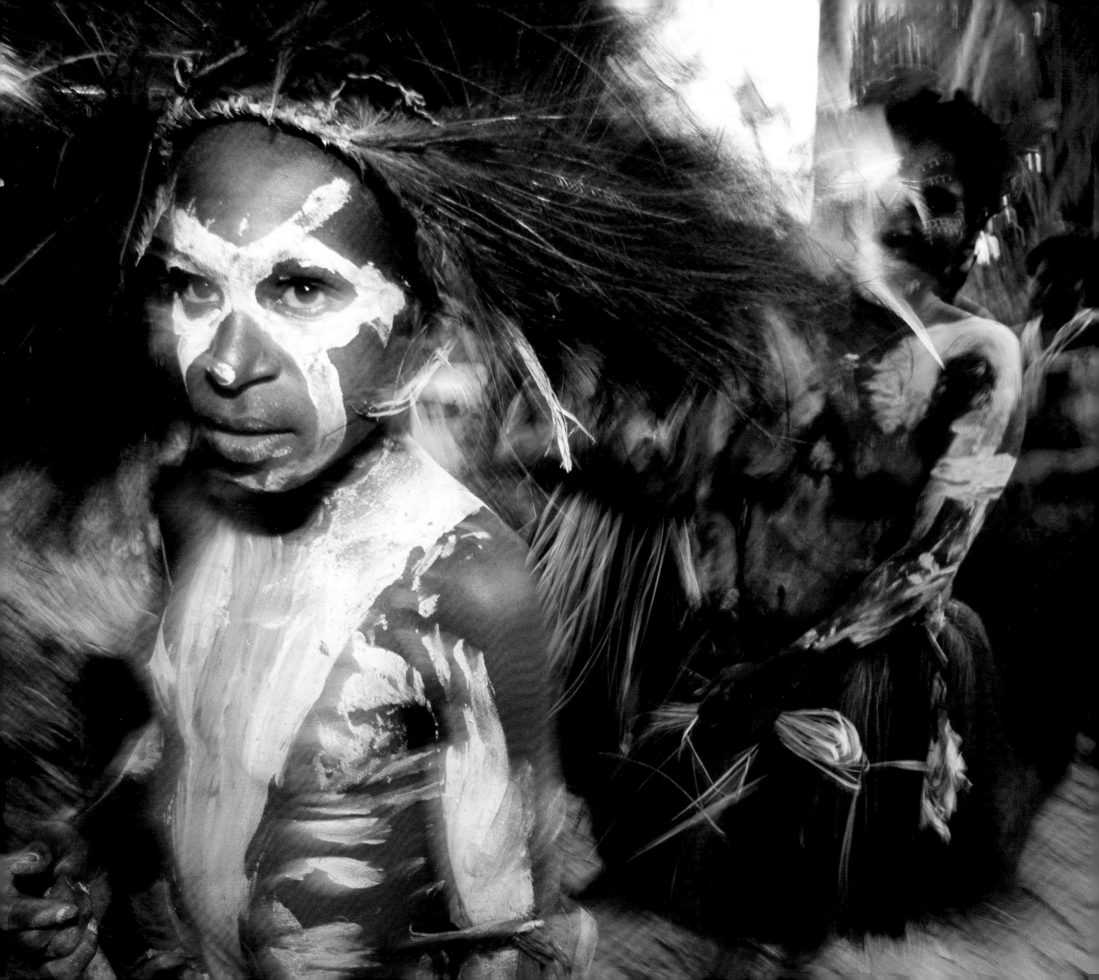

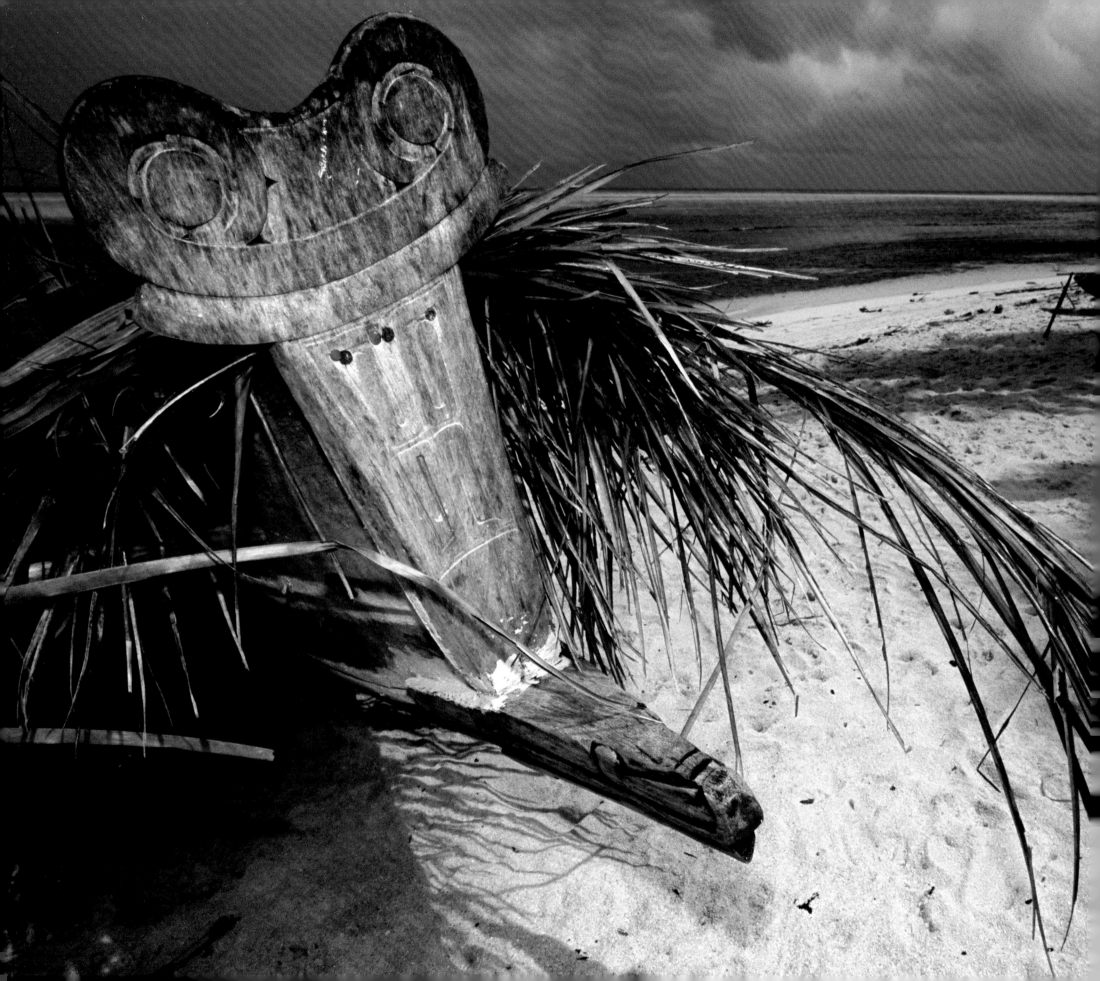

THE KULA RING

STRANDED IN NEW GUINEA BY THE OUTBREAK OF WORLD WAR I, the Polish anthropologist Bronislaw Malinoski spent two years in the Trobriand Islands, an archipelago of flat coral reefs and islands located some 150 miles northeast of New Guinea. He was interested in trade at a time when economics implied only two possibilities, either the theories of Karl Marx or those of Adam Smith, both of which defined wealth in strictly material terms. What Malinoski discovered in the Trobriand Islands challenged all conventional ideas about the nature of wealth and the purpose and meaning of exchange.

The Trobriand Islands anchored a trading network that linked scores of communities across hundreds of square miles of ocean. Known as the Kula Ring, it was a system of balanced reciprocity based on the ceremonial exchange of two items: necklaces of discs chiselled from red spondylus shells, and armbands of white cone shell. These were strictly symbolic objects with no intrinsic or utilitarian value. And yet for at least five hundred years men had been prepared to risk their lives to carry these jewels across hundreds of miles of open sea.

Through the years the necklaces moved clockwise while the armbands moved in reverse, always travelling in a counterclockwise direction. Each person involved in the circular trade had at least two partners, one on each of the two participating islands closest to his own. These relationships, the foundation of the distribution chain, were intended to last for life and even be inherited by subsequent generations. To one partner a voyager would give a necklace in exchange for an armband of equal value, and to the other he would pass along an armband, receiving in return a necklace. The exchanges did not occur all at once. Once in possession of a highly valued object, a trader was expected to savour for a time the prestige it conferred even as he made plans ultimately to pass it along. As a single object made its way around the Kula, perhaps taking as long as twenty years to complete the passage, only to continue again, its value grew with each voyage, with each story of hardship and wonder, witchcraft and the wind, and with the names of all the great men whose lives it had passed through. Thus the sacred objects were in constant motion, encircling the scattered islands in a ring of social and magical power.

For the Trobriand Islanders value and wealth lay not in the usefulness of the object, but in the social and metaphysical outcomes of the trading network that the object made possible.

On the beach of Bodaluna Island lies a *masawa* canoe built expressly for the Kula. The elegantly carved *lagim*, or splashboard, that encloses the end of the hull and the decorative *tabuya*, or wavesplitter, it rests upon, are decorated with shallow symbolic carvings. Once on the water the canoe could not come about, let alone tack into the wind. It was built to go point to point, sailing with the wind like an arrow on a single trajectory. Kula implied, if nothing else, commitment.

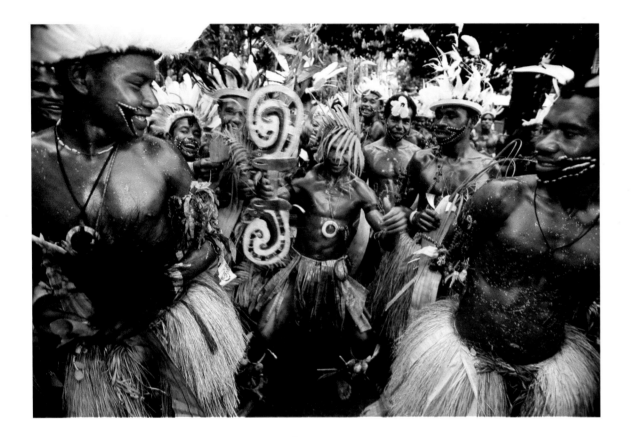

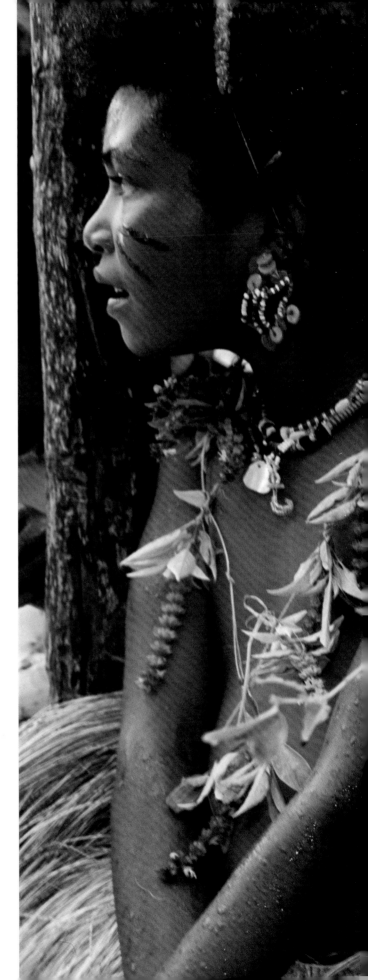

ABOVE: These dancers at the yam festival on Kitava are remarkably healthy because their diet is based exclusively on local foods: fresh fruit, fish, coconut, and tubers such as yams, cassava, taro and sweet potatoes. Intake of dairy products, tea, coffee and alcohol, as well as sugar, grains and fats such as margarine, is close to nil. Salt intake is low. The average person spends less than three US dollars a year on Western foods. As a result diabetes, heart disease, dementia and obesity are unknown, as is acne, a skin condition that afflicts more than 80 per cent of North American teenagers.

RIGHT: Bodaluna Island is an islet on a coral atoll at the easternmost limit of the Kula Ring. A sliver of sand on the fringe of a reef, protected from the typhoons by nothing more than a scattering of coconut palms, it is home to perhaps twenty families who maintain small gardens with soil crushed from coral. In daily life they approach every task fully adorned.

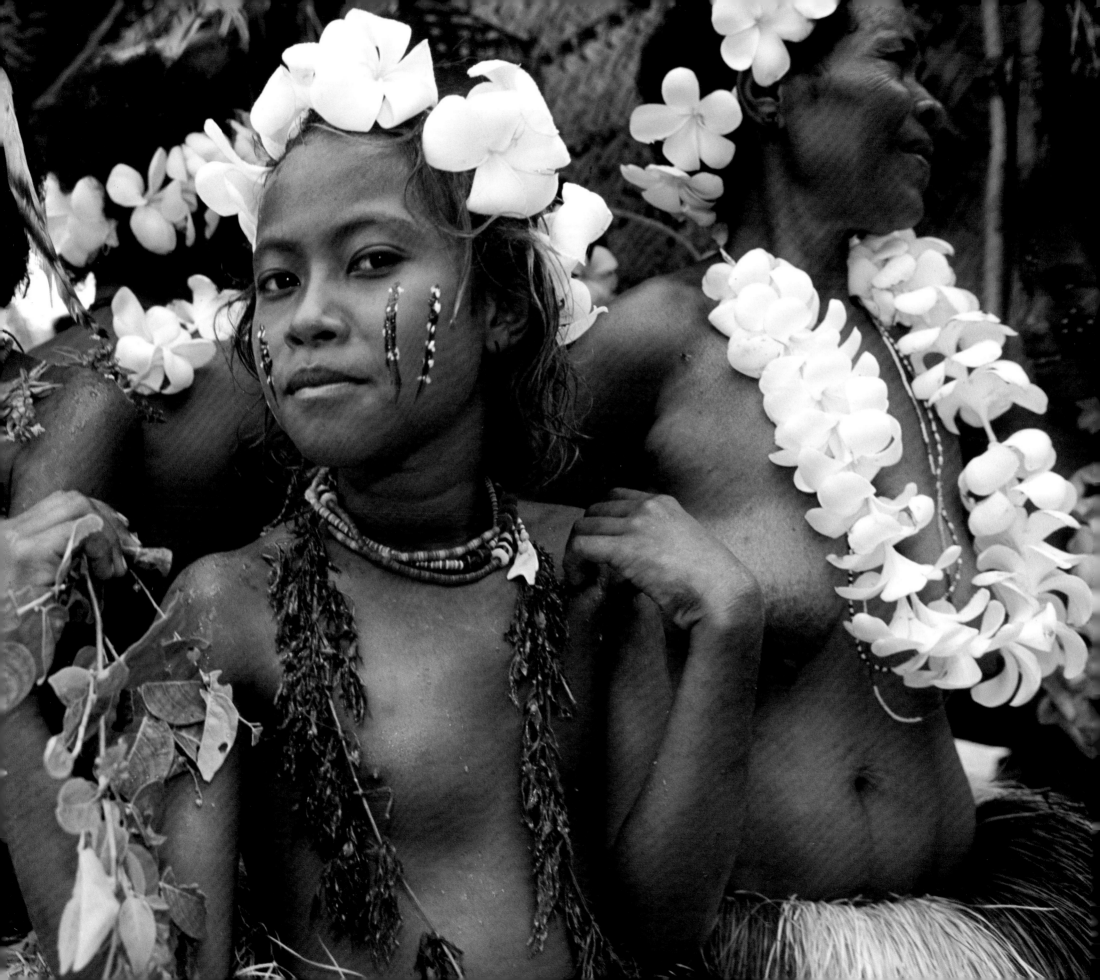

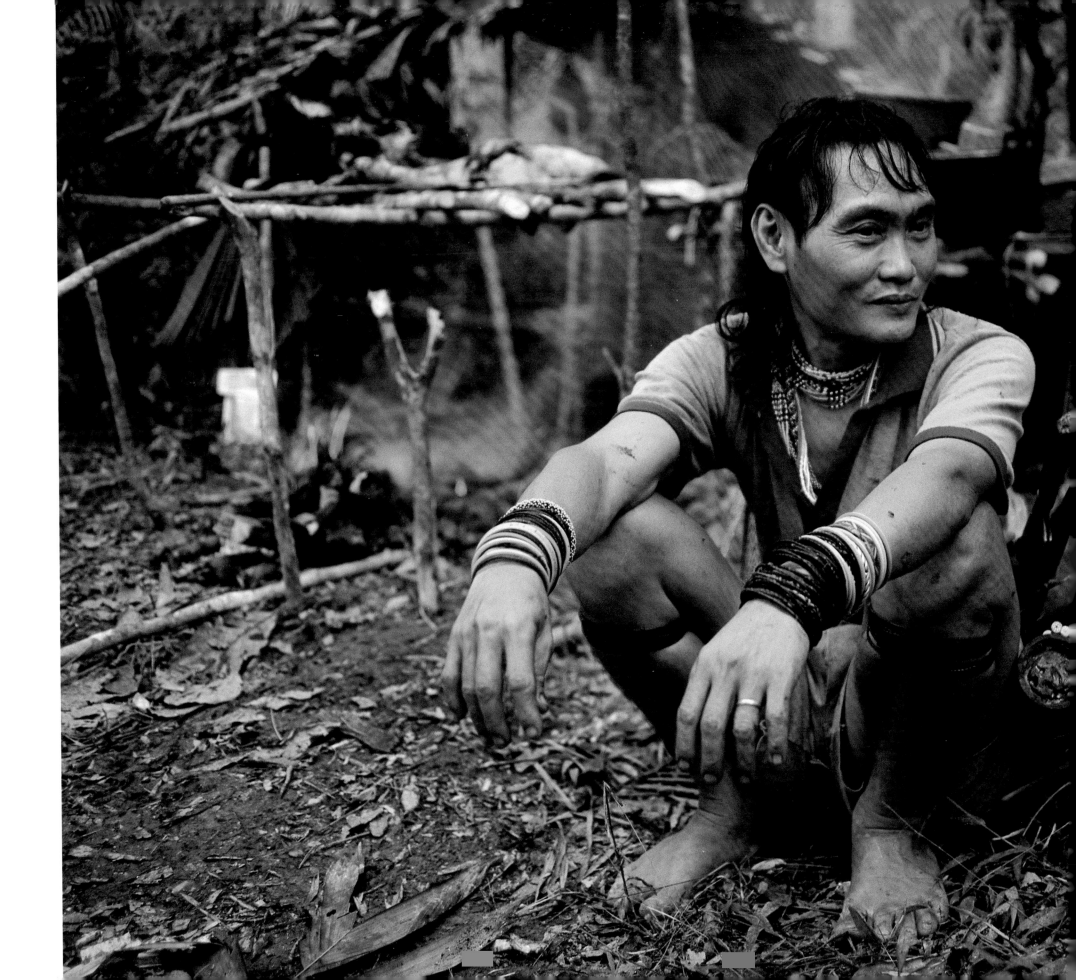

NOMADS OF THE DAWN

GENOCIDE, THE PHYSICAL EXTERMINATION OF A PEOPLE, is universally condemned. Ethnocide, the destruction of a people's way of life, is in many quarters sanctioned as appropriate development policy. Modernity provides the rationale for disenfranchisement, with the real goal too often being the extraction of natural resources on an industrial scale from territories occupied for generations by indigenous peoples, whose ongoing presence on the land proves to be an inconvenience.

Such has been the fate of the Penan, the last nomads of the Borneo rain forest, whose homeland for two generations has been ravaged by the highest rate of industrial deforestation in the world. For the Malaysian government the existence of a tribal society living freely in the forest was an embarrassment, and it set in place programs intended to emancipate the Penan from their backwardness. What this meant was freeing them from who they were as a people. When the Penan resisted, blockading the logging roads with rattan barricades—blowpipes against bulldozers—they were said to be standing in the way of development, which became grounds for dispossessing them and destroying their way of life. Their disappearance was then said to be inevitable, as such archaic folk cannot be expected to survive in the twenty-first century.

Today throughout the traditional homeland of the Penan, the sago and rattan, the palms, lianas and fruit trees lie crushed on the forest floor. The hornbill has fled with the pheasants, and as the trees continue to fall, a unique way of life—morally inspired, inherently right and effortlessly pursued for centuries—has been destroyed in a single generation.

Living in isolation, utterly dependent on the bounty of the forest, the Penan followed the rhythms of the natural world. With no incentive to acquire possessions, they explicitly perceived wealth to be the strength of social relations among people. There is no word for "thank you" in their language, for everything is freely given. Their worst societal transgression is *sihun*, meaning to covet or hoard. Hand a cigarette to a Penan woman and she will tear it apart to distribute the individual strands of tobacco to each hut in the encampment, rendering the product useless but honouring her obligation to share.

MORNING STAR SONGLINE

WHEN HUMANS FIRST REACHED AUSTRALIA THEY WENT WALKING, and over the course of centuries established ten thousand clan territories, a matrix of culture imposed over the length and breadth of the most arid of continents. Linking these homelands was a subtle but universal philosophy called the Dreaming, or Dreamtime. It refers on one level to the first dawning, when the Rainbow Serpent and all the ancestral beings created the world. And it is remembered in the Songlines, which are the trajectories travelled by the ancestors as they sang the world into being—paths still taken today as the people travel across the template of the physical world.

The Dreaming is what happened at the time of creation but also what happens now and what will happen for all eternity. In the Aboriginal universe there is no past, present or future. In not one of their 670 languages and dialects is there a word for time. There is no notion of linear progression, no goal of improvement, no idealization of the possibility of change. On the contrary, the Dreaming is all about stasis, balance and consistency. The obligation of men and women is not to improve upon nature, but to engage in the ceremonial activities considered essential to maintaining the world precisely as it was at the moment of creation. The literal preservation of the land was the fundamental priority—nothing was to change. Clearly, had humanity as a whole followed the ways of the Aborigines we would not have put a man on the moon. But on the other hand, had the Dreaming become a universal devotion we would not be contemplating today the consequences of industrial processes that by any scientific definition threaten the very life supports of the planet.

Fire is both a symbol of purification and transformation and a tool for the hunter—as in this image of the bush deliberately set aflame during a kangaroo fire drive in Arnhem Land, Northern Territory. In a vast landscape the flames coming from three sides force the prey into a reduced area where they are vulnerable to men on foot. To hunt is to engage in a dance of sacrifice and creation. Every kill is treated with extraordinary respect, its body and limbs processed according to strict ritual protocol.

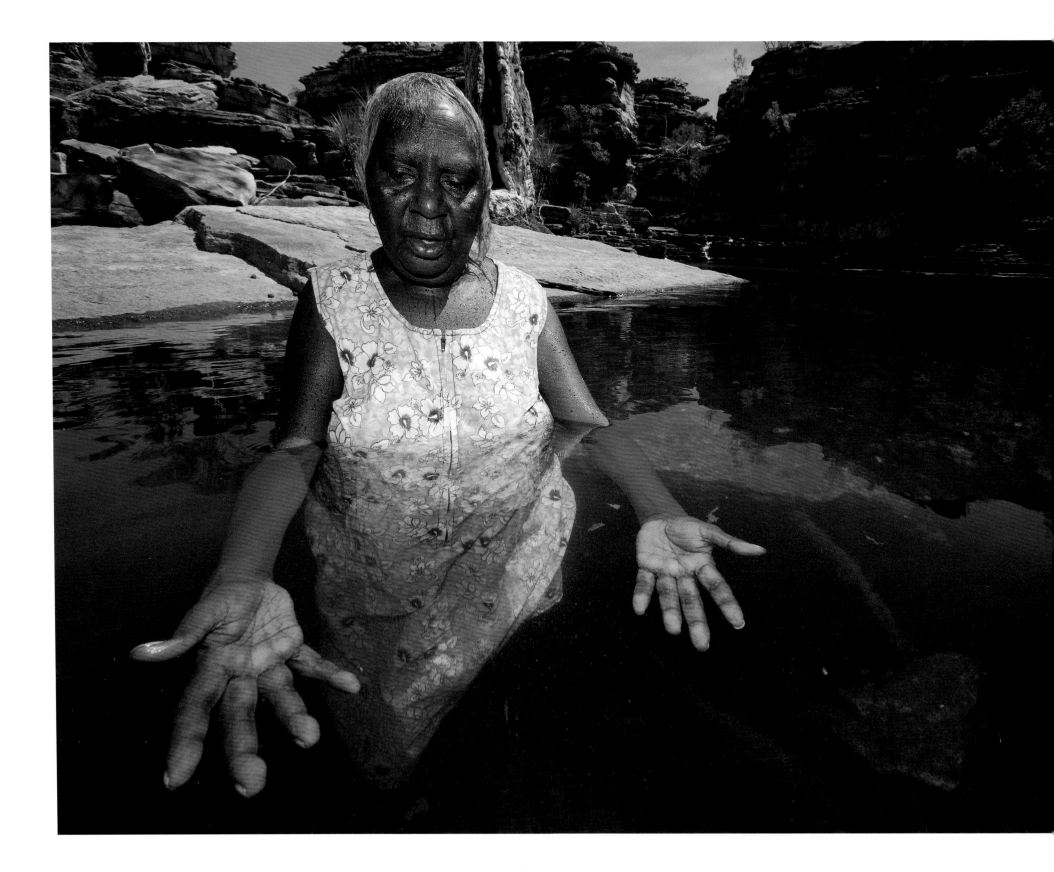

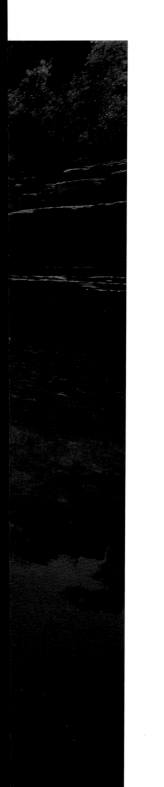

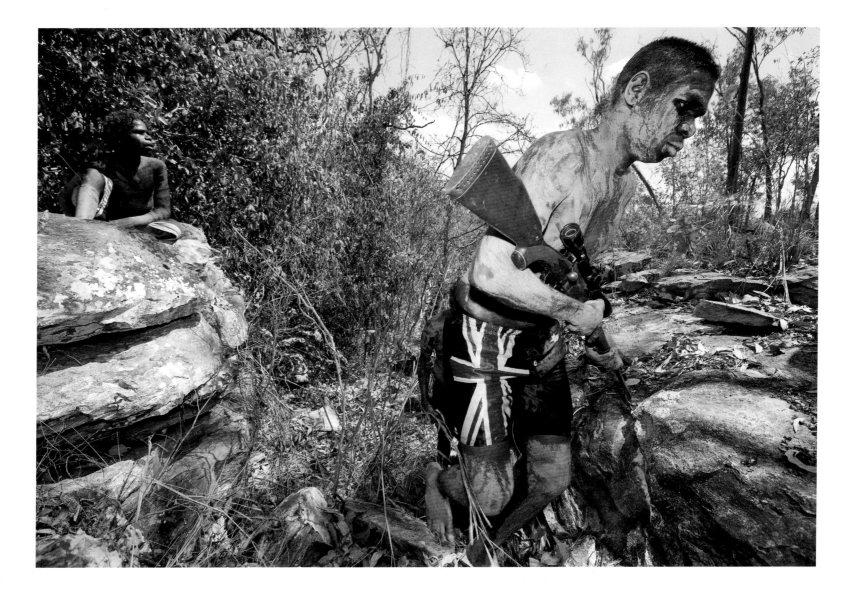

ABOVE: The British who reached the shores of Australia in the last years of the eighteenth century lacked the language or imagination to begin to understand the profound intellectual and spiritual achievements of the Aborigines. What they saw was a people who lived simply, whose technological achievements were modest, whose faces looked strange, whose habits were incomprehensible. That the Aborigines had no interest in improving their lot epitomized European notions of backwardness. As recently as 1902 politicians formally debated in parliament in Melbourne whether or not Aborigines were human beings.

LEFT: A traditional owner of the Crocodile clan of the Yolgnu, having returned to her territory for the first time in decades, stands in a pool she played in as a child. The site is today several hundred miles from the nearest road, but judging from the abundance of petroglyphs on the overhanging rocks it was occupied for tens of thousands of years.

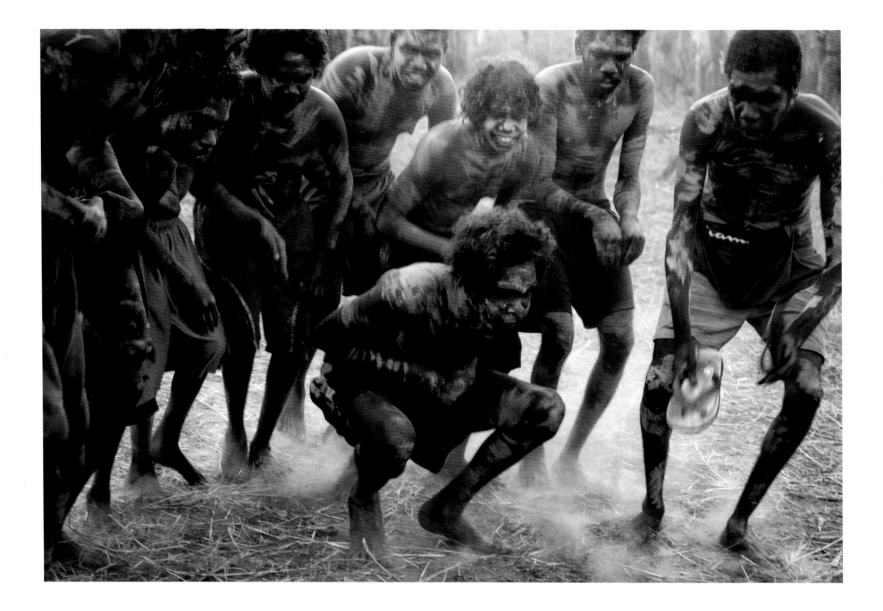

ABOVE: On the eve of a kangaroo hunt, a group of young men mimic in dance the movements of their prey. To walk the land is to become part of the ongoing creation of the world, a place that both exists and is still being formed. Thus the Aborigines are not merely attached to the earth but are essential to its existence. Without the land they would die. But without the people the ongoing process of creation would cease and the earth would wither.

RIGHT: Dreamtime is neither a dream nor a measure of the passage of time. It is the realm of the ancestors, a parallel universe where the ordinary laws of time, space and motion do not apply; where past, future and present merge into one. The early English settlers called it the Dreaming, but the term is misleading. A dream by Western definition is a state of consciousness divorced from the real world. Dreamtime, by contrast, is the real world, or at least one of two realities experienced in the daily lives of the Aborigines.

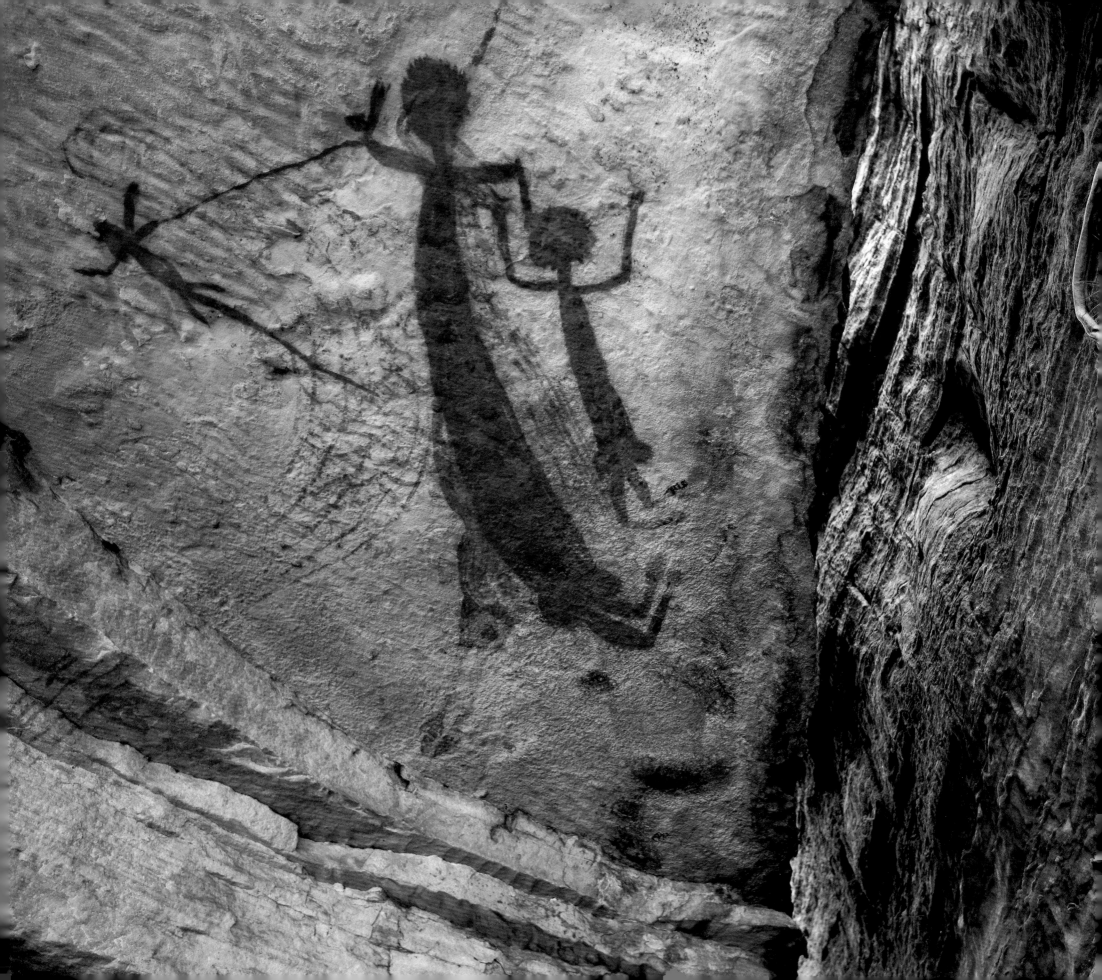

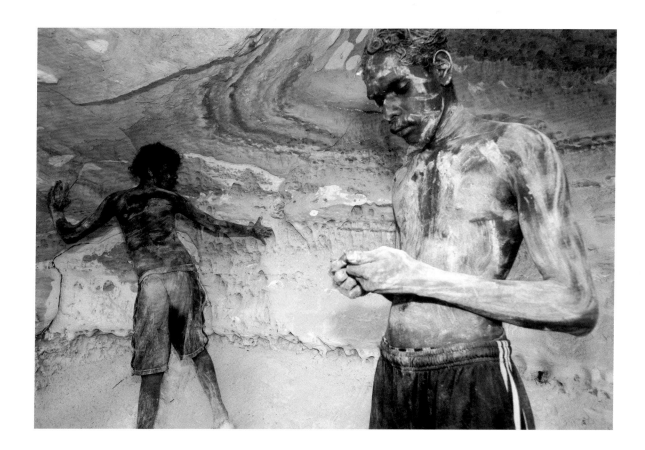

ABOVE: Everything on earth is held together by Songlines and everything is subordinate to the Dreaming, which is constant yet ever changing. Every animal and object resonates with the pulse of an ancient event while still being dreamed into being. The world as it exists is perfect though constantly in the process of being formed.

LEFT: For over 55,000 years the Aboriginal peoples of Australia thrived as hunters and gatherers and as guardians of their world. In all that time the desire to improve on the natural world had never touched them. They accepted life as it was—the unchanging creation of the first dawn, when earth and sky separated and the original ancestor, the Rainbow Serpent, brought into being all the primordial ancestors who, through their thoughts, dreams and journeys, sang the world into existence.

THE MYTH OF MODERNITY

JUST BEFORE SHE DIED ANTHROPOLOGIST MARGARET MEAD spoke of her concern that as we drift toward a more homogenous world, we are laying the foundations of a blandly amorphous, generic modern culture that will have no rivals. The entire imagination of humanity might be confined, she feared, to a single intellectual and spiritual modality. Her nightmare was that we might wake one day and not even remember what had been lost. Our species has been around for some 200,000 years. The Neolithic Revolution, which gave us agriculture, occurred only 10,000 years ago. Modern industrial society is scarcely 300 years old. This shallow history should not suggest that we have all the answers for all the challenges that will confront us in the coming millennia.

All cultures are ethnocentric, fiercely loyal to their own interpretations of reality. Indeed the names of many indigenous societies translate as "the people," implying that every other human is a savage. We too are culturally myopic, often forgetting that modernity is but an expression of our cultural values. It is not some objective force removed from the constraints of culture. And it is certainly not the true and only pulse of history. It is merely a constellation of beliefs and paradigms that represent one way of doing things.

Our achievements have been stunning. The development within the last century of a modern, scientific system of medicine alone represents one of the greatest episodes in human endeavour. Sever a limb in a car accident and you won't want to be taken to a herbalist. But these accomplishments do not make the Western paradigm exceptional or suggest that it ought to monopolize the path to the future.

An anthropologist from a distant planet landing in the United States would see many wondrous things. But he, she or it would also encounter a culture that reveres marriage, yet allows half of its marriages to end in divorce; admires its elderly, yet has grandparents living with grandchildren in only 6 per cent of its households; loves its children, yet promotes 24/7 devotion to the workplace at the expense of family. By the age of eighteen the average American youth has spent three years watching television or playing video games. One in five adults is clinically obese. The nation consumes two-thirds of the world's production of antidepressant drugs, even as it spends more money on armaments and war than the collective military budgets of its seventeen closest rivals. Technological wizardry is balanced by the embrace of an economic model of production and consumption that challenges the very life support systems of the planet. Our way of life, inspired in so many aspects, does not represent the supreme achievement of human endeavour.

The Croatian citizens of Dubrovnic believed that their city's status as a UNESCO World Heritage Site, heralded for its architectural and historic beauty, would insulate it from the ravages of war in the Balkans. The attacking Yugoslav People's Army, backed by Serbia, could not have cared less, destroying much of the ancient centre in a siege that lasted many months.

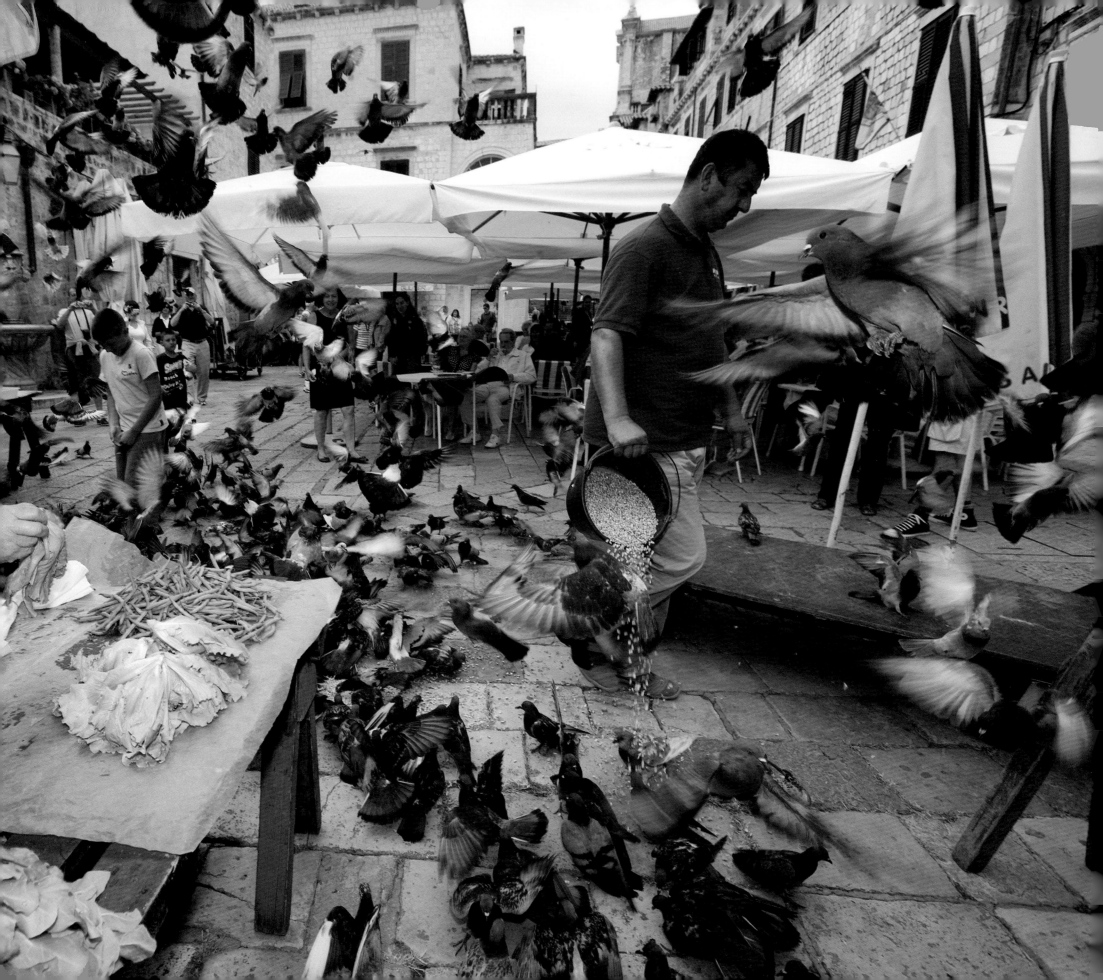

ABOVE: A young man at the holiest of Tibetan shrines, the Jokhang Temple in Lhasa, a city today completely dominated by Han Chinese.

RIGHT: On the streets of Barcelona, as in much of the developed world, the gap between those who have and those who have little seems only to widen. In 1990 three Penan men left the forests of Borneo for the first time and landed in Vancouver BC. Nothing confused or impressed them more than homelessness. In their culture everything is shared. They truly live by the adage that a poor man shames us all.

ABOVE: Brazilian sightseers fight the crowds beneath the statue of Christ the Redeemer overlooking Río de Janeiro from the summit of Mount Corcovado.

RIGHT: Visitors enjoy the colonial quarter of Bahía, or Salvador, the heart of Afro-Brazilian culture. Travel is a 3.5-trillion-dollar business, the largest economic engine in the global economy. Tourists fly to the most remote outposts of the planet in a day with absolute assurance that they will be able to scurry back home in a week, just in time for a family wedding. By contrast the traveller is loyal to everywhere and nowhere, with home being the ground beneath one's feet and movement the natural way of things. The quality of a journey, not the remoteness of its destination, lends meaning to travel, and it is time alone that allows a traveller to be transformed, which ultimately is the goal of every journey.

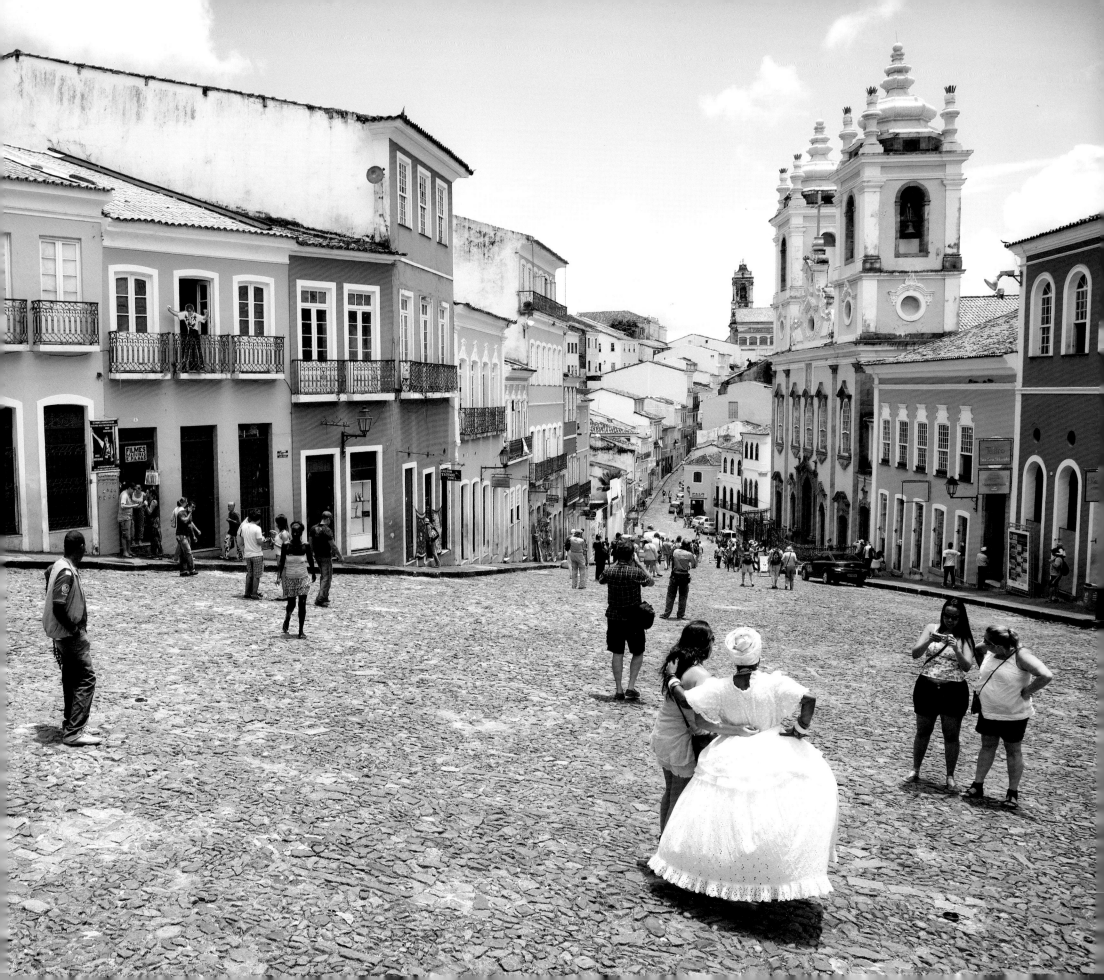

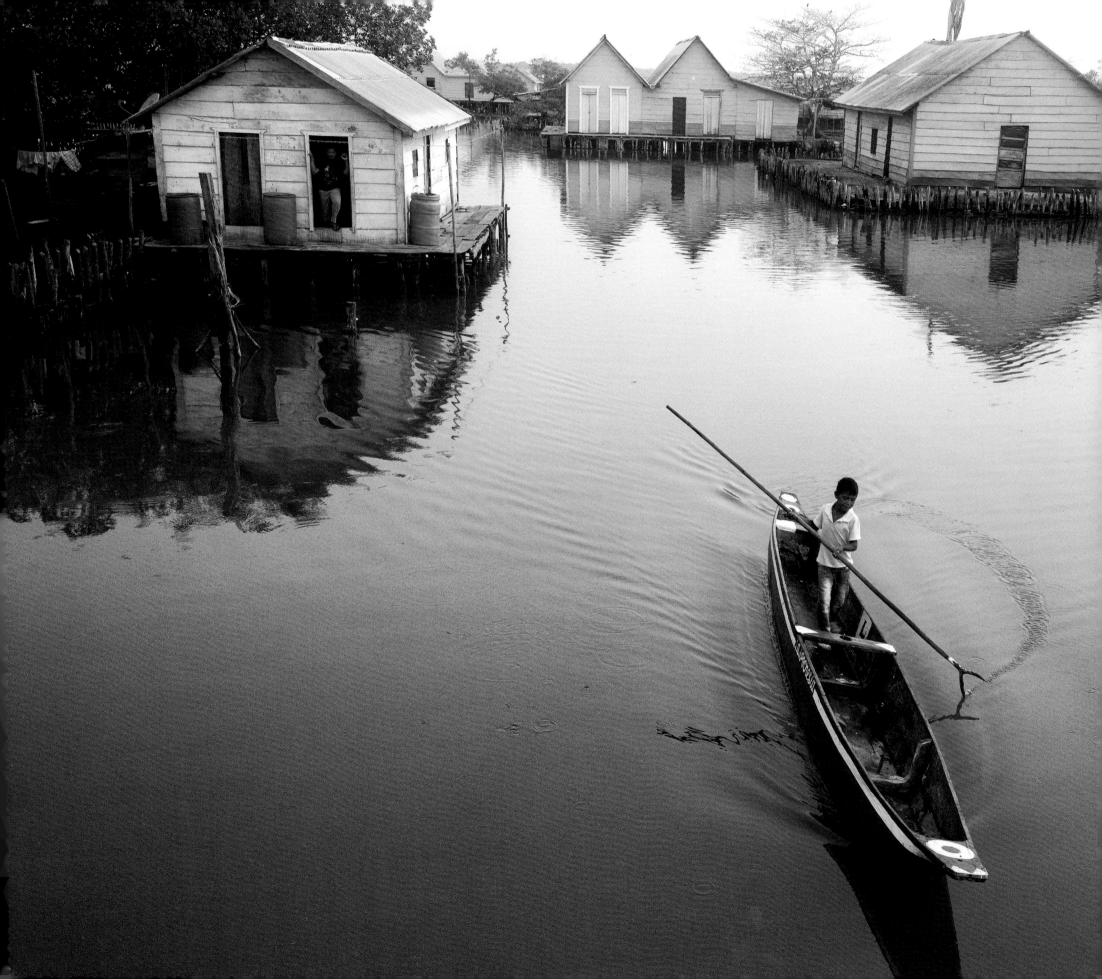

A NEW DAWN FOR COLOMBIA

TRAVELLERS OFTEN FALL IN LOVE WITH THE FIRST COUNTRY that captures their hearts and gives them licence to be free. For me it was Colombia. At fourteen I lived for a summer with a family in the mountains above Cali. Several of the other Canadian students on that exchange longed for home. I felt as if I had finally found it.

Six years later, in the spring of 1974, I returned to Colombia with a one-way ticket and no plans save a promise not to return to the United States until Richard Nixon was no longer president. I had just a small backpack of clothes and two books, Lawrence's *Taxonomy of Vascular Plants* and Walt Whitman's *Leaves of Grass*.

At the time I believed that bliss was an objective state that could be achieved simply by opening oneself unabashedly and completely to the world. Both figuratively and literally I drank from every stream, even from tire tracks in the road. Naturally I was constantly sick but even that seemed part of the process, malaria and dysentery fevers growing through the night before breaking with the dawn. Every adventure led to another. Once on a day's notice I set out to traverse the Darien Gap. After nearly a month on the trail I became lost in the forest for a fortnight without food or shelter. When finally I found my way to safety I stumbled off a small plane in Panama, drenched in vomit from my fellow passengers, with only the ragged cloths on my back and three dollars to my name. I had never felt so alive.

Along the way I became an acolyte of the legendary botanical explorer Richard Evans Schultes. He too had found his life in Colombia. When years later I would write his biography it was inevitable that the book would be a love letter to a nation by then scorned by the world.

Cocaine has been Colombia's curse, but the engine driving the trade has always been consumption. I was there at the beginning and watched as small-time Colombian hustlers joined forces with American Vietnam vets, pilots who flew the cocaine to Texas and Florida. No one knew how sordid it would all become, or that the blood money would fuel a fratricidal conflict that has left 200,000 dead and six million displaced. There is no one in Colombia who has not suffered. Yet through all these years of crisis Colombia has maintained civil society, grown its economy, greened its cities, sought meaningful restitution with indigenous peoples, set aside millions of acres as national parks and laid the ground for a cultural, economic and intellectual renaissance unlike anything that has ever been seen in Latin America. After forty years of war, peace has broken out. The whole world may be falling apart, but Colombia is falling together.

Nueva Venecia is one of several floating fishing villages on the Ciénaga Grande de Santa Marta. It is a close-knit community where all movement is by boat, and where the dogs are afraid of the water and cats swim. Magical realism as celebrated in Latin American literature is, in Colombia, mere journalism.

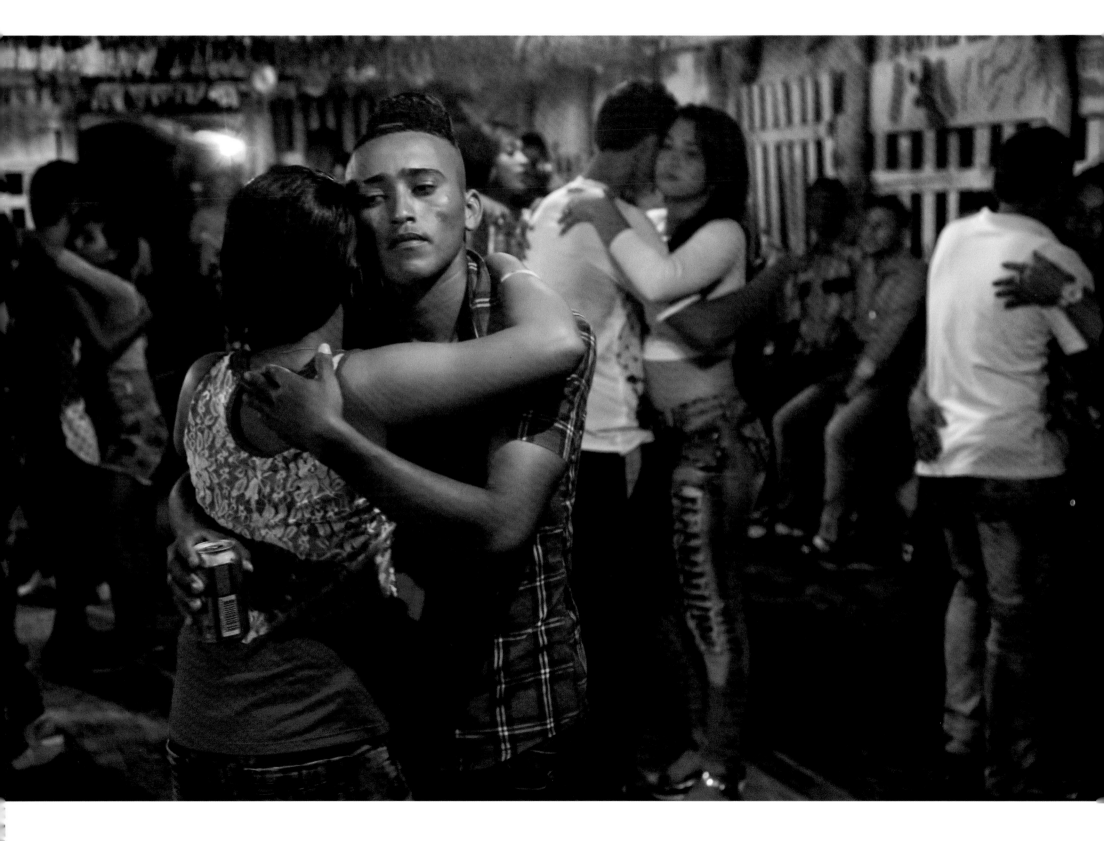

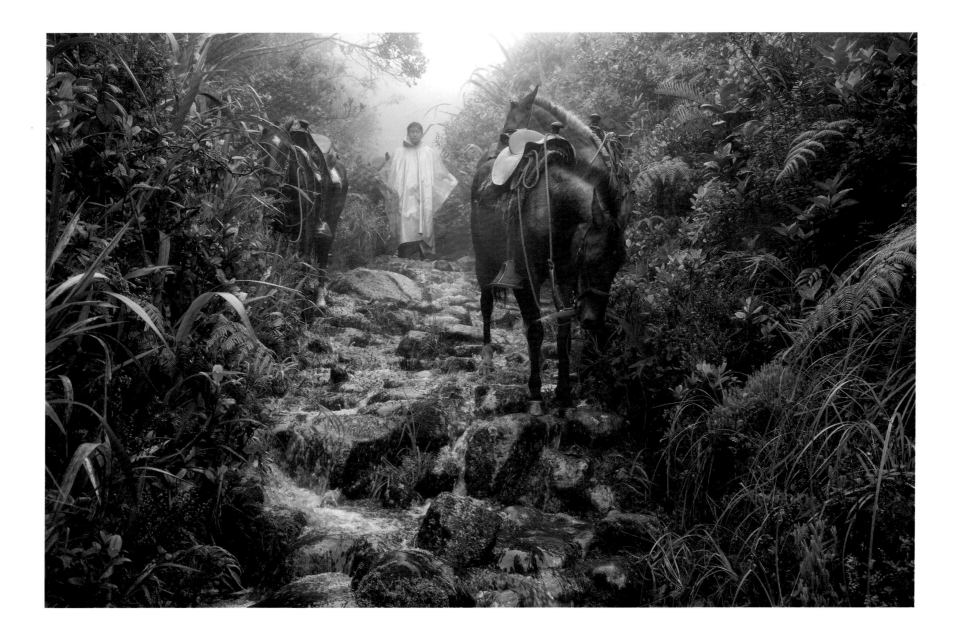

ABOVE: Crossing the Colombian massif from Popayán to San Agustín along remnants of the Incan road. Colombia—with three great branches of the Andes fanning out northward from the massif toward the wide Caribbean coastal plain, the rich valleys of the Cauca and Magdalena rivers, the sweeping grasslands of the eastern llanos and the endless forests of the Chocó and Amazonas—is ecologically and geographically the most diverse country on earth. A naturalist need only spin the compass to discover plants and even animals unknown to science.

LEFT: A Saturday night dance in Nueva Venecia. Colombia is often described as the land of a thousand rhythms; ethnomusicologists have in fact identified precisely 1,025. Cumbia, celebrated today throughout the world, originated as a courtship dance on the Colombian coast not far from the Panama border. Vallenato is a genre made up of four distinct rhythms: *son*, *puya*, *merengue* and *paseo*. It too was born on the Caribbean coast but in Valledupar, a city on the east side of the Sierra. Salsa came early to Colombia from Cuba and Puerto Rico, only to be reinvented and exported in a style that is indelibly Colombian.

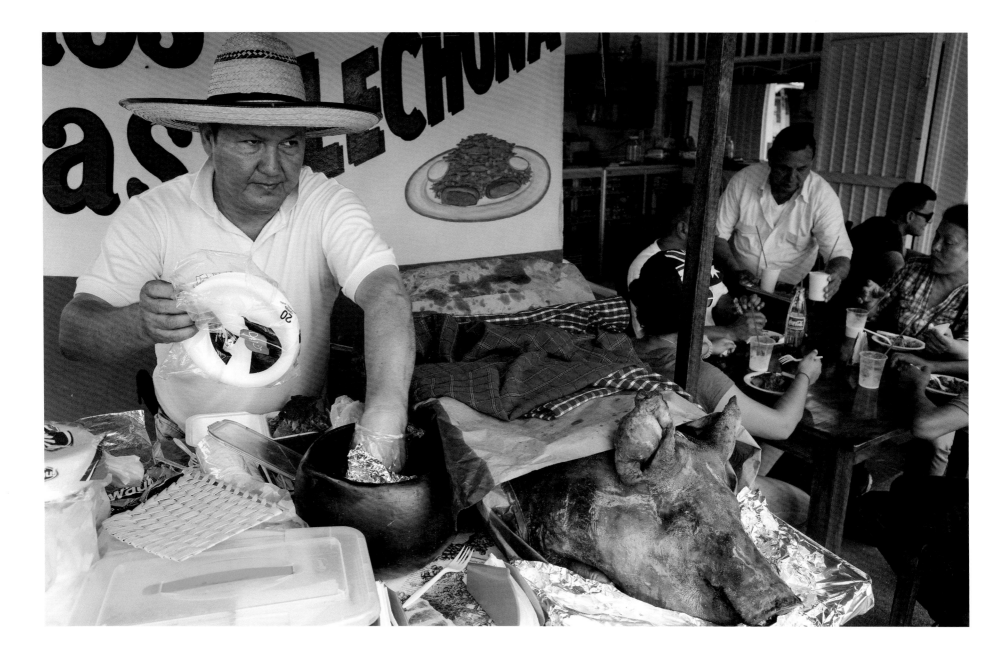

ABOVE: Sunday in Colombia is a time for family and friends, for endless *paseos* in the countryside, roadside restaurants and glorious food. The classic dish of Tolima is *lechona*, an entire pig stuffed with rice, peas and magic spices.

RIGHT: A farmer in Huila, close to the headwaters of the Río Magdalena, prepares *panela*, blocks of raw sugar processed from cane juice and boiled down to a thick concentrate that is poured into molds to harden.

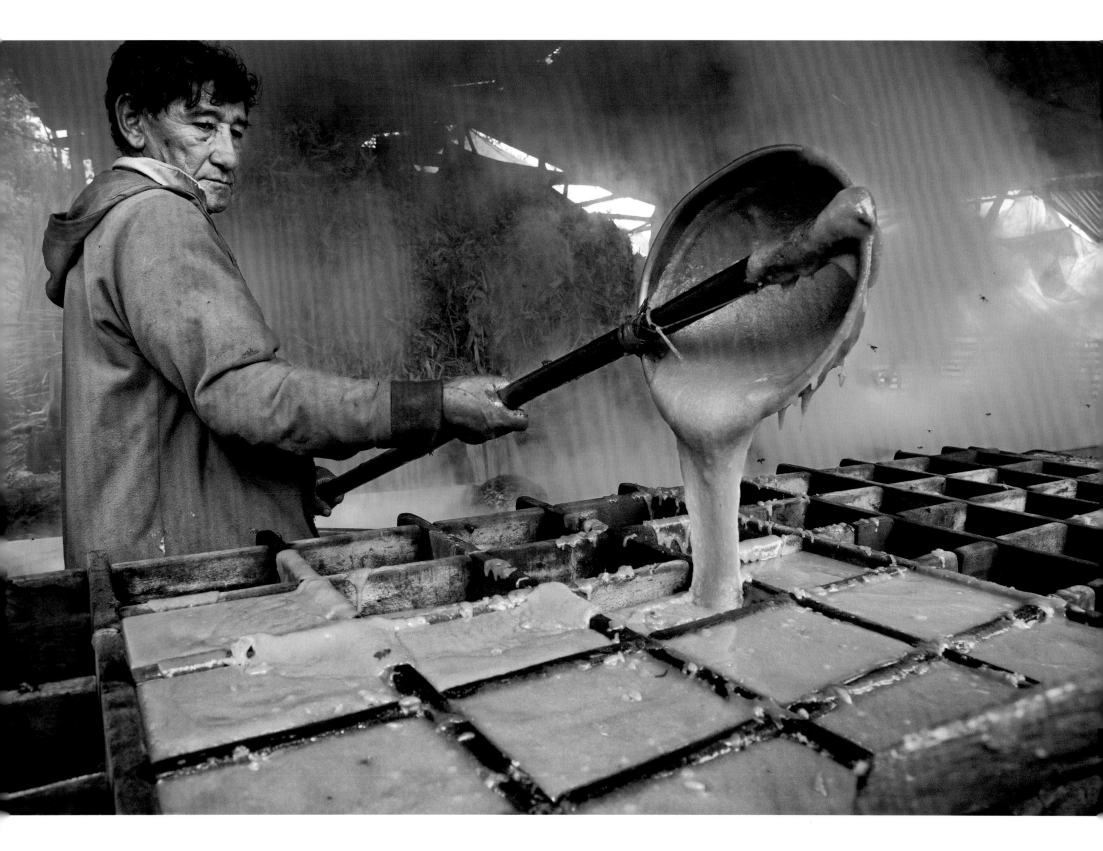

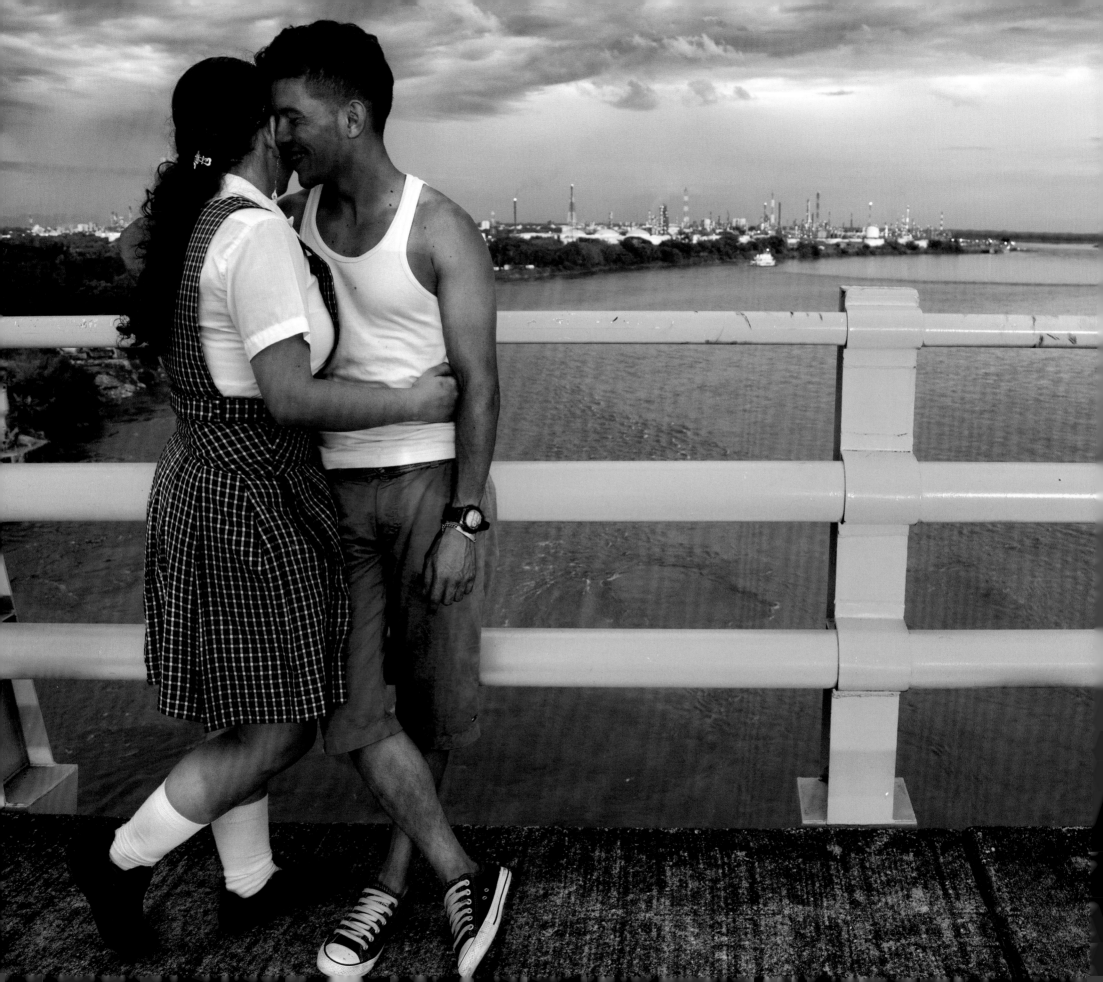

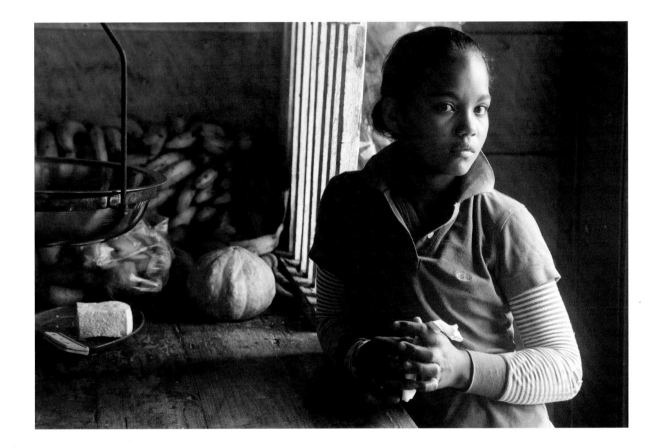

ABOVE: A young girl looks to her future in the village of Nueva Venecia. The village was caught between the army, the leftist guerrillas and the right-wing paramilitaries, and like so many small towns in Colombia it became a victim of all. On November 22, 2000, six boats carrying seventy paramilitary arrived at night to round up those they accused of having collaborated with the ELN, a leftist force that no doubt had compelled the local fishermen to sell them supplies or gas. In front of their families, before the door of the church, thirty-six innocent men, fathers and sons, were murdered in cold blood. Though a major Colombian military base was nearby, it took the army five days to arrive in force.

LEFT: Young lovers at sunset on a bridge over the Río Magdalena, with Barrancabermeja, the oil capital of Colombia, behind them. For many years the Magdalena carried the bodies of victims of the violence, often with vultures perched on their backs. Today the river, which has always defined the nation, carries the hopes of new generations as yet unborn, Colombians who will come into a nation at peace.

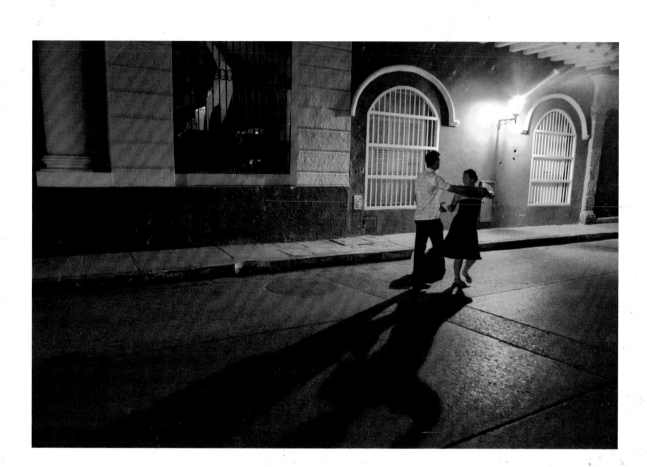

ABOVE: On a street of the old city of Cartagena on the Caribbean coast a Colombian couple practise their salsa at two in the morning, perfectly safe, sober and in love.

RIGHT: In the mountains of Tolima, far above the valley of the Río Magdalena, the sun shines through the clouds, causing the crown of a solitary palm to appear in silhouette at the bottom right of the frame. This is *Ceroxylon quindiuense*, Colombia's national tree, endemic to the region and the tallest palm in the world. In terms of biodiversity Colombia is the second-richest nation on earth. Only Brazil ranks higher. For number of species of birds Colombia has no rivals.

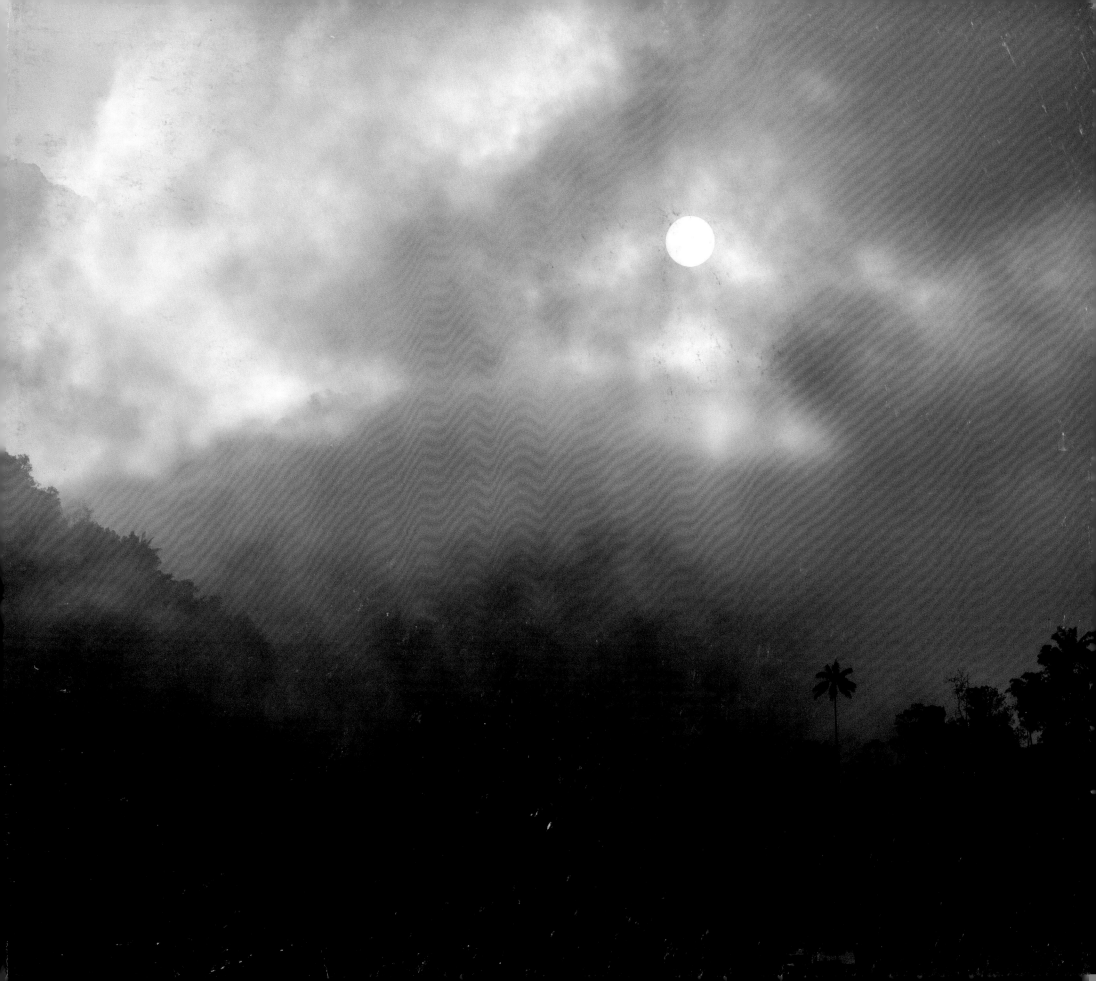

ACKNOWLEDGEMENTS

The photographs that appear in this book were taken over many years and across much of the world. The list of individuals who have helped me in one way or another, as colleagues in the field and editing suites, as teachers and guides, as companions and ambassadors of their peoples, as hosts and supporters, lovers and friends, is virtually endless. My gratitude is immense, and I trust it has been felt by all those with whom I have worked and travelled. A special thanks to the National Geographic Society, which made so many of these journeys possible; to the men and women of so many profound indigenous traditions with whom I found myself living as a guest; to my family, Gail, Tara and Raina; my good friend Chris Rainier, a partner in so many adventures; Jay Eberts, Nicol Ragland and Caroline Bennett who helped with the photo edit; and of course the splendid editors and designers at Douglas & McIntyre: Peter Robson, Roger Handling, Kathy Vanderlinden, and Ernst Vegt. This book is dedicated to Scott McIntyre, a wonderful publisher and heroic advocate of the arts in Canada.

Douglas and McIntyre (2013) Ltd.
P.O. Box 219, Madeira Park, BC, V0N 2H0
www.douglas-mcintyre.com

Project manager Peter Robson
Edited by Kathy Vanderlinden
Dust jacket and text design by Roger Handling, Terra Firma Digital Arts
Scanning and image processing by Coast Imaging Arts

All photographs by Wade Davis

Printed and bound in Canada
Printed on Forest Stewardship certified paper containing 10% recycled content

Douglas and McIntyre (2013) Ltd. acknowledges the support of the Canada Council for the Arts, which last year invested $153 million to bring the arts to Canadians throughout the country. We also gratefully acknowledge financial support from the Government of Canada through the Canada Book Fund and from the Province of British Columbia through the BC Arts Council and the Book Publishing Tax Credit.

Library and Archives Canada Cataloguing in Publication

Davis, Wade, photographer

 Wade Davis : photographs / Wade Davis.

ISBN 978-1-77162-124-3 (hardback)

 1. Davis, Wade. 2. Documentary photography. I. Title. II. Title: Photographs.

TR820.5D39 2016 779.092 C2016-905375-X